Animating with Stop Motion Pro™

Animating with Stop Motion Pro™

Mark Sawicki

Routledge
Taylor & Francis Group
New York London

First published 2010 by Focal Press

711 Third Avenue, New York, NY 10017, USA
2 Park Square, Milton Park, Abingdon, Oxon OX14 4RN

Routledge is an imprint of the Taylor & Francis Group, an informa business

First issued in hardback 2017

Library of Congress Cataloging-in-Publication Data
Sawicki, Mark.
 Animating with Stop motion pro / Mark Sawicki.
 p. cm.
 Includes bibliographical references and index.
 ISBN 978-0-240-81219-9 (pbk. : alk. paper) 1. Computer Animation. 2. Puppet films. 3. Stop motion pro. I. Title.
 TR897.7.S3665 2010
 006.6'96—dc22

 2009046737

ISBN-13: 978-0-240-81219-9 (pbk)
ISBN-13: 978-1-138-45626-6 (hbk)

For
Juniko and Jennifer
and
our beloved Sam.

Contents

Acknowledgments

I am extremely grateful to Elinor Actipis and Kathryn Spencer of Focal Press, along with Paul Howell, Ross Garner, and Diane Cook of Stop Motion Pro without whose faith and contributions this book would not have been possible. I also want to thank Joe Clokey and Premavision.com for sharing Gumby and Will Vinton for sharing his wonderful Claymation stills from willvinton.net. The richness of the illustrations would have fallen far short without the much appreciated contributions of publisher Ernest Farino and his fabulous book *Ray Harryhausen Master of Majicks* by Mike Hankin from archive-editions.com. Another well-deserved nod goes to Harry Walton, who lived and practiced the history of the art and shared stills of his journey from vfxmasters.com.

I'd also like to extend thanks to the following supportive individuals:

The Evangelical Lutheran Church of America for the fabulous Davey and Goliath still
Rick Goldschmidt and Rankin Bass for sharing the Rudolph still (www.enchantedworldoffrankinbass .blogspot.com)
Jason Rau of Cameracontrol.com
Susannah Shaw for sharing some great illustrations from her book: *Stop Motion Craft Skills for Model Animation.*
Kathi Zung for sharing her terrific DVD available at www.angelfire.com/anime4/zungstudio
Dave of Dave's camera in Camarillo, who let me shoot one of his cameras on the sidewalk outside of his store
Mr. and Mrs. Aldo Balarezo for letting me photograph their daughter Francheska in her debut as a clay animator
My former student Lucy Xi Xing, who graciously let me turn her into an animated character
Reynier Molenaar for photographing me (reyniermolenaar.com)
My wife, Juniko, whose tremendous support gave me the ability to write this book in the middle of the worst recession in recent memory

Lastly, I want to acknowledge a man who had no direct involvement in this book but provided a great deal of inspiration to me as a youth and shared many marvelous tips and tricks with me. The late David Allen was a kind and gentle man who was one of the great stop motion animators of his day. He continues to be missed, and I remember him fondly.

Introduction

Devices You'll Need and Teacher Ideas

This book is designed to explore the history and technique of stop motion animation. The software is secondary and is in fact so easy to use and ingenious that it allows you to concentrate on the art instead of the technology. You will need to use a computer, a camera, and connectors, so let's get these issues out of the way so we can start having some fun.

Computer

Stop Motion Pro is designed to run on the Windows operating systems XP, Vista (32 bit, 64 bit), or Windows 7 (32 bit, 64 bit). It is recommended that you have at least a 1.8+ GHz CPU and 1 GB of RAM for Windows XP and 2 GB for Vista or Windows 7. The faster the machine, the better! For hard drive space, you should have more than 10 GB to store your projects. If you are an Intel MAC user, you can run Stop Motion Pro if you install Apple boot camp, Parralells, or VMfusion and a version of Windows XP, Vista, or Windows 7.

If you are using a web cam, keep in mind that it will have system requirements as well so you will need to add those to the Stop Motion Pro recommendations. For Chapter 1 I use a Microsoft LifeCam VX-6000 web cam. Its system requirements are as follows:

- Processor
- Windows Vista
- Intel Pentium 4 2.8 GHz (Pentium Dual Core 2.0 GHz or higher recommended), 1 GB of RAM (2 GB recommended), 200- to 600-MB hard drive
- Windows XP with Service Pack 2 (P2) or later
- Intel Pentium 4 1.8 GHz (Pentium Dual Core 1.8 GHz or higher recommended) 256 MB of RAM (500 MB recommended) 400- to 1250-MB hard drive

As with all things digital, the faster the CPU and the more RAM and disc space you have, the better off you will be, especially if you embark on large projects.

Where to Get Stop Motion Pro

The software is available in the United States directly from Amazon, or go to www.filmingthefantastic.com, click on the product page, and select Software. Both the Action! and Action! Plus editions are available as well as the video adapter. You can also download a free trial version from www.stopmotionpro.com. For educational sales, a list of resellers can be found at www.stopmotionpro.com.

Versions and Editions

All of the exercises in this book can be done with the Stop Motion Pro Version 7 Action Plus edition. Features of higher-end editions are also examined. Here is a breakdown of the new editions as compared to version 6.5:

- SMP Action—An enhanced version of the 6.5 junior
- SMP Action! Plus—Enhanced SMP v6.5 Education
- SMP Action! HD—Replaces SMP SD, offering high-definition capture for home use
- SMP Studio—Enhanced SMP v6.5 HD
- SMP Studio Plus—Enhanced SMP v6.5 HD Studio

You can find a list of the features in each edition at stopmotionpro.com.

Connectors

It used to be dreadfully difficult to get video in and out of the computer. Today we have many options. To begin with, an electronic camera will output an analog signal, a digital signal, or both.

Analog Signal

The best way to think of an analog signal is by comparing it to a traditional clock with sweep hands that are in constant motion. An analog signal is a constant flow of varying voltage. Much like an analog clock is subject to running too fast or too slow, an analog video signal has similar drawbacks because the quality of the image can deteriorate each time it is copied. Typical connectors for analog video can be found at the back of a VCR or DVD player. You will find RCA connectors that are used for the video signal and the right and left audio signal. Another connector you might see is what is called an S-video connector, sometimes called super video. S video is another type of analog signal that has better quality than the signals coming out of the RCA connectors. The analog signals coming from the camera can be either composite or component signals. Composite signals take all

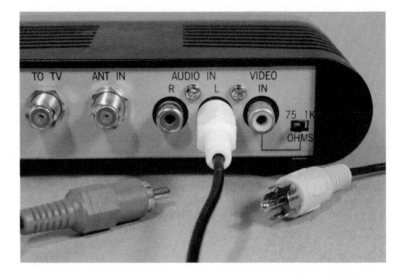

Figure 1 *Analog connectors on the back of a DVD player. RCA plugs for video and right and left audio signals.*

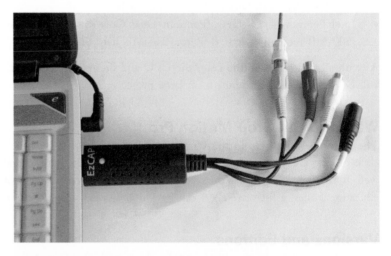

Figure 2 *The Stop Motion Pro Video Adapter converts standard composite video into digital and plugs into the USB port of your computer. This is the easiest and most universal way to use video cameras with Stop Motion Pro.*

the RGB information and blend it together to create a "composite" signal that is of lesser quality. For your computer to translate these analog signals, you will need a special video card or the Stop Motion Pro Video Adapter that will turn the video signals into digital signals that can be used by Stop Motion Pro and your computer. A component signal is fairly easy to understand, as it breaks the video signal into the three component colors that make up a color image, namely red, green, and blue. If your high-definition camera has this type of output, you will have three cables, one for each color RGB. For high-definition signals, Stop Motion Pro recommends using the Blackmagic-design Intensity card that will convert a wide range of video signals to digital (www.blackmagic-design.com).

Digital Signal

One can think of a digital signal as a digital clock that breaks time down into discrete separate numbers. It isn't a continuously varying signal but a stream of distinct binary codes that when uncoded create an image. A digital signal is better than an analog signal because it does not suffer from the degradation that analog images are prone to. Digital outputs can be DV or HDV. DV (or digital video) gives a digital signal for standard definition television with an aspect ratio of 1.33 to 1. HDV is the new high-definition video signal that has an image with a much wider aspect ratio of 16 × 9. There are two primary connectors for a digital signal; the first is the IEEE 1394 interface commonly known as FireWire (Apple Inc.), i.LINK (Sony), and Lynx (Texas Instruments). These can be either smaller four-pin connectors or larger six-pin connectors. There are a number of cables you can buy that will go from four to six, four to four, or six to six, and so on that will accommodate whichever input and output your camera and computer will accept. The other connector is called a USB connector

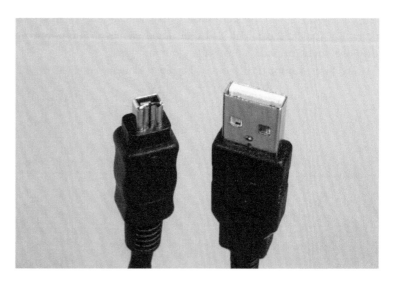

Figure 3 *An iLink connector on the left and a USB connector on the right.*

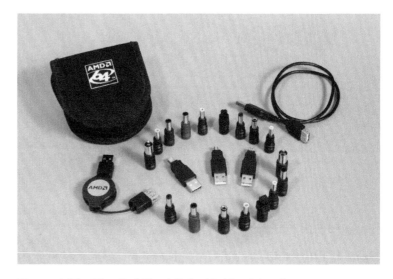

Figure 4 *The Ultra Cord Travel Pack with 13 varieties of connectors.*

and has grown quite popular with computer users as this universal connector is used for all sorts of gadgets such as printers and scanners as well as cameras. There are at present four variations of the USB connector: the type A, type B, mini-A, and mini-B. Your local computer store will be able to supply you with an assortment of USB cables that will allow you to connect your camera to your computer. With all these different connectors, I have found it invaluable to purchase a connector kit like the Ultra Cord Travel Pack, which has 13 varieties of connectors.

Cameras

Stop Motion Pro can use both analog and digital cameras. You can use web cameras, video cameras, high-definition cameras, and high-end digital still cameras. The important common denominator with cameras is that they must provide a live video output signal.

To use Stop Motion Pro, you will need a camera

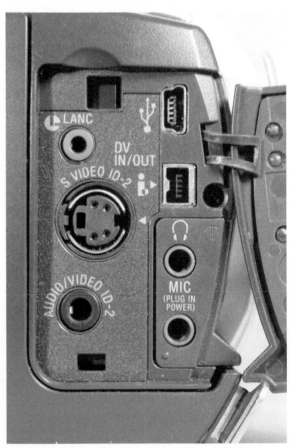

Figure 5 *A Microsoft LifeCam VX-6000 can be used with Stop Motion Pro as well as the Logitech line of cameras. Check with stopmotionpro.com for up-to-date camera suggestions.*

Figure 6 *The output ports of a Sony TRV 27 camera. There are ports for USB, i.LINK, S video, and standard analog video. Older cameras are less expensive and can have many more connection options. The universal solution is to use the Stop Motion Pro Video Adapter to convert analog video to digital. The adapter is covered in depth in Chapter 10.*

that has this ability. For some exercises in this book I chose to use a Sony TRV 27 camera. It is an older mini-DV tape camera, but it has all of the outputs previously mentioned: RCA, S video, i.LINK, and USB. For some exercises I used a cable for the i.LINK that went from the camera's four-pin output to my IMAC computer (running Windows) and its six-pin input. In most cases your best bet is to use the analog output from your camera and plug it into the Stop Motion Pro Video Adapter that in turn plugs into the USB input of your computer. The adapter will easily convert the analog signal to digital and away you go.

Resolution and Video Formats

Resolution, for the most part, generally refers to how many pixels make up your video image. A pixel or picture element is a tiny square of color that makes up the mosaic of a digital image. High definition has many more pixels than standard definition. One high-definition standard has an image that is 1280 pixels across by 720 pixels high, whereas standard definition (your traditional old-style TV image) is 720 pixels across by 480 pixels high. Most of the exercises in this book will use standard resolution, as it allows you to use less storage space for the projects while keeping the image quality quite acceptable. Video signal formats vary depending on where you live: NTSC for the United States and PAL for the United Kingdom, Europe, and other countries. Stop Motion Pro is capable of accepting video signals from all over the world. As I am in the United States, my video will be in the NTSC format. The differences between video formats will be examined in more detail in Chapter 1 and Chapter 10.

WebCam
320 X 240

Standard Definition
720 X 480

Hi Definition
1920 X 1080

Figure 7 *The size and quality difference of a variety of resolutions.*

File Formats

Digital imaging systems use a variety of file formats, and this part of the operation is invisibly handled in the background of Stop Motion Pro but does deserve a brief mention. Several formats are sited in the menu tree of Stop Motion Pro, and they are JPG, BMP, TIF, TGA, AVI, and WMV. The first four are still image format files of which JPG (JPEG) is among the most popular and universal. Stop Motion Pro stores each animation frame as a JPG file and plays back the succession of still image files to generate motion. The other files—BMP, TIF, and TGA—are other still image files and are included as options for importing still images

into the software, such as when you want to add a background using the Chroma Key option. The other format files—AVI and WMV—are used in the Make Movie function in Stop Motion Pro and allow you to post projects on the Internet or load your animation sequences into editing software. The AVI format is uncompressed and is used to transfer your animation to an external video editing or effects application. The AVI format ensures the quality of the captured frames is not compromised. WMV (Windows Media Video) is a compressed format and is therefore smaller than the AVI files. These files can be used directly on the Internet or sent to YouTube and MySpace.

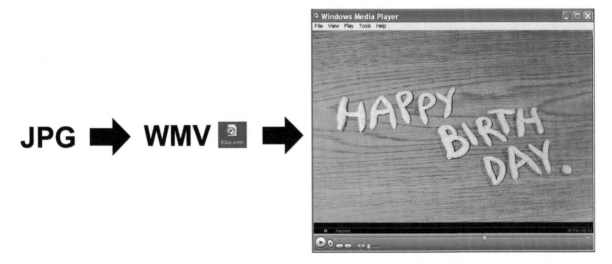

Figure 8 *Your animation is converted to AVI or WMV files for editing or playback over the Internet.*

For Instructors
The text is broken down into three primary categories to assist the teacher in creating a rewarding classroom experience. I begin with history and at the end of the chapter suggest films that can be shown as part of an audiovisual presentation during the lecture phase. In each chapter I present an exercise or two that explores a particular aspect of the history examined. The exercises are merely a suggestion and starting point for many more imaginative variations that the students can self-generate. The exercise chapters end with a summary of what was covered. This summary is a good starting point for creating multiple choice or written tests that can be added to the curriculum. The study of stop motion is a terrific introduction to the animation art and is taught by many schools as a prerequisite for the study of computer-generated animation. In fact, direct comparisons between the disciplines can be sited again and again, as I pointed out in Chapter 3 of my book on visual effects, *Filming the Fantastic.* In today's competitive job marketplace, the large studios want much more from job seekers than the ability to push software buttons. They are required to have fine art portfolios and examples of traditional work. Stop motion animation makes a terrific resume addition for the student entering the workplace.

All the Rest

There are a few more technical details that will be addressed bit by bit using purposeful exercises that illustrate the tools in Stop Motion Pro. For the most part, the lessons involve the development of the reader as an artist. The exercises are more about your thought processes as you use the software tool rather than memorizing button pushes. Stop motion, like fine art, provides a direct connection between artist and audience. Whether you move a puppet, an object, or a lump of clay, you are the ultimate performer and the movements you create come directly from you. Most important are the magic and fun of it all. Even after my 30-year career in the effects field, I have never grown tired of the simple and unbridled joy of breathing life into an inanimate object. It is really the stuff of wonder! Enjoy.

Mark Sawicki
Oxnard, California by the Sea
September 2009

All the Rest

Chapter 1

Animate Time

Today we live in an age where moving images are all around us: television, motion pictures, billboards, the Internet, and even cell (mobile) phones. It is hard to imagine that just a little over a century ago there was no such thing as moving images. Before we get involved with synthetically creating motion through animation, we need to explore the development of motion pictures.

Persistence of Vision

In the 19th century, many fun and amusing devices were created to evoke motion into two-dimensional objects. One of the simplest was the thaumatrope, invented by Dr. John Paris of England in 1824 to demonstrate a phenomenon known as *persistence of vision*. A typical thaumatrope consisted of a rapidly rotating disc. On one side of the disc was a drawing of a bird on a perch on a blank field of white; on the other side was a drawing of an empty birdcage. When the disc was spun rapidly past the eye, it appeared to the viewer that the bird was in the cage; the images of the cage and the bird melded together because the eye retained both images simultaneously, ergo creating a "persistence" of vision. In today's scientific circles, this simplistic idea of the phenomenon is considered false science, but for artistic purposes the idea of "persistence of vision" … persists. This amusing toy transformed into more sophisticated devices such as the zoetrope that allowed a series of slightly different images to move past the eye to create cyclical motion. It wasn't long before the magic of photography and persistence of vision came together to create motion pictures.

Eadweard Muybridge

Muybridge was an English photographer whose early career involved the pictorial documentation of the early West where his work was very popular. In 1872, Leland Stanford, a former governor of California and a racehorse owner, had boldly taken a position on one of the hotly debated questions of the day: whether all four hooves of a horse left the ground at the same time during a gallop. Stanford believed that all hooves did

doi: 10.1016/B978-0-240-81219-9.00001-5

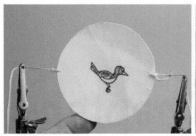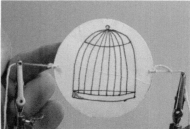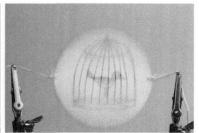

Figure 1.1 *The thaumatrope.*

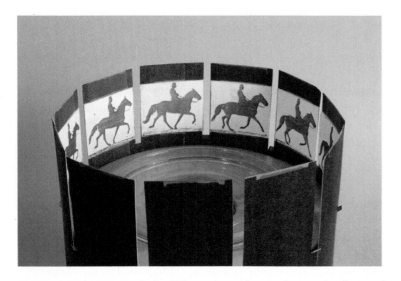

Figure 1.2 *A zoetrope cylinder. When spun rapidly past the eye, the illusion of cyclical motion was obtained.*

indeed leave the ground to produce an "unsupported transit" for the animal and sought to prove this fact scientifically. It is hard to imagine the mindset of only a few generations ago, but then again it is hard to imagine a world without moving pictures. Stanford hired Muybridge to settle the question. To create proof of the claim, Muybridge rigged up a series of still cameras that would take pictures when prompted by an electrical trigger created by John C. Isaacs, chief engineer for Southern Pacific Railroad. The series of photographs did indeed settle the question and ushered in a remarkable collection of motion studies of human and animal alike. These studies of motion are available in books of Muybridge collections and can be used as a motion template in Stop Motion Pro. Today the fabulous work of Muybridge is an invaluable reference for both 2D and 3D animators the world over.

The Motion Picture Camera

Toward the end of the 19th century, inventors around the world began to experiment with placing photographic emulsion on flexible film to enable them to take a series of still pictures rapidly with a single camera. This movie camera was the obvious extension of the work of Muybridge and enabled the rapid adoption of the film industry. One of the main hurdles to overcome was how fast you should take the pictures. The tremendous number of experiments with persistence of vision revealed that you could eliminate the perception of "flicker" (a rapid variation in brightness) in the images if they were flashed past the eye at 45 images or

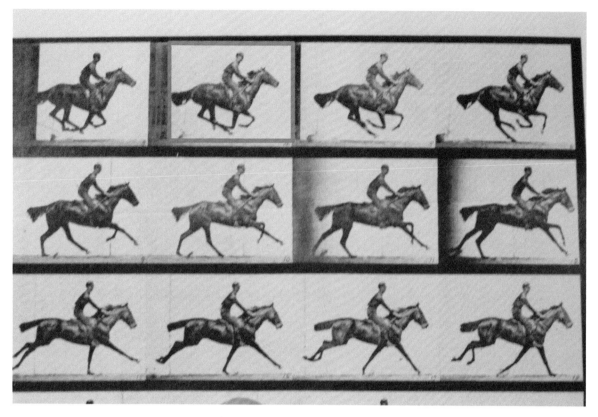

Figure 1.3 *Proof of the unsupported transit using Muybridge's photography.*

more per second. Being a frugal generation, early inventors would hold a single image in the gate of the projector and reveal that image to the audience through a three-bladed shutter that would flash the same image three times in rapid succession on the screen before the shutter blocked the light and the next frame was pulled and placed into position. Using a three-bladed shutter in the projector and a capture rate in the camera of approximately 16 frames per second (fps), you created imagery that flashed past the eye at 48 flashes per second. Sixteen actual frames multiplied by a three-bladed shutter reveal 48 flashes. Now because these early cameras did not have motors but were hand cranked, the speed often varied depending on the operator and the desire of the filmmaker. Hand cranking yielded an organic variable frame rate of sorts, and if projected too slowly it would introduce the perception of flicker. Hence, early silent films became known as "flickers."

The Introduction of Sound

During the late 1920s, sound was introduced to motion pictures, and as the variability of frame rates became untenable, standardization needed to be adopted. A group of theater owners convened and compared the different frame rates they had been using over the years to decide upon the best presentation speed. They

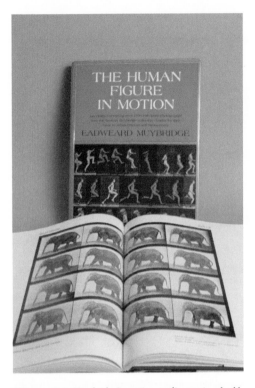

Figure 1.5 *The motion picture camera.*

Figure 1.4 *Muybridge's motion studies are invaluable references for animators. These excellent books are available from Dover Press.*

decided to go with 24 frames per second and switch to a two-bladed shutter that once again created an image refresh rate above 45 : 24 frames per second times a two-bladed shutter = 48 image flashes per second. As sound films became the dominant art form, this new film speed created an odd perception of the golden age of silent films when they were resurrected for inclusion into a sound speed film. If the 16 fps silent film was used "as is," it would appear to be moving comically fast when projected at 24 frames per second. This did little damage to light-hearted comic films like the *Keystone Cops* comedies that involved outrageous car chases, but it was a notable disservice to the beautiful dramatic films of the era that were always meant to be projected at their native rate of 16 frames per second. The important point to keep in mind is that if you capture and play back at the same frame rate, the motion will remain natural as long as the capture rate is rapid enough to blend the images together. This concept is important to remember when you see all the different frame rates offered in Stop Motion Pro software.

Television

Motion pictures were the high point of entertainment for many years, as they were the only venue for cinema. The 1950s presented competition for the silver screen with the introduction of mass television broadcasts. This led to further developments in the motion picture field, the most important for this discussion being the birth of the 30-frames-per-second rate for video. One would think that because 24 frames per second had been used for years in movies, television technology would have adopted it as well. The actual outcome, however, lies in a brief history of power transmission.

Figure 1.6 *If you don't play back motion at the same speed it was captured, the action will become fast or slow. Silent films shot at 16 fps and played back at 24 fps look ridiculously fast. Pictured is Vladek Savitskus in* The Big Bum, *circa 1914. Courtesy of NGM Entertainment. Just kidding, it's me.*

In the late 1800s, Thomas Edison and George Westinghouse were battling over how electricity was to be delivered to consumers. Edison was a fan of direct current (DC) as one finds in batteries with a constant flow of positive and negative energy. Westinghouse and the genius inventor Nikola Tesla promoted alternating current (AC), which alternates the positive and negative poles at a cyclic rate. AC eventually won out because of the extreme energy loss of DC with long-distance transmission. Because AC cycles back and forth, Westinghouse had a similar problem as that faced by the makers of motion picture technology, and that was how to reduce flicker, but this time with regard to street lighting. Westinghouse in the United States came up with a system that would enable arc and other public lighting to appear flickerless by choosing a rate of 60 cycles per second for his AC power. Around this same period of time, electrical developers in Europe chose an AC rate of 50 cycles per second. The reason these two power rates become the cornerstones for television frame rates is that the electronic medium of television is built around power, and 30 pictures per second is a convenient mathematical and electrical subdivision of the power supply. So in a nutshell, U.S. video is 30 frames per second because of 60 cycles per second AC, and in Europe video is 25 frames per second because of its 50 cycles per second AC power.

Now those of you who were paying attention might say, well yes, but 30 frames per second is still below the minimum 45 flashes per second to prevent flicker. This would be correct, except for the fact that one picture of video is composed of two partial pictures of the same frame called fields. These fields blast by our eyes 60 times per second and therefore preserve the persistence of vision phenomenon. The rapid presentation of field 1 and field 2 is similar to the shutter idea used in motion picture projectors. This system of creating images in video is called *interlace*. Video is made up of lines of information. Field 1 contains odd-numbered lines, and field 2 contains even-numbered lines. When these odd and even collections of lines are flashed in sequence at 1/60th of a second, the viewer receives an interwoven view of these two fields together. If nothing moves in the image, one perceives a whole picture. If an object or camera moves in between the creation of field 1 and field 2, then there will be an offset to the imagery that yields a stairstep appearance. This stair stepping or aliasing of moving images is one of the primary image differences between video and film.

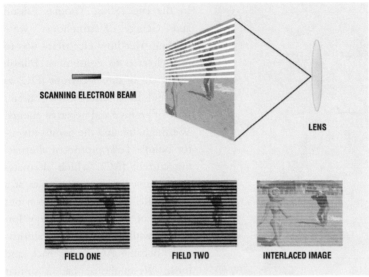

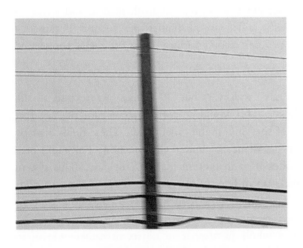

With the advent of digital video, digital cinema, and high definition, a few new terms have come into the mix. The most prominent of these is *24p,* which stands for 24-frames-per-second progressive imagery. The term *progressive* means that each single frame of the digital image is made at one time with no video interlace. This form of digital video mimics film because it does not have odd and even fields, just one whole digital image. Interlace is still available in these digital formats, which have labels such as 30i for 30-frames-per-second interlace.

Figure 1.7 *Each video frame is made up of two interlaced fields.*

But Wait, There's More!

When television went to color in 1953, the engineers had a problem. By then all the TV stations had been established and the airwaves were full. To add the color information, the engineers couldn't very well ask channels 4 and 6 to "move out of the way" for channel 5 to have room to broadcast RGB color, so they had to come up with a clever scheme to add color within the same space occupied by the black-and-white signal. The system was labeled NTSC in the United States. The engineers used a lot of technical and

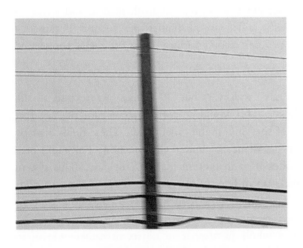

PROGRESSIVE

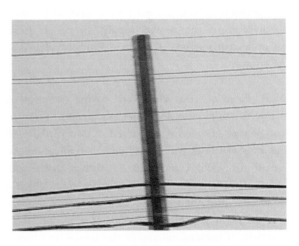

INTERLACE

Figure 1.8 *The image difference between an interlaced and progressive capture.*

mathematical magic to cram color into the signal and in doing so slightly altered the 30-frames-per-second frame rate to 29.97.

For an artist, numbers like this usually instill unbridled panic, but there is no need to be alarmed. As far as an animator is concerned, 29.97 is exactly the same as 30 frames per second. The only time 29.97 matters is when a long program (such as one that runs for an hour) is being evaluated for real time. For example, there are 60 seconds in a minute and 60 minutes in an hour, so $60 \times 60 = 3600$ seconds \times 30 frames = 108,000 frames; 3600 seconds \times 29.97 frames = 107,892 frames. So the difference between running an hour-long program at 29.97 fps and 30 fps is that you will lose 108 frames. This insignificant change only becomes important during the postproduction process when we need to know the exact length of a program. Most animation shots typically last for 120 to 240 frames, and the slight speed difference is completely imperceptible in the performance. The use of 29.97 is an engineering label, so that Stop Motion Pro is absolutely accurate. As an animator, you will be much happier if you think of 29.97 as being exactly the same as 30 frames per second and plan accordingly. Here are the primary capture speeds for a variety of media as seen by an animator:

- Motion pictures: 24 frames per second
- U.S. video: 30 frames per second (forget that it's really 29.97)
- European video (PAL): 25 frames per second

As you look at the main capture speed pulldown of the Stop Motion Pro speed menu, all of the choices will begin to make sense. At the bottom we have 5 frames per second. If images are recorded and played back at this rate, a second will be a second but the motion will be choppy as the refresh rate is so slow. One might ask, why do I have this option at all? The 5-frames-per-second rate is ideal for the 5-year-old tiny tyke who has a short attention span. Moving an object 5 times for a second is just right. As the child grows older, the frame rate goes up, to 6 frames per second for the 6-year-old and so on. Things get interesting when we get to the 12-frames-per-second rate, which is half of the standard 24. Many professional animators will animate at this rate or in the case of professional venues shoot on "2"s or 2 frames for each position, which amounts to animating at 12 frames per second and time stretching to 24 for standard projection. Some of the fabulous work of the animators at the Aardman studio is done at this frame rate, and the quality is astounding.

For student and professional work, these would be the frame rates I would use:

- 12 frames per second for a speedier production with pro results
- 24 frames per second for the full advantage of moving for each frame (Harryhausen [Chapter 7] would use this rate)
- 29.97, otherwise known as 30 frames per second, for the maximum refresh rate for video presentation

Figure 1.9 *Frame rates available in Stop Motion Pro.*

For my work I usually stick with 24 frames per second, as I did with traditional film cameras. I save the effort of shooting 30 frames per second because I know the film-to-video transfer would generate what is known as a 3 : 2 pulldown that essentially transforms 24 fps footage into 30 fps footage, yielding acceptable results for television broadcast. If I animate a long project I shoot at 12 frames per second to speed up the production process while still maintaining quality.

Resolution

Digital images are made up of a mosaic of colored squares or picture elements called pixels. The lower the pixel count, the lower the resolution and the less distinct or fuzzier the image is. For example, 160 pixels wide by 120 pixels tall might be a typical low-resolution web cam image, whereas a full-blown, high-quality motion picture frame converted to pixels might be 2048 × 1556. Standard definition video in the United States is 720 × 486, and a typical high-definition frame resolution falls around 1280 × 720. When digital still cameras are used, the nomenclature changes a bit in the sales brochure as the resolutions are referred to in megapixels. To obtain the megapixel count, you multiply the horizontal and vertical pixel counts together. So 2048 × 1556 = 3,186,688 or more than 3 megapixels. Fortunately for us, Stop Motion Pro takes the pain out of the mathematics and sets up automatically or lets you choose exactly the resolution you want to use. Now that we have those frame rates and resolution issues out of the way, let's look at cameras.

Cameras for Stop Motion Pro
The Electronic Camera

Stop Motion Pro is an excellent tool for digitally capturing moments in time and generating animation. The reason it is a much more effective tool than older motion picture cameras is that you can always reference what you shot (or captured) previously with what the camera is seeing now. Once you shoot a frame in a motion picture camera and then move the subject, that original position is lost to everything except the animator's memory until the film is processed. With Stop Motion Pro, the animator has a continuous record of exactly what was captured in the past that can be immediately referenced during animation. To do this, Stop Motion Pro requires a camera that can supply a live video feed. An assortment of cameras of varying quality can do this. The most readily available and inexpensive

Full Aperture 4k scan 4096 x 3112

2k scan 2048 x 1556

Digital Cinema frame 1920 x 1080

Hi Def 1280 x 720

**Standard Definition Video
720 x 486**

Figure 1.10 *A few standard digital resolutions.*

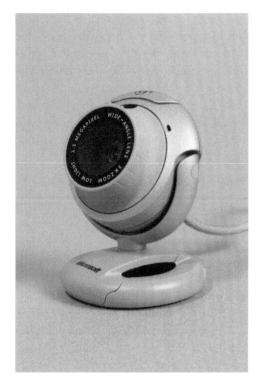

Figure 1.11 *A Microsoft VX-6000 Web Cam. The Logitech series of web cams are also compatible with Stop Motion Pro. To obtain the latest up-to-date list of compatible cameras, go to www.stopmotionpro.com.*

Figure 1.12 *Click on Stop Motion Pro.*

camera that meets these criteria is the web camera. There are many kinds of web cameras, but the most useful for stop motion animation would be one that has an easily adjustable mount that can be taped or clamped in place to ensure that the camera doesn't move yet allows for subtle pan and tilt adjustments for composition and camera moves. The input into the computer usually comes via a universal serial bus (USB) plug. Although these web cameras are the least expensive and readily available, they are typically of low resolution and should be used for animation exercises and not for actual productions. Stepping up from the web camera we have a number of digital or analog video cameras. These cameras offer higher resolution and can output a continuous live view through a USB connection, FireWire, or straight analog output if you use the Stop Motion Pro Video Adapter Kit. Because your computer is the central hub of your input, it is best to see what connections your particular computer offers. You can then match the input compatibility with the output of the camera. High-definition cameras can be used as well, as long as they provide that continuous live input signal. At the extreme high end of cameras for professional feature film use is the digital still camera such as the Canon DSLR 1000D, which offers this live view feature and is able to capture extremely high-resolution images. For our first exercise, we will use a simple web cam to create a time-lapse shot.

The Time Machine

A good starting point for understanding animation timing is to record a natural event and work out how to manipulate its speed using simple mathematics. For this exercise, you will need to purchase and install the software for a web cam. In this case I used a Microsoft Life Cam VX-6000, but you can

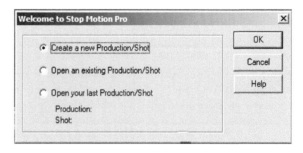

Figure 1.13 *When the prompt comes up, select "Create a new production shot," and click OK.*

9

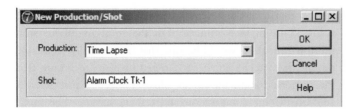

Figure 1.14 *Name the production "Time Lapse" and the shot "Alarm Clock Tk-1." Click OK.*

use other models as well such as those from the Logitech line. Check out the Stop Motion Pro web site to check on compatibility before purchasing a camera. If you have a camera, you can download a trial version of Stop Motion Pro and check to see if your camera will work. Now we'll set up Stop Motion Pro to do a time-lapse shot of an alarm clock.

After installing the Stop Motion Pro software, you should have an icon on your desktop for starting the tool.

This next section is very important and holds true for all the cameras we will be using throughout the book. Because you want full control over your animation and don't want any changes to the image other than what you decide to change (animation), you will want to disable all the automatic functions on the camera. If the automatic settings are used, you will notice that as you bring your hand close to the lens of the camera, the image will brighten to compensate for the reduction of light. When you move your hand away, the image will go from bright to a proper exposure as the camera adjusts to the changing light conditions. If you let the camera "help you" in this manner, your animation will flicker constantly as the camera makes minute adjustments frame for frame. For animation you want to make sure the camera does nothing without your consent. Follow the steps in Figures 1.12–1.22 to make time "fly".

Figure 1.15 *The capture settings window should appear. In the top menu, select Web Cam. Stop Motion Pro will recognize your web camera and set up accordingly. If the model of your web cam does not appear, you may find it as you scroll down the device menu. Go to the size drop-down menu and select 640 × 480 pixels 30 fps. I chose this for no particular reason other than it is a nice, viewable image that won't take up too much memory. Click Apply.*

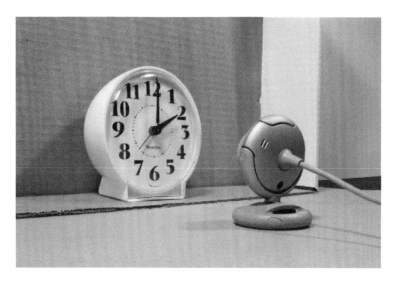

Figure 1.16 *Position your web cam to frame the clock. Position both in a bright, flatly lit area to avoid reflections on the face of the clock.*

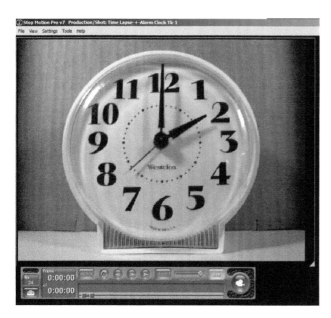

Figure 1.17 *The web cam image will now appear in the Stop Motion Pro main panel. The next step is to turn off all automatic functions on the camera.*

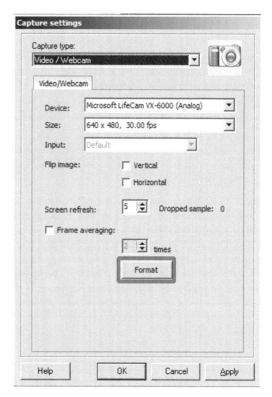

Figure 1.18 *Click on the format button in the capture settings window. This will open up the control panel of your web cam.*

Figure 1.19 *Different manufacturers have different controls. What you want to look for and turn off or disable are Face Tracking, Auto Exposure, Auto Gain, Auto White Balance, Auto Focus, and, well, anything auto. Once you do this, you can use your hand-in-front-of-the-lens test to make sure that the camera isn't compensating. Then go to the capture settings window and click OK. The Stop Motion Pro web site has an excellent step-by-step video tutorial of this process.*

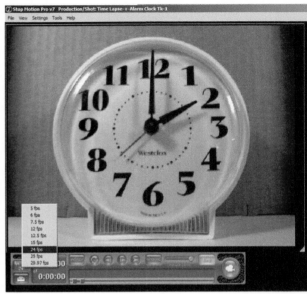

Figure 1.20 *Go to the lower menu bar of Stop Motion Pro, and place the cursor over the fps button. Push down the right mouse button, and select 24 frames per second. This will be our standard motion picture time base. Note that the 24 fps option is available from the Stop Motion Pro Action Plus on up.*

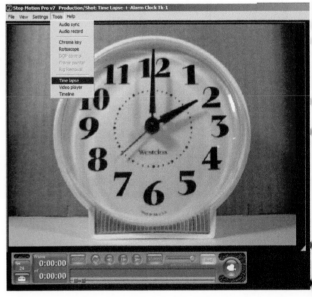

Figure 1.21 *From the top menu bar, select Tools, Time Lapse with the left mouse button.*

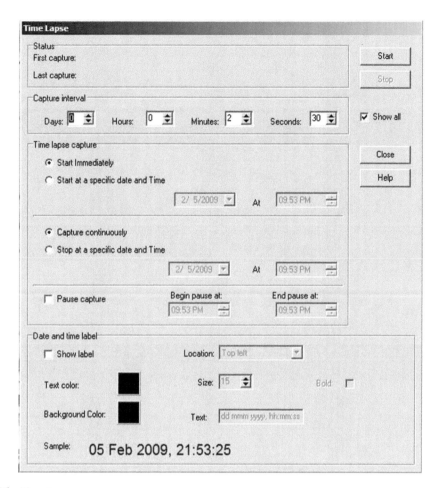

Figure 1.22 *The Time Lapse menu.*

You now have a control panel that will allow you to manipulate time. This exercise requires you to have an analog clock (a clock with hands). Our goal is to have the hands move one hour in one second. The calculation is simple once you know the time base of your project, which in this case is 24 frames per second. First we need to make all the time units the same. Instead of thinking of one hour, we have to know how many seconds are in an hour. We know that there are 60 seconds in a minute and there are 60 minutes in one hour, so 60 seconds × 60 minutes = 3600 seconds in an hour. If we want one hour to pass in one second of our time base (or 24 frames), then we merely need to divide 3600 by 24 to learn what interval of time we need to capture the clock: 3600 divided by 24 = 150 seconds. If we go back to the Time Lapse control panel, we see that the seconds window only goes up to 60, at which point the minutes window takes over. We will need to use both minutes and seconds windows by converting the 150 seconds into minutes and seconds. So 150 seconds divided by 60 seconds (representing a minute) = 2.5 minutes or 2 minutes and 30 seconds. In the Time Lapse window, put in those settings for the capture interval. Now to start the project:

Select Start Immediately
Select Capture Continuously
Push the start button and go to lunch

When you return, simply press the stop button on the time-lapse control and then go to the play button to see one hour zip by in 1 second or 24 frames. This simple exercise will give you a good foundation for how an animator thinks about his or her main tool of the trade—that is, the control of time.

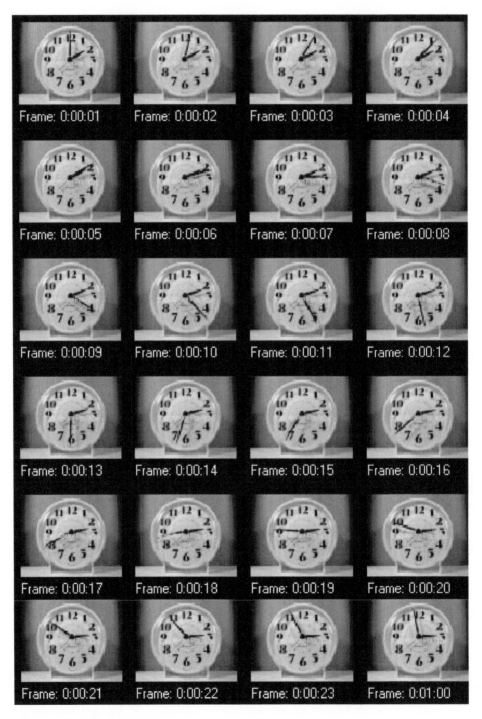

Figure 1.23 *The time-lapse sequence.*

Summary

1. Though not a true scientific theory, persistence of vision is the common explanation for how moving images work.

2. A thaumatrope persistence of vision toy is easy to create. Can you come up with other ideas to create a two-position animation thaumatrope?

3. One of the first frame rates was around 16 frames per second and would vary as the camera was cranked by hand.

4. A three-bladed shutter was used in silent cinema to ensure that the images flashed by the eye at a rate slightly higher than 45 flashes per second to eliminate flicker.

5. Upon the advent of sound, theater owners established the sound standard speed of 24 fps.

6. In the 1950s, U.S. television was invented around the 60-cycle power available. As a result, the U.S. video frame rate is 30 fps.

7. In Europe, the power cycle is 50 cycles per second. This is why PAL video runs at 25 frames per second.

8. Video images are composed of two fields of image lines representing odd and even lines that are interwoven in time to create interlace images.

9. In a move for digital video to replicate a film look, progressive imaging schemes were invented that create whole digital image frames without interlace. One common notation for this process is 24p, meaning 24 frames per second progressive.

10. With the introduction of color in the 1950s, the video frame rate had to be altered to 29.97. This new rate change is subtle and of no concern to animators who still think of U.S. video as running at 30 fps.

11. As long as an image is recorded and played back at the same rate (regardless of speed), a second of time will be a second. The quality or smoothness of the motion may be choppy at slower frame rates.

12. An animator's job is to work to a master frame rate and break down movement and its desired effect into a block of time. In this chapter, we made the hour-long movement of the minute hand fit into a second of screen time.

13. Can you think of other candidates for time lapse? Further exercises would be to plot out and shoot a time-lapse sunset. Make clouds roar overhead. Show a breathtakingly fast snail. Make an ice cube melt in less than a second. Traffic jam? Not using time lapse with Stop Motion Pro. The cars will begin moving again in seconds.

14. For further reading on cameras and resolution, I suggest *Filming the Fantastic* by Mark Sawicki and *Digital Compositing for Film and Video,* Second Edition, by Steve Wright. Focal Press publishes both.

Film to See

One of the most remarkable time-lapse films ever made is *Koyaanisqatsi* (1982), directed by Godfrey Reggio. The title is derived from a Hopi Indian word that means "life out of balance." It is an amazing look at modern society through the eyes of the time-lapse camera and high-speed camera, and it gives a chilling perspective on our environmental crisis.

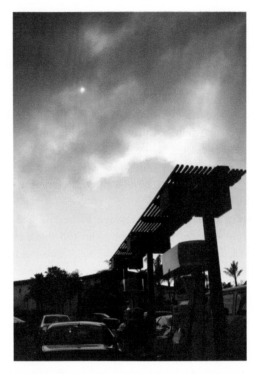

Figure 1.24 *Although this is not a scene from Koy-aanisqatsi, it is indicative of the type of startling imagery contained within this excellent film. This image is from the 2009 Santa Barbara fire.*

Chapter 2
Animate People

Since the birth of cinema, a number of notable pioneers have used stop motion to generate visual effects that create fantastic worlds. An early example is the work of French magician George Méliès. His pivotal work, *A Trip to the Moon,* made in 1902, explored a whole host of tricks that became the foundation for visual effects as we know them today. One trick related to animation is thought to have been discovered by accident. As the story goes, Méliès was photographing a horse-drawn carriage parked in front of a shop when the "hand-cranked" film camera froze up and jammed. As a result, the filming abruptly stopped and the operator paused to unsnarl and fix the jam that apparently involved something outside of the film chamber as the film stayed arrested in the confines of the dark camera chamber during the fix. During this camera fix, the horse-drawn carriage moved on and a horse-drawn hearse took its place and happened to park in the same area. When the photography resumed, little notice was made of the change in the subject until the film was processed and projected the next day and the audience witnessed a horse-drawn carriage "magically" transform into a horse-drawn hearse! As with all animation techniques, we learned that we were able to manipulate subjects in between exposures to amazing effect.

For *A Trip to the Moon,* Méliès made use of the mistake (now turned technique) in a scene in which a group of wizards magically changed their raised telescopes into chairs in the blink of an eye; Méliès created the effect by merely stopping the camera to allow the switch before photography resumed. This simple trick and Méliès' work is documented beautifully in Part 12 of the Tom Hanks HBO miniseries *From the Earth to the Moon,* titled "Le Voyage Dans La Lune." It was only a matter of time before filmmakers explored the magic of manipulation in between exposures to generate synthetic movement. In the landmark film *Nosferatu* by F.W. Murnau (1922) (the first film version of the famous Dracula story by Bram Stoker), the film was enhanced with stop motion animation for the ocean voyage sequence. When the vampire comes up from the hold of the ship, live action set pieces were animated to create the effect of the cloth cover magically moving away from the hatch that opens by itself; then we suddenly go to a live-action performance of the vampire emerging from the hold.

© 2010 Mark Sawicki. Published by Elsevier, Inc. All rights reserved.
doi: 10.1016/B978-0-240-81219-9.00002-7

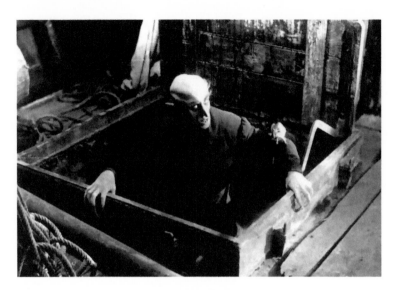

Figure 2.1 *The vampire emerges from a hatch that was opened via stop motion animation. From the film* Nosferatu, *1922.*

In other shots from *Nosferatu,* the camera is "undercranked" or run at a taking speed of 8 frames per second when shooting the vampire moving his coffins about. As we saw with the clock exercise in the previous chapter, when filmed at slower than normal speed the vampire seems to set about his tasks with superhuman speed. These techniques laid the groundwork for the animation of human performers often referred to as *Pixillation* (not to be confused with the digital artifact known as pixelation). A landmark film that utilized Pixillation was the Academy Award–winning short subject *Neighbours,* by Canadian filmmaker Norman McLaren in 1952.

As a side note to *Nosferatu,* I always point out to my students that this film is a prime example of why everyone should honor copyright. F.W. Murnau and his production company, Prana Film, never obtained the rights to do a screen adaptation of *Dracula* that was published in 1897. Bram Stoker's widow successfully sued the filmmakers for copyright infringement, and Prana Film subsequently went bankrupt after only making this one film. The bankruptcy judge also ordered all prints and negatives to be destroyed. It is only by chance that this landmark film survives; had it not been widely distributed at the time, this classic would have been lost to the ages. The moral of the story is to honor copyright, credit the author, and ask for permission.

Norman McLaren

Norman McLaren was born in Scotland in 1914 and trained in set design at the Glasgow School of Art. During his early career as an experimental filmmaker, he made films in London and eventually lived in New York. In 1941, McLaren was invited to join the animation division of the National Film Board of Canada (NFB), where he won world acclaim for his development of experimental animation techniques and award-winning films. The National Film Board is a unique studio that has a purpose and mandate outside the scope of profit-driven studios. The award-winning films of the NFB involve social relevance and thought-provoking subject matter that set it apart from other studios and have made it a wellspring of creativity over the years. Films such as *The Big Snit* (by Richard Condie and Michael J.F. Scott), *The Cat Came Back* (by Cordell Barker), *The Sand Castle* (by Co Hoedeman), and *Neighbours* (by Norman McLaren) are a great inspiration to the animation community at large.

Neighbours (1952) was born out of McClaren's experiences during a tumultuous time in history and had a decided antiwar message. In the film we see two neighbors living in simple cardboard boxes next to each other. Trouble begins when a small flower grows between the houses and the two neighbors fight to the death for the tiny bloom. Aside from using live actors as animated actors with Pixillation, McLaren also created synthetic audio by physically drawing on the film's soundtrack itself to create an oddly disturbing montage of sound effects to enhance the image. *Neighbours*—along with many other NFB animations—has no dialogue and takes advantage of the universality of visual storytelling to make its point. As a result, these films have become timeless classics that have global appeal. Other great examples of pixilation technique are Jan Kounen's *Gisele Kerozene* (1989) and the work of Mike Jitlov, *The Wizard of Speed and Time* (1979). Animating people is a great deal of fun and the results are captivating. Pixillation is one of the most physically demanding animation projects you can undertake. I hope you have a lot of energy, because here we go.

Setting up the Camera

For this exercise, we will be using an older-generation digital video camera. The Sony TRV 27 is a terrific mini-DV camera that has a large number of outputs for you to connect with the computer. The main thing to remember when you are using a mini-DV or any tape recording device is to remove the tape. The tape is fragile and sensitive to the constant abrasion of the rotating tape head. To prevent damage, the camera has an automatic "turn off" circuit that will shut down the camera if you keep it on pause for too long. Because Stop Motion Pro (SMP) records from the constant feed it receives, there is no need to record anything to tape as the animation is recorded on your computer's hard drive. To keep the constant video feed coming in to Stop Motion Pro and prevent a camera shutoff, all you need do is remove the tape from the camera. Remove the tape and the camera will not shut off until you turn it off. Next, arrange a long extension cord for both the camera and the computer so that we can do some outdoor animation. If you run Stop Motion Pro on a portable laptop computer, both the camera and the computer can run off batteries, but it is always better to have a constant power supply than have to worry about the battery dying right in the middle of your shot. Because we are shooting outside, you will want to set the camera for shooting in daylight. This will ensure that all the colors will come out properly and not appear blue. Daylight has much more blue light in it than indoor tungsten light, and the camera needs to have its sensitivity adjusted accordingly. For the TRV 27, you would open the menu of the camera and select "outdoor" under WHT BAL (white balance). Place the camera on a sturdy tripod, and point it at your subject. In this case, it is a shady part of a driveway. Shady settings are good for video cameras, as the extreme contrast of bright sun is difficult for many video sensors to handle. Shooting in shade or on overcast days is always best if you want to see pleasing detail in the image. The other advantage is that you won't see the shadows move during long animation sequences.

When the big studios started building back lots in the 1920s, they made sure that all the streets ran north to south. Because the sun rises in the east and sets in the west, it would guarantee that one half of the street would be in shade in the morning and the other half would be in shade in the afternoon. The trick was to shoot into the shady side of the street in the morning and use reflectors to control where the key light or sunlight came from. In the afternoon, the crew switched to the other side of the street. At high noon, the sun is directly overhead, causing deep shadows in the eyes of actors. Shooting was avoided by calling "lunch," or things were arranged so that action was shot underneath the shade of a tree or diffusion material was suspended above the performers to bathe them in soft, shadowless light.

The final two things we want to do with any animation camera is to prevent it from "helping us." Just like the web camera, most digital video cameras have automatic focus and exposure that constantly adjusts to create a good picture under changing conditions. The problem with using automatic settings during animation is that the camera might change focus and exposure slightly in between each frame as we animate. The result can be a flickering of exposure and focus, because Stop Motion Pro might grab a frame while the camera is making an automatic adjustment. To eliminate this problem, set both the focus and the exposure to manual, find an ideal focus and exposure setting, and leave them there. If you do that, then nothing will change except the changes you make to your animation.

Animating Actors

For this exercise, we will animate our character riding on her behind (as if she was a car) to enter a garage. Choose a frame rate of 12 frames per second, and be sure to tell your actor that you want him or her to sit on the ground so the actor won't bring his or her best pair of pants to the shoot. To begin, we will want to animate the garage door opening, and we run into our first problem. You can press the automatic garage door opener and stop the door at any point, but when you press it again, the door will close, defeating your efforts to animate. You can do one of three things:

1. Raise the door to the first position and photograph it. Put in a C stand, tripod, or some other pointer that indicates where the door was. Close the door, and then open it and stop when it gets to the next position beyond your marker. Remove your marker, photograph the door, and repeat. Needless to say, this is time consuming.

Figure 2.2 *Remove the tape from the camera.*

Figure 2.3 *Mount the camera to a sturdy tripod.*

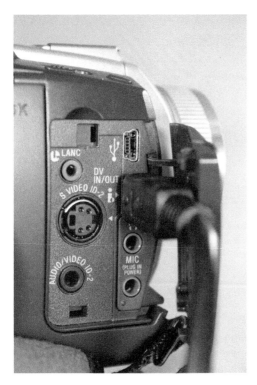

Figure 2.4 *If your camera and computer have an iLink or FireWire cable, you can use that connection. Another solution is to use the video out with the Stop Motion Pro Video Adapter.*

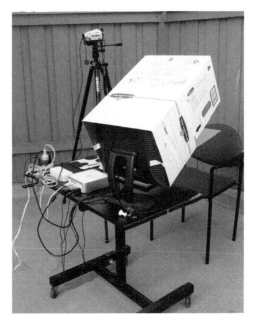

Figure 2.5 *If shooting outside, get a long extension cord for both camera and computer and make a sunshade for the monitor from a cardboard box. Mount your equipment on a roll-around table so you can easily move your setup.*

Figure 2.6 *Set your focus to manual, find a good focus, and leave it alone. This prevents auto focus fluctuations.*

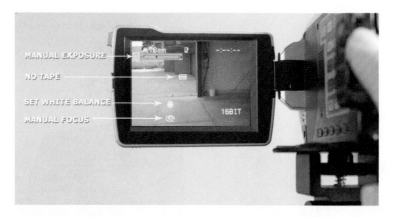

Figure 2.7 *Set the camera white balance for daylight or the outdoor setting. The sun icon should appear. Set your exposure to manual, find a good setting, and leave it alone. This prevents auto exposure fluctuations.*

Hooking up a Digital Video Camera to Stop Motion Pro

At this point, we will begin to use video cameras to image our animation. There have been tremendous changes in technology over the years, with many cameras, formats, and cables coming into the mix. With an older camera like this Sony TRV 27, a digital iLink cable was a good choice if you were fortunate enough to have an iLink connector on your computer. Stop Motion Pro would recognize the signal instantly. As time went by and things became a bit more confusing with different signals and formats, one signal remained constant, and that was the video signal coming out of cameras that allowed you to see the image on your TV set. Because this was stable technology, Stop Motion Pro has come up with a great solution for getting video cameras to talk to computers. In these situations, you can use a converter box called the Stop Motion Pro Video Adapter. All you need do is take the yellow video output from your camera, plug it into the SMP video adapter, and plug the adapter into the USB port of your computer. It's as easy as that. This system will work for a wide range of cameras and is reliable for Windows XP, Vista 32, Windows 7 32, and Windows 7 64. There will be more on this technology in Chapter 10. The SMP Video Adapter is available on Amazon and can be found in the products page at filmingthefantastic.com.

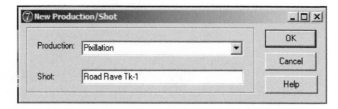

Figure 2.8 *Open Stop Motion Pro and create a new production called "Pixillation shot: Road Rave Tk-1." Click OK.*

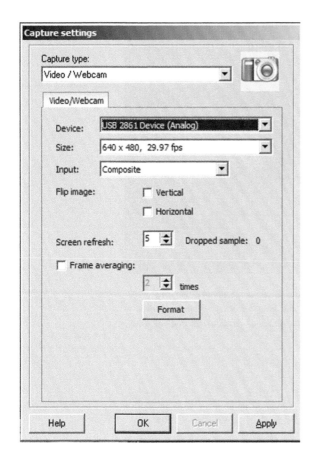

Figure 2.9 *The Capture Settings window comes up, and the software has recognized the DV camera at the default setting of Full Resolution. Click OK.*

2. Unplug the automatic door opener and open the door manually bit by bit, locking it in position for each frame.

3. The fun way is to not care how fast the door opens and just click on the Stop Motion Pro capture button several times in rapid succession as the door is opening. This is not only fast but also captures the blur of the door opening because it will be moving as you are taking the pictures.

All you need do now is direct your actor to pose like he or she is driving and have the actor come down the driveway and move into the garage. The easiest way to direct your actor is to reference the set. In this case, the driveway was made up of several large concrete pads that made a convenient checkerboard and alignment grid. There were 10 division lines from the street to the garage door opening. You can instruct your actor to position his or her feet at the division line for each frame and also align the body along another line so that the actor travels straight. Have the actor strike her pose, shoot a frame, and tell her to get up and reposition on the next line. Once she is set, shoot the next frame and continue. Because we are shooting at 12 frames per second, we know we will get to the garage in a little less than 1 second. On the 11th frame, we instruct the actress to turn her body. You can use your hands as a guide for her to position her feet. When she has entered the garage and exited the frame, click away and close the door again. Presto! You've done Pixillation.

Flying People

Many pixillated films have images of actors flying through the air. When animating with a film camera, you had to trust your sense of timing as you had the actor jump just as you pressed the camera button. In most cases, the camera operator was able to shoot the actor at the height of the jump. One would never know for sure until the film was processed the next day. Needless to say, this blind procedure can be nerve wracking. Happily, when animating with Stop Motion Pro you can always reference the frame you just shot by pressing the space bar. Use this procedure:

1. On the count of three, have your actor jump as you press the capture button.
2. After you shoot the frame, press the space bar to see the frame you just photographed. If the actor is in the air, "hooray"; you can move on to the next frame. If you didn't time it right, you will know instantly

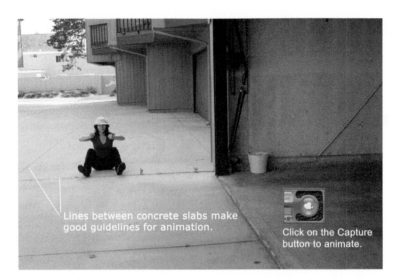

Figure 2.10 *Use the gaps in the concrete to direct your performer. For this frame, Lucy was told to position her feet at the line and keep 4 feet away from the driveway line to her left. Click on the capture button for each new position and animate away.*

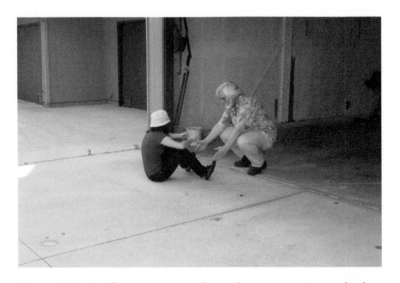

Figure 2.11 *As a director, you may need to guide your actor using your hands.*

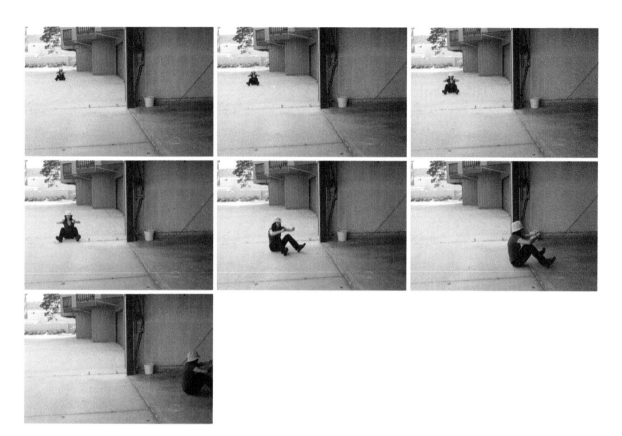

Figure 2.12 *Animating people is fast and fun.*

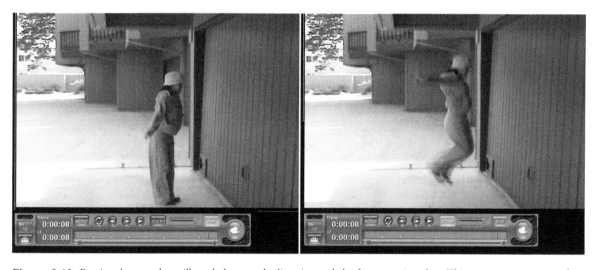

Figure 2.13 *Pressing the space bar will toggle between the live view and the frame you just shot. This is a great way to see if you captured the high point of the leap. You will know if you got it instantly and can proceed or do the frame over. This toggle tool can also gauge the effectiveness of the next animation position in the live view before you commit. Toggling back and forth creates the sense of the movement you are generating.*

and will be able to take the frame over again. The bad frame can be hidden later, as we will see with the next example.

Flying People Using Multiple Capture

The older method of synchronizing the jump and button push might be anxiety provoking for some animators. For animators who are more editorially driven, there is a way to capture a number of frames at once and then pick the best one later by using the Editor. This method can increase your chances of getting a good frame, as you will be shooting a burst of frames.

When this setting is made Stop Motion Pro will continuously capture eight frames with every button push. The idea is that within those eight frames will be an image that has the figure at the top of the jump. Later on when you use the frame editor, you will "hide" all but the best of the eight frames to create your animation. For this exercise, we will animate Lucy flying through the closed garage door. So let's start with the flying:

1. Have the performer stand ready. On the count of three, have the actor jump as you press the button. You will capture eight frames of the actor's jump.
2. Check the frames you just shot by pressing the space bar and moving along the timeline. You should find a good frame; if not, you can always try again.

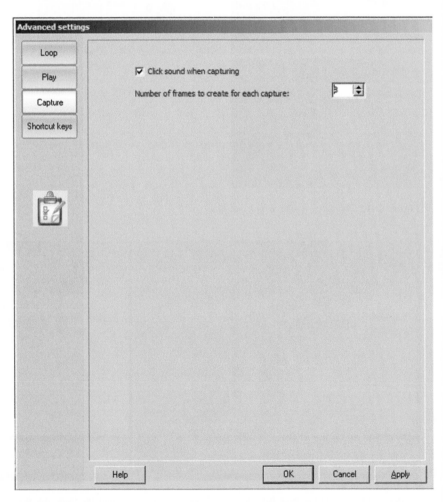

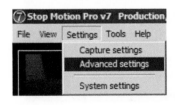

Figure 2.14 *In the upper menu list, click on Settings Advanced Settings.*

Figure 2.15 *Click on the Capture button and select perhaps 8 frames for each capture. Click OK.*

3. Have the actor walk one step forward and then say, "Ready?" When the actor acknowledges that he or she is ready, repeat step 1.

4. To create the illusion of Lucy flying through the door, all we need do is create one frame that gives a sense of her passing through. In this case, I had her wear a shirt and hat that were removed and pinned to the garage door to make it appear that half of her body went into the door.

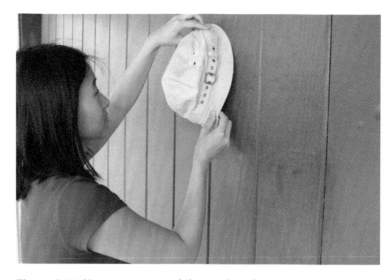

Figure 2.16 *You can tape or pin clothing to the wall to create a special animation frame that gives the sense that a character has gone through the wall.*

Edit the Sequence

After shooting the animation, you can use the editor tool to "hide" the unwanted frames.

The preceding example merely scratches the surface of the editing tool. Using the simple selection process, you can copy and paste frames, cycle animation, cut out mistakes, extend or shorten shots, and do any number of nondestructive editing functions to hone your animation to perfection.

Figure 2.17 *Click on the Editor button just to the right of your frame counter.*

Prepare Your Subject for Animation

If you do a lot of this type of work, your actors will become exhausted quite quickly. Be sure you have readily available chairs for them to rest in between takes and plenty of water, food, and shade. Jumping up in the air once is a breeze, but doing it 150 times can be pretty rough. The other issue is that props don't lend themselves easily to animation unless you have special rigs that enable them to be supported. People can hold still, but a flap of clothing or a hat has trouble suspending itself in midair. The good thing is that this type of animation is very forgiving because of its graphic nature. Things can't help but look herky-jerky because of the imprecision of the process, but it is this lack of precision that lends Pixillation its endearing charm. As a result you can get away with murder. If the hat, for example, needs to look like it is falling off the actor's head in midair, I could use a wire rig but more than likely I would just clamp the hat from behind to the performer's outstretched arm. This will give the appearance of the hat floating, but in actuality it is clamped from behind and the power of impression will lead the mind's eye to think it was in the air for a brief moment. In the rock video *Point of No Return* by Nu Shooz, I had the performers' shoes unlace themselves and slide off the performers' feet. It was a simple matter to make a thin slit in the shoelaces and insert aluminium wire inside the fabric of the lace. In this way the shoelace could stand on end and seemingly defy gravity without the use of "hanging" wires.

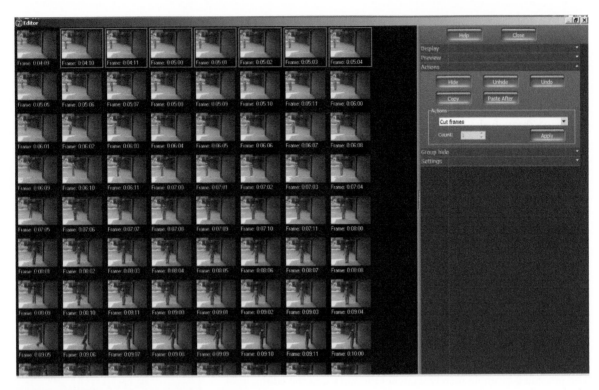

Figure 2.18 *You now see every frame that you photographed as a thumbnail image. Use the left mouse button and click on the first frame you want to hide. Hold down the shift key and select the last frame you want to hide. The entire row will light up. Click on the actions arrow to open that control panel.*

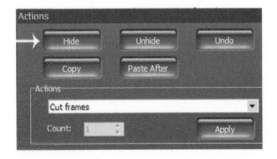

Figure 2.19 *Click on the Hide button and all the frames you highlighted will have a diagonal line applied to them indicating that they will be ignored in playback. Note that the frames are ignored (i.e., hidden and not deleted). If you should change your mind, you can quickly go back and "unhide" any frames you want to.*

More Ideas

In the book *Experimental Animation,* an illustrated anthology by Robert Russett and Cecile Starr (1976, Litton Educational Publishing, p. 126), McClaren wrote of his techniques:

It became apparent that the single frame approach was best only for certain types of shot. To meet all our requirements, we decided to use a whole gamut of shooting speeds, from one frame every five minutes to one frame every 1/16 of a second, depending on the nature of the shot, so we would select the most desirable shooting speed. Within one shot we might often vary the shooting speed if different parts of the action demanded it. The tempo of the actor's movement was also considered a variable factor, ranging from very slight changes of static positions, through

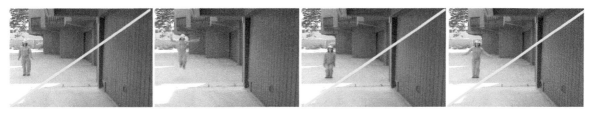

Figure 2.20 *Choose the frames you want to hide, and then close the edit window to view your finished sequence, or you can select the Preview option to see a thumbnail playback of your edited sequence before exiting the editor.*

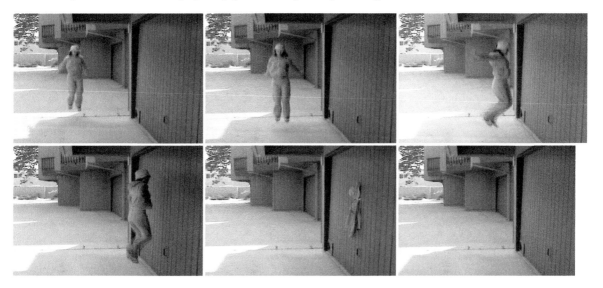

Figure 2.21 *The edited sequence showing Lucy vanishing into the wall. Although the pinned clothing looks odd as a single frame, it creates a convincing illusion when the sequence runs at speed. Improvements could be made by using the toggle function and perhaps repositioning the pinned clothing to better align with the height of the last frame of Lucy.*

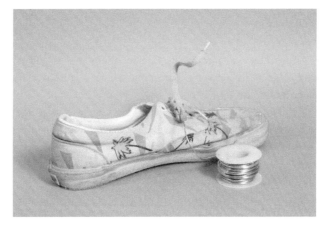

Figure 2.22 *Wires inserted within the subject can be a great invisible aid in posing tough subjects such as clothing. I used the support technique of inserting aluminum wire within shoelaces for the rock video* Point of No Return *by* Nu Shooz.

very slow movement, up to normal speed. The tempo of the actor's behavior and the tempo of the camera's shooting were therefore adjusted to any desired ratio, depending on the final desired effect, and the speed at which it would be easiest for the actor to achieve his point. For instance, if the actors moved half as slow as normal (twelve frames per second), the final screen speed would appear normal but, in the process of shooting, a tempo-control factor of two had entered in and the actor, by performing at speeds between half-normal and normal, had available a range of final screen speeds ranging from normal to twice normal. The concept of a tempo-control factor proved to be a useful one.

Many rock videos have built upon McClaren's ideas to create novel movement in performances, such as the Eurythmic's video *Missionary Man*. The performer performs to a slow playback of the music and then is speeded up to normal speed to generate bizarre movement. You can experiment with tempo control by using the Time Lapse tool in Stop Motion Pro and shooting at 1 frame a second. Have the performer perform 12 times slower (for a 12-frames-per-second rate). In other words, if the intent is to have the performer stretch out his arm in 1 second, it would normally take 12 frames or 1 second. If you shoot at 1 frame per second with the Time Lapse tool, the performer would slow down his movement and stretch out his arm in 12 seconds. If a performer performs this movement slowly yet in the middle of the performance makes a sudden movement, it will create a startling effect when speeded up. The possibilities are endless and the results are loads of fun.

Figure 2.23 My pixillated performer was Lucy Xi Xing, who was born in China and immigrated to the United States where she attending Michigan State University and then moved on to work in Los Angeles as a graphic designer. Lucy was one of my stellar students at UCLA Extension and kindly allowed me to animate her for this book. She is currently pursuing a career in visual effects.

Summary

1. George Méliès (a stage magician) was one of the first to discover that you could create effects and animation by manipulating subjects in between exposures. Méliès's landmark film *A Trip to the Moon* is a testament to this pioneering genius.
2. F.W. Murnau's film *Nosferatu,* made in 1922, made use of early stop motion in the ocean voyage sequence. The film was nearly lost because of reckless copyright infringement.
3. Pixillation is defined as the animation of live subjects as opposed to pixelation, which is a visual artifact involving digital pixels.
4. Norman McClaren of the National Film Board of Canada made use of pixillation in his Academy Award–winning film *Neighbours* in 1952.
5. For outdoor shoots, it would be best to use a power supply for the camera and the computer rather than to depend on a battery during a long animation shoot.
6. Mount your camera on a sturdy tripod that will prevent unwanted movement of the camera.

7. When setting up a video camera for Stop Motion Pro animation, it is important to disable all automatic functions such as auto exposure and auto focus to prevent fluctuations in the animation sequence.

8. It is important to set the sensitivity of the camera for the light source used to image the subject. If outside, you should choose the sun icon or technically the color temperature of 5500 degrees Kelvin. If shooting with tungsten lighting or 3200 degrees Kelvin, you should choose the lightbulb icon. For more on color temperature, refer to Chapter 5 of *Filming the Fantastic* from Focal Press.

9. Because pixillation is demanding on your actors, make sure they have a place to rest and plenty of water and refreshments.

10. When shooting flying people animations, you will need to synchronize the jump of the actor and the button push of the Stop Motion Pro operator so that the image is captured at the height of the jump.

11. You can shoot multiple frames during a single button push to "oversample" if you wish to use editing to find the best frame.

12. Having the performers move in one-footstep increments is a good start for a simple pixillation exercise. As you learn more about animation you will be able to refine the movements of your actors for even more professional results.

Films to See

Figure 2.24 *I highly recommend the film* Neighbours, *by Norman McClaren. It is available for viewing and purchase at the National Film Board of Canada web site, www.nfb.ca. Photo illustration © Mark Sawicki.*

Chapter 3

Animate Objects

As we learned from the previous chapter, animation in the real world can be challenging when it comes to gravity. With pixillation, we have the advantage of our subjects being able to move and jump for us to create the illusion of flight. Inanimate objects such as office tools, kitchen utensils, and the like will need to be supported and modified in various ways to prepare them to defy gravity. Let's explore several approaches for preparing everyday objects for animation.

Modifying Objects for Animation

I have noticed that when I have invited people to animate a little Lego dump truck using Stop Motion Pro at conventions, neophyte animators have no trouble pushing the truck along to generate forward motion but inevitably get disappointed when trying to raise the shovel. In their mind's eye, they can envision the shovel raising but when they attempt to make that happen through animation, two things occur:

1. The shovel pivots on loose hinges and won't stay put when raised.
2. If the shovel can be held in place by some last-minute means such as with the use of tape, the shovel creates a weight imbalance and the rear of the truck tips upward.

Our little Lego dump truck is a wonderful toy, but it needs to be modified or rigged to make it useful for animation. In this case, I needed to rig something quickly and came up with two simple solutions. Because the shovel was on a loose hinge and I did not have time to create a stiff hinge from scratch, I gave the existing hinge some resistance by placing rubber bands around the arms of the shovel, thereby pinching them in creating tension on the loose hinge. Because I did this, the shovel could be moved upward and stay in position. The camera would see these rubber bands, but for the purposes of demonstration this solution was perfect. To solve the second problem of weight imbalance, I chose to advise the animators to take a lump of clay and affix the far tires (out of sight of the camera) to the floor. The lumps of clay were hidden by the toy and

doi: 10.1016/B978-0-240-81219-9.00003-9

made sure that the truck stayed stuck to the floor with all four wheels on the ground as the shovel was raised. This lump of clay is the simplest of what are called tie-down systems. A tie-down system is anything that can be used to support an object or puppet so that it can maintain an imbalanced position during an animation frame exposure. Besides clay, the animator can make use of sticky gums used for affixing objects to furniture in earthquake regions.

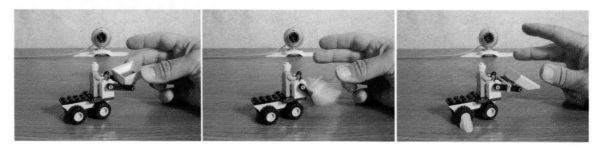

Figure 3.1 *Many objects and toys can be difficult to animate. In the case of this Lego toy, the shovel won't stay put after positioning. The solution was to bind the arms of the shovel with a rubber band to give it tension and to affix the truck to the table with clay on the off-camera side.*

Throughout the history of stop motion, artisans have devised several other systems for supporting puppets. Feet can be bolted from underneath the stage floor. Feet can be pinned to permeable floors. Magnets can also be used.

Sometimes the best-intentioned tie-down schemes have drawbacks. An electromagnet tie-down scheme was used for the so-called Kineman characters for the 1954 stop motion film *Hansel and Gretel: An Opera Fantasy*, released by RKO. Electromagnets were placed underneath the table where they attracted the metal feet of the puppets to hold the figures in place. It has been said that during a particularly arduous shot involving many figures, the animators decided to go to lunch and the last person out hit the light switch that also happened to power the electromagnets under the table. As a result, when the animators came back from lunch they were chagrined to find all the puppets had fallen down, and they were doomed to start over. Today this incident would not be a catastrophe. Stop Motion Pro software can enable you to superimpose the last frame you took over the live view so you can reposition figures exactly where they were on the last frame using the Onion Skinning tool.

Aside from tie-down methods, the actual object itself may need modification. One of the best subjects for a beginning animator to use is the ubiquitous spring-loaded desk lamp designed to hold its position in a variety of orientations. These desk lamps are readily available and lend themselves easily to animation. In other cases, springs will need to be removed from objects so that the animator isn't fighting what the spring was designed to do. If one were to turn a spring-loaded office staple remover into a menacing predator with snapping jaws, provisions would need to be made to remove the spring and replace it with malleable aluminum wire that would hold the position of the jaws during the animation process.

Figure 3.2 *Replacing the taut spring of this staple remover with soft aluminium wire allows it to be animated. The wire would be attached to the remover using super glue or epoxy putty.*

Floating and Jumping Objects

As we saw in the previous chapter, we can create the illusion of a person flying in the air by timing the exposure to record at the height of a jump. In the case of an object, this becomes a much more difficult proposition as the subject is inherently inanimate and can't help you by actually jumping. Thin support wires seem to be the obvious solution, but using these wires is a cumbersome technique. It is difficult to hide the wires and even more difficult to obtain stability. The figure or object will wobble about after being touched, and you have to wait until it settles down to shoot the frame. In some cases, this wobble can be used to your advantage, as an object or character moving or wobbling during the exposure will create a blur. Capturing a blur can be a tremendous aid in obtaining fluid animation, especially with fast-moving objects, but it is difficult to control during animation. For myself, I have had a great deal of success having the subject hide its support. In the educational film *Build a Better Bag Lunch,* I created floating crackers by merely placing them atop clay pedestals that extended down to the stage floor. From the camera's viewpoint, all you saw was the cracker that completely obscured its support. In cases where a character or object jumps out of frame, one can do a handoff from a stage floor–based tie down to an off-screen support from above on the next frame.

Figure 3.3 *The "floating" cracker.*

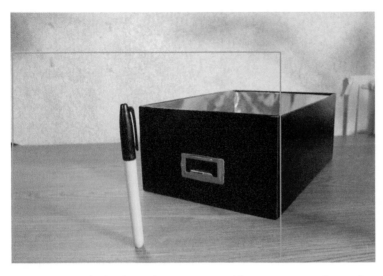

Figure 3.4 *In the first frame, the pen is supported by a pin projecting from its base and stuck into the floor. The red rectangle indicates the view of the taking camera.*

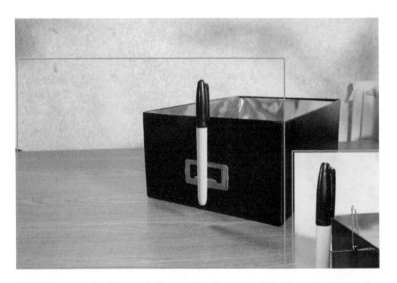

Figure 3.5 *In this frame, a duplicate pen without a pin hides the new support—that is, a paper clip attached to the rim of the box.*

You can also attach the character to a Plexiglas sheet that is drilled to allow for a bolt to attach the subject to it. Once again, the character hides the support bolt and the background can be seen through the plexiglas sheet. With this technique, care must be exercised to avoid the inevitable reflections. The use of polarizing filters on the lights and lens is very helpful in this regard. The advantage of this system is that moving the Plexiglas sheet can move many characters in unison.

As a young animator, I would study the films of the past frame by frame and pick up on these clever techniques, as the support mechanisms would occasionally be photographed. In the days before videotape and DVD, such errors were generally forgiven, as the audience never had the ability to do frame-by-frame analysis. The important thing, after all, was the story and performance. Today with the advent of digital, many of the classic films have been reworked and sanitized to take out the short glimpses of the clever rigs, so it is difficult for the student to learn from what has gone before. Fortunately for us, we can use those same digital tools to erase much sturdier supports that would have been impossible to hide in the past. We will explore this support erasure method at the end of this chapter. For now, let's set up our camera and a light and do some tabletop animation.

Setting Your Camera and Light

For this exercise, we will use the same camera we used in Chapter 2. The only difference is that because we will be inside, we will set the camera to the lightbulb icon or tungsten lighting because we will use a

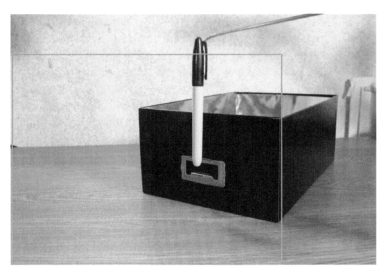

Figure 3.6 *On this frame, we lose the paper clip and mount the object with an off-screen support from above. This is called a handoff technique.*

Figure 3.8 *A simple setup to animate a toy truck.*

Figure 3.7 *Figures supported from behind on moving Plexiglas.*

common desk lamp to light the subject. Once again, we will place the camera on a sturdy tripod alongside a stable heavy table or desk that will become our animation stage. When you only have one light, the best place for a good overall appearance is directly above the camera shining directly at the subject. The light should be soft and even, so a frosted bulb is a good choice. To avoid the complexity of making a backdrop, make sure the camera is high enough so that the table fills the frame. Have the angle be wide enough to be able to show the entire length of a 12-inch ruler. We will be making tiny pencil marks on top of the table, so be sure to use a piece of furniture that is expendable or can take a little abuse. In other words, don't use the good dining room table! Set up Stop Motion Pro as you did in Chapter 2, and set the frame rate to 12 frames per second (fps). Call this production "Linear Animation," shot "Linear Truck Tk.1."

How Far Do I Move It?

In this example I have chosen to animate a little toy truck. Many people who animate for the first time often move the object too far, as they think in terms of the beginning and end rather than the process of getting there. To see an example, place the truck at the left-hand side of the screen and take your first picture. After you have shot this frame, move the truck to the far right side of the frame. Without taking a picture, press down on the space bar of your keypad. When you toggle back and forth, Stop Motion Pro enables you to see a rough two-frame animation, much like an animator who uses drawings examines his or her animation by flipping back and forth between the pages. You will notice that when the subject is displaced too far from the first position, the viewer gets the impression that the subject has disappeared and then reappeared in a different place. This popping off and on covers too much distance to be considered a "movement." Keep moving the toy back toward its original position while toggling the space bar. You will eventually reach a point (especially if the image of one overlaps the image of the other) that you will get a sense that the truck has moved by itself. My general rule of thumb is to move the subject to a point where there is some overlap or at least to the point where the first image left off. If you go any farther than this, it would be best to introduce some kind of blur to justify a move of that distance in the span of one frame.

Figure 3.9 *The move is too big between frames 1 and 2 and looks like the truck popped off and on.*

Figure 3.10 *This move is good, as there is an overlap between the position of truck 1 and 2. The eye will blend these positions together and create the illusion of movement.*

Now to create our first linear animation, we will need a guide. Remember the ruler that you used to frame the shot? Place the end of that ruler so that it lines up with the front of the toy truck on the first frame you photographed. After you have placed the ruler, make light pencil marks on the table showing where you placed the corners of your ruler. This will allow us to use the ruler as a guide and bring it in and out as we animate. Once you have marked and placed the ruler, push the truck so that its front aligns with the 1-inch mark on the ruler. We will animate the truck moving 12 inches in 12 frames. Once you

Figure 3.11 *In between animation frames, you can put in a ruler to use as a guide.*

have moved the truck, remove the ruler and take a picture. Replace the ruler using the guide marks on the table and move the truck forward another inch. Remove the ruler and take a picture. Repeat this process until you have moved to the end of the ruler.

Now play back the animation, and you will see that the truck moves across the table and your ruler guide is never visible. Because we used even increments (1-inch moves), we call this a linear move. This is the simplest form of animation, but we can make it a lot better by making use of the process of ease in and ease out.

Ease in and Ease Out

English physicist Sir Isaac Newton described three laws of inertia. The first of those laws is of primary importance to animators and is often paraphrased by the statement "An object at rest tends to stay at rest unless a force is acted upon it and an object in motion tends to stay in motion unless a force is acted upon it." Inertia, by the way, is defined as the resistance of an object to change its state of motion (either moving or not). What this means for an animator is that matter never starts moving or stopping at a constant speed. Car manufacturers always brag that a particular model goes from 0 to 60 miles per hour in so many seconds. It takes a while for the car to accelerate or speed up to get to 60 miles per hour. It never starts at 60 miles per hour. Conversely, unless the car hits a brick wall, it never stops instantly. The car and everything else for that matter slows down. So everything we animate will look far more natural if we speed it up and slow it down or ease in and ease out. Eases are typically worked out on the fly in the mind of the animator.

To make the process clearer, I'll illustrate a way of creating an ease using simple math and geometry. First, place the ruler on a large piece of poster board and draw a straight line along its length. Using a compass with its point in the middle of the ruler (6 inches), draw an arc. Using a flexible ruler, measure the length of this arc. You should get something close to 18.87 inches. Because our move will take 1 second, divide the length of the arc by our frame rate of 12 fps; you will obtain 18.87 divided by 12 = 1.57 inches, or roughly

1½ inches. Set your compass to 1.5 inches, and start dividing your arc into 12 segments. Once you have done this, set your ruler along the straight line and line it up with the hash marks you have drawn on your arc. Then make marks along your 12-inch line. As you proceed along the arc division by division, you will see that the marks along your straight line become more widely spaced apart. The first increment will be small and get gradually larger until we get past the midpoint and the progression reverses. Using this method, we have created by graphic means an ease in and ease out.

For those of you who are fond of mathematics, a precise way of finding the increment is to solve the circumference by multiplying the diameter times pi (π), or 3.14. So if the diameter of your arc were the length of the move, 12 inches, you would multiply $12 \times 3.14 = 37.68$ to get the full circumference of the circle. Our arc is half of this circle. To obtain the length of the arc, divide the circumference by 2: $37.68 \div 2 = 18.64$. You then divide the length of the arc 18.64 by the length of the move to get the increments: $18.64 \div 12 = 1.57$.

Use Stop Motion Pro to Make Animation Guides

Moving a ruler in and out of the scene is cumbersome and risks the problems of bumping props or accidentally leaving the ruler in the shot. An easy solution to this potential headache is to create guide marks on the viewing window of Stop Motion Pro. Figure 3.19 shows window guide marks based on your ease graph.

Set this project up as the Ease project. Once you have finished this animation, you will see that our toy truck moves much more naturally because it speeds up and slows down. If you'd like to see a video demonstration of this technique, you can refer to the "Stop Motion Animation with Stop Motion Pro" DVD, available from filmingthefantastic.com.

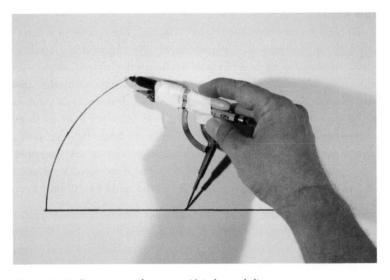

Figure 3.12 *Draw an arc above your 12-inch travel distance.*

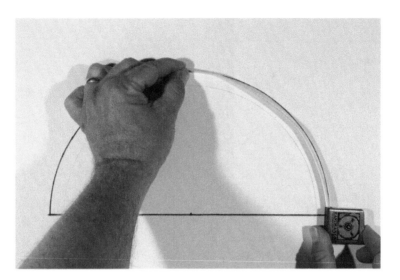

Figure 3.13 *Measure the arc with a flexible ruler and divide this length by 12.*

Figure 3.14 *Divide the arc using the increments you calculated, 1.57 inches.*

Figure 3.15 *Project down the arc divisions onto the straight line to obtain an ease in and ease out. After you have made these marks, cut out the straight line and use this as a guide.*

Figure 3.16 *Place your guide in the frame along the line you want your truck to travel.*

Figure 3.17 *With the left mouse button, go to view and select Show markers.*

Figure 3.18 *With the right mouse button, click on the image frame and select Add Crosshair.*

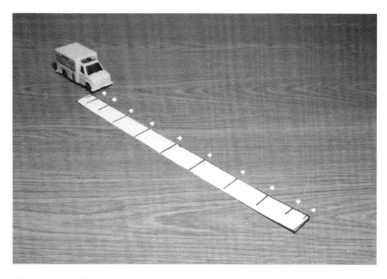

Figure 3.19 *Use the left mouse button to place crosshairs at the ease points along the imaged graph. When you are done, remove the guide graph. You can now animate your truck using the crosshairs as a guide. They will not be photographed. This will speed up your work tremendously. Feel free to try the other options of star, point, dots, line, and the like to suit your individual project.*

A Flying Truck Exercise Using the Onion Skinning Tool

For this exercise, we will use a surface gauge as a support rig to make the toy truck fly. A surface gauge is a machinist's tool that is used for precision metal work. Stop motion animators have used this tool over the years as a guide to let them know where the puppet was during photography so they could accurately gauge how to move to the next position. Stop Motion Pro has a remarkable Onion Skinning tool that makes this cumbersome method obsolete, so now I can use my surface gauge as a support rig. For those of you who don't have a surface gauge, the same effect can be done with a flexible wire attached to a heavy base that is strong enough to support the toy. Once again I will be using a mini-DV camera at full resolution at 12 fps. Name this project "Fly Truck." The first thing to do is shoot an empty frame. This first frame is known as a *clean plate* and will be used later to erase the support.

The Onion Skinning tool is a vast improvement over the surface gauge methods of the past. With onion skinning, you see every part of the next position superimposed on the last position to see the displacement before you commit to photography. The surface gauge could only remind you of a single point in space. Animators of the past would often use multiple surface gauges as markers for complex characters. For example, a dinosaur model might have a surface gauge for the top of the head, a foot, and the end of a tail to keep track of everything. Not only was this method mentally taxing, but the animator oftentimes forgot to remove

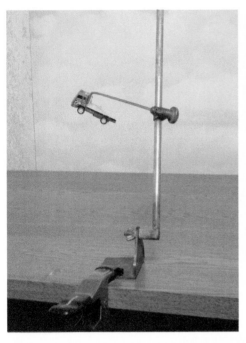

Figure 3.20 *A machinist "surface gauge" can be utilized as a movable support that is easily animated. Note that I chose to support the truck from the top to prevent the support from going over portions of the truck. Erasing supports that go over the model is more time consuming and difficult.*

Figure 3.21 *Always shoot a "clean frame" with no subject that you can use to later erase the support.*

Figure 3.22 *Shoot the first position.*

the surface gauges before photography. In the age before digital cleanup, even the great masters of animation would accidentally leave the gauges in, and they can be seen on old releases of Fantasy Films of the 1950s. During that period, such errors were forgivable mistakes. A surface gauge suddenly appearing for one frame went completely unnoticed by the general audience. With onion skinning, we have a much clearer picture of positioning without any danger of photographing a surface gauge. A good general procedure for working with the Onion Skinning tool is as follows:

1. With the Onion Skinning feature on, position the model to make use of what we learned before about ease in and ease out.

Figure 3.23 *With the Live View button activated, move the Onion Skinning slider to the midway point and move the model forward. You will now see a ghost image of the live view on top of the previously shot frame.*

Figure 3.24 *After you have positioned the model using onion skinning, you can confidently shoot the next frame. In this image, the slider has been moved back to the full live feed position.*

Figure 3.25 *Jim Danforth animating a sea monster for the film* Jack the Giant Killer *(1962). Note the use of four surface gauges to keep track of all the tentacles. You can see how easy it would be to forget to remove a gauge before taking a frame. Photo courtesy of Archive-Editions.com.*

2. After positioning, quickly slide the Onion Skinning slider back and forth to see the previous position next to the new position.

3. Another technique is to move the slider all the way to the left to reveal only the live view. You then use the space bar to toggle back and forth to judge the movement.

4. When you are satisfied, take a picture.

5. Once you have a picture, you will notice that when you bring up the Onion Skinning slider to the halfway point you will not see any ghosting, as the last frame taken will match the live view. When you move the truck, you will begin to see the ghosting and can once again judge your next animation position.

Do not be afraid to try different positions of the Onion Skinning slider. The halfway mark may not necessarily be the right position for the image you are working with. As you learn to use the tool, you will develop your own style and working methodology. As you get better and better with practice, you may find that you prefer to animate straight ahead without the use of gauges or the Onion Skinning tool. Go ahead and complete a 12-frame animation of the truck flying past the camera.

Figure 3.26 *Go to Tools, Rig removal.*

Removing the Support with Rig Removal

Play back your animation. I think you will find that the use of onion skinning made the animation task easier and gave very good results. The next task is to remove the rig. Follow the steps from Figures 3.26–3.29 to erase the support and make the truck fly.

Figure 3.27 *You now see the rig removal screen. The large image shows the frame you have currently shot. With the left mouse button, click on the background plate arrow located in the upper right-hand corner. You will now see a smaller image of the very first frame you shot—that is, the "clean plate" that has nothing but sky. This image will be used to paint out the support by painting pixels from this image on top of the support. With the left mouse button, click on Brush size.*

Figure 3.28 *Two sliders will now appear that allow you to choose the size of your brush using the radius slider. The feather slider adjusts the softness of the outside of your brush. All you need do now is paint on top of the large image and the support will be cloned away using pixels from the first frame. Once done, you merely press the next button at the bottom and continue the process. When you have a moving camera, the background is liable to change a great deal. This is where the choice of background plate becomes important. With a rapidly moving camera, you may find that you will use frame 9 to paint over frame 10 in order to create a seamless support erasure.*

Figure 3.29 *The rig removal tool enables you to animate flying objects with ease. The Actions buttons on the right are great tools for making the erasing easy. The first button on the left is the clone tool itself, which you will activate when erasing. The points of the Compass button next to it work in tandem with the Full Size and Best Fit buttons below the large image. If you choose to enlarge the image, the Actions arrow button will enable you to move the image about to obtain the best working perspective. The two middle Action buttons allow you to draw a freehand selection for tight, delicate work. If you make an error, the Remove Selection button is to the right of the Selection button. The two arrow buttons on the right allow you to move forward and back with ease so you have no fear of making a mistake when removing rigs.*

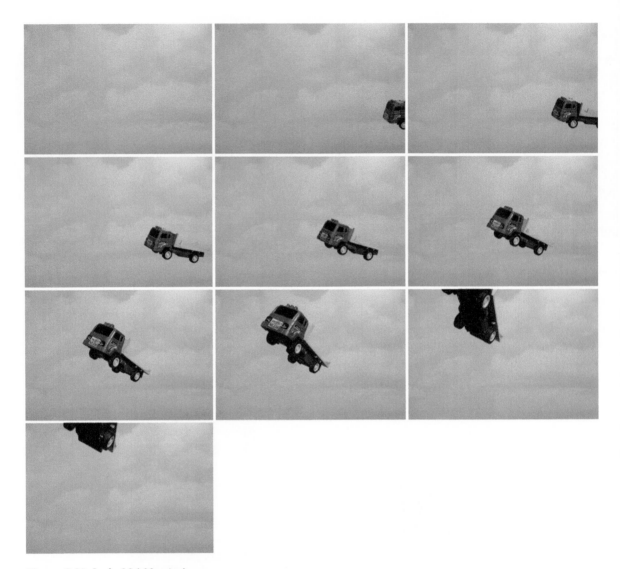

Figure 3.30 *Look, Ma! No wires!*

Summary

1. Everyday objects often need modifications to prepare them for animation. Things such as built-in springs or uneven weight distribution need to be overcome to allow for stop motion animation.
2. Tie-down systems are a variety of methods that enable the subject to be affixed to a tabletop in order to overcome the gravity restrictions of falling over and eliminate the need for employing complicated overhead wire supports.
3. Having the subject hide its own support is one of the best tactics in achieving a flying mount.
4. It is often best to overlap the subsequent position of an object to achieve fluid motion.

5. The ease in and ease out process of using greater and lesser increments when positioning the subject is the key to fluid animation.
6. Newton's first law of inertia is the foundation of eases.
7. Eases can be worked out using simple geometry and mathematics.
8. The surface gauge is a machinist tool used by animators to help them remember the previously exposed position of the subject.
9. The Onion Skinning tool is the digital equivalent of the surface gauge and has many more advantages than the old gauge system.
10. Today, airborne characters are easily animated with sturdy supports that can be erased using the rig removal tool.
11. Always shoot a clean frame without the subject so you have picture information to replace the support when you erase it.

Films to See

Objects and toys have been animated for many fantasy sequences, such as the magical self-cleaning room in *Mary Poppins* (Disney, 1964). A sample of some of my work in the field is *Home Alone, You're in Charge* (1986), available from www.a-barr.com. This is an educational film for latch-key children who have to deal with being home alone. Throughout this film, I utilized live-action puppetry and stop motion animation to create the effects.

Figure 3.31 *An animation setup for* Home Alone, You're in Charge.

Chapter 4
Animate Voices

J. Stuart Blackton (1875-1941) was an American film pioneer who is often cited as the father of the drawn animation film. He founded the Vitagraph Company and, building on the work of Méliès, created a combination stop motion and drawn animation film titled *The Enchanted Drawing,* made around 1900. In this film, Blackton sketched on a blackboard a character smoking a cigar. Blackton then plucks the cigar off the board, transforming it into a real cigar as the drawn face reacts. From here, Blackton went on to direct *Humorous Phases of Funny Faces* in 1906. Needless to say, this frame-to-frame drawn animation was quite time consuming, perhaps even more so than puppet animation in that the characters needed to be redrawn for each frame. You can try this form of frame-to-frame drawn animation by using the modern whiteboard and dry erase markers.

These tools are a tremendous improvement over the chalkboards used in the silent era. In the years that followed Blackton's success, mass production was introduced into the art and gave rise to the cel animation system. In the drawn animation assembly line process, it no longer became necessary for a single artist to create the animation alone. The workers in this system were broken down into several basic categories:

1. The key animator, whose duty was to roughly draw in the key poses of the character at important points of the movement
2. The in-betweener, who roughly drew in all the drawings in between the key poses sketched out by the animator
3. The cleanup artist, who took the rough scribbles of the previous artists and made clean definitive lines to help finish the look of the character
4. The inker, who would ink black lines on a clear animation cel to finalize the lines of the cleanup artist
5. The cel painter, who would flip the cel over and paint in the colors, staying within the lines of the inker

There are many more positions, of course, but these are the main delineations. This method streamlined and sped up the animation process tremendously. All along the line of production, one could have checks and

doi: 10.1016/B978-0-240-81219-9.00004-0

Figure 4.1 *Blackboard animation is much simpler today using a whiteboard and dry erase markers.*

tests to monitor the progress of the work. The main quality control was the use of the pencil test. The pencil test took the rough pencil drawings made by the animator and in-betweener and photographed them on film. This rough animation was then viewed and refined until one achieved a final approval and could move on to the inking, painting, and final shoot. By contrast, stop motion animation seemed doomed to forever be tied to the straight-ahead process of stop motion. With all these advances in drawn animation, it will not be surprising to learn that stop motion animators experimented with similar ideas. One of the most successful practitioners of the assembly line system for puppet animation was George Pal.

George Pal

George Pal (1908–1980) was a Hungarian-born animator and film producer. In the early 1930s, he worked in Berlin in association with the famous UFA studios, and it was at this time he patented his Pal-Doll system known as Puppetoons in the United States. Essentially, a Puppetoon film was a three-dimensional mimic of the drawn animation process; instead of creating thousands of drawings with a different pose, Pal devised a system for making thousands of individual three-dimensional wooden puppets with slightly different poses. The technical process is replacement animation in that you place one figure in the shot, take an exposure, and then remove that figure and "replace" it with the next figure in the sequence. His studio personnel were referred to as animators with a lathe and blade. On average it took 9000 separate figures to create a 7-minute short. On the surface this might seem like an exercise in insanity, were it not for the amazing metamorphic changes that can be achieved via this process. Because the figures were not limited by a fixed physicality like a jointed puppet, they were free to grow or shrink, stretch or squash, and distort with the freedom of drawn animation except the characters were in three dimensions! Pal did a number of commercials in Europe using this process, depicting dancing cigarettes among other subjects. When Hitler came to power in the 1930s, Pal immigrated to the United States and began making films for Paramount studios. With bigger Hollywood budgets at his disposal, Pal made a number of classic Puppetoon films in the 1940s, such as *Tubby the Tuba, John Henry and the Inky Poo,* and *Jasper in a Jam*. In 1942, Pal made a war propaganda film, *Tulips Will Grow,* which enabled him to depict through animation the terror he went through as he fled Holland when the Nazis took over. *Tulips* and the last Puppetoon film, *Tubby the Tuba,* are perhaps the finest of this spectacular process.

Unfortunately, the Jasper films were a product of their age and depicted a racial stereotype of a black child that is unacceptable by today's standards and have to be viewed in context. Many of these films were nominated for the Academy Award and are well worth seeing. There is a terrific compilation film, done in 1987, called *The Puppetoon Movie* by Leibovit Productions that I highly recommend for studying this art form. Over time, the cost associated with Puppetoons made production unworkable by the 1950s, and Pal continued the art using traditional single puppet techniques while still keeping the branded name of "Puppetoons." Fortunately for us, Pal built on his success in puppet animation and went on to become one of the most prolific producers of classic science fiction and fantasy films during the 1950s and 1960s. His charming work can be seen in *Tom Thumb, War of the Worlds, The Time Machine, Wonderful World of the Brothers Grimm,* and *7 Faces of Dr. Lao,* among others. Pal was truly an inspiration for a whole generation of stop motion animators to follow.

Figure 4.2 *A view of replacement animation characters used for one of the last Puppetoon shorts "The Toolbox" from the television series* The Curiosity Shop *(1971), animated by Harry Walton. Courtesy of Harry Walton, vfxmasters.com.*

Creating Speech with Replacement Animation

The one holdover of the replacement animation system was the ability to facilitate speech in characters. A simple up and down jaw movement of a jointed character fell

Figure 4.3 *A wide view of the Puppetoon stage. Courtesy of Harry Walton, vfxmasters.com.*

short when called on to execute high-quality dialogue sequences. To show speech, systems were devised that required the creation of multiple replacement heads formed to mimic the basic mouth shapes used to create phonetic sounds. The popular Pillsbury Doughboy character, for example, had a rubber body, which could

be posed and a number of replacement wax heads to facilitate his timeless giggle and speech. Other methods were much more frugal in execution, using sticky paste on mouths to execute the dialogue. The popular *Davey and Goliath* films from Clokey Productions and *Robot Chicken* by Seth Green and Matthew Senreich use this technique, as will you in our next exercise.

Figure 4.4 *A replacement animation series used for a rock video.*

Mouth Positions

Creating the illusion of speech can be daunting to a beginning animator, as it involves breaking down a soundtrack not alphabetically but into phonemes, which are the audible sounds that represent letters, and translating those sounds into visemes, or mouth shapes that are a rough simulation of the shape a mouth makes when making those sounds. Animators throughout the years have devised many assortments of mouth shapes to generate dialogue. Some computer graphic artists use as many as 22 different mouth positions for their characters. One standard for drawn animation has been Preston Blair's breakdown of 10 mouth positions used at the Disney studio for many years. Preston Blair breaks down the Disney system on page 17 of *How to Animate Film Cartoons,* published by Walter T. Foster Company. This book is generally available at fine art stores and is an excellent reference for drawn animation principles. The explanation of mouth shapes in this book is a bit confusing and intimidating, as it is written for a more advanced animator. For the beginner, I am fond of the bare bones viseme breakdowns used by TV animators that are illustrated on page 71 of *The Technique of Film Animation,* by John Halas and Roger Manvell (1971, Focal Press).

Figure 4.5 *The bare minimum number of replacement mouths with the corresponding sound guides. This is my redrawing of the Halas and Manvell illustration.*

I am including my own version of this excellent breakdown that you can use to create replacement mouths for a puppet character we will make as homage to George Pal and his Puppetoons. As you become a more advanced animator, you will be able to build on these basic shapes and exaggerate them based on the performance of your character.

Building a Puppet Head

Creating wooden puppets requires a good deal of skill and specialized tools. For Pal, the medium of wood seemed the most pliable at the time. Fortunately for us, there are many new clay mediums that enable us to create dimensional art with much less effort. For this project, we will use polymer clay that can be baked in a home oven to harden.

The puppet head will be fashioned as a polychrome, meaning that we will blend several colors of clay to create the character. Here is what you will need from your local arts and crafts store:

1. One box of Super Sculpey, manufactured by Polyform products
2. An assortment of colored clay called Premo, also manufactured by Polyform (Sculpey) (get white and brown)
3. An assortment of brushes and a sample kit of acrylic paints
4. An assortment of sandpaper, from medium to fine grit
5. Aluminum foil

Figure 4.6 *It is easy to make a head with a few simple materials. In the United States, all of these products can be found at local arts and crafts stores such as Michael's.*

Form a rough armature from the foil. Blend a bit of white into the beige Super Sculpey to get a lighter skin tone or blend in brown clay to get a darker shade for your character. Form a head around the foil ball. With clean hands, take the white clay and roll two identical spheres on top of a smooth surface. After you roll the balls, bake them in a home oven at 275 degrees for 15 minutes, and let them cool slowly to harden them. Once the spheres are hard, sand both so they become half spheres and press them into the head with the flat surface facing outward. Sculpt the hair and texture it with a tool. Leave the mouth area flat and smooth. Once done, bake your finished head as you did the eyes but perhaps for 20 minutes at 275 degrees. Turn off the oven and let the piece cool slowly inside. Once your head is cool, you can sand the surface under running water to create a smooth finish. Start from medium grit and gradually use finer sandpaper, such as 600 grit, until the surface is perfect. To paint the figure, you can dilute black acrylic paint and "wash" it atop the hair. Let the paint set a moment, and then wipe the raised areas clean with a paper towel. The black paint will stay in the textured areas and bring out the detail. To create subtle paint effects, you can use Genesis Heat dry oil paint to paint in blush

Figure 4.7 *Sculpt the basic head shape.*

Figure 4.8 *Insert hard half spheres for the blank eyes.*

Figure 4.9 *Add the hair and texture.*

Figure 4.10 *Bake in a home oven at 275 degrees for 20 minutes. After 20 minutes, turn off the oven and let the piece cool inside.*

Figure 4.11 *Sand the head under running water with various grades of sandpaper from coarse to the ultrafine 600 grit to obtain a smooth finish.*

Figure 4.12 *You can paint a wash of color onto a textured area, let set, and then wipe the surface to bring out the detail.*

Figure 4.13 *Genesis heat-set oils are a great paint to use for model making.*

Figure 4.14 *Add the paper mouth and pupils, and use clay for the eyebrows. The head is ready to attach to an armature.*

Figure 4.15 *Using the paper cutouts and stick glue, you can animate the eyes and replacement mouths atop the solid head.*

on the face. This paint will remain liquid until baked between 265 and 280 degrees for several minutes to set. A solid head such as this would now be attached to a flexible body.

Making Replacement Mouths

You can scan the illustration in this book for the mouth positions, or you can draw your own. It is a good idea to make a number of them so that you always have fresh mouths, as they will get worn out with use. For the pupils, use a round hole punch to cut discs out of shiny black paper. After printing the mouths, take an Xacto knife or scissors and cut out the mouth positions; place them on wax paper so they are easily accessible. Use temporary stick glue to affix the eyes and mouth to the face. You now have a puppet head that's ready to animate. All you need now is a voice.

Using the Audio Tool in Stop Motion Pro
Recording

The first step is to record a short piece of dialogue using Stop Motion Pro. Follow the steps from Figures 4.16–4.19.

All you need do now is press the Record button and say a short phrase like "Buy *Filming the Fantastic* from Focal Press." You can then have your puppet say this phrase and post it all over the Internet. How's that for viral marketing? Ah, but all kidding aside, you should record a very short phrase so you can practice breaking down speech. In this case I recorded "I want that one!" Once you have recorded your phrase, save it to the desktop as a wav file. Once saved, Stop Motion Pro will prompt you to copy the recording into

Figure 4.16 *Go to File New Production and name it "Replacement shot: Talking Tk-1."*

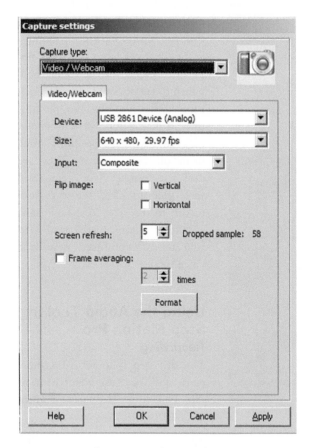

Figure 4.17 *Select your input device. In this case I am using the DV camera at full resolution and selecting OK.*

the audio sync tool. Say yes. For those who prefer ready-made soundtracks, I have created a number of license-free recordings that can be used for voice exercises. They are available on the Focal Press web site.

An Audio Sync window will appear that shows a graphic representation of the dialogue. To hear the file, you simply click on the play arrow to the left of the toolbar. As you listen to "I want that one," you will note that the speaker puts special emphasis on the word "that." To create a more effective speech performance, plan to do something other than replace the mouth at that point, such as raising the eyebrows and moving the head. To more effectively analyze the file, you'll want to scrub through it. To do this, click the play arrow on and off in quick succession. This will result in a white bar appearing over the sound graph. You can select this bar with the left mouse button and while holding the button down you will be able to scrub through the graph to know exactly when each sound or word occurs along the timeline.

The Exposure Sheet

In traditional cel and stop motion animation, a special exposure sheet is used that breaks down every frame of the sequence along horizontal lines on a long sheet of paper. These lines are divided into columns that represent different aspects of the scene. In the case of drawn animation, one column would be the background and another column might be a cel containing the head of a character. Professional exposure sheets can be found at such companies as cartooncolour.com, but for our purposes we can easily make one ourselves out of lined notebook paper. The phrase "I want that one" only takes up 23 frames. On a sheet of notebook paper, number the lines from 1 to 23 on the left. Now scrub through the audio track to find the sound, the frame, and the appropriate mouth position that you will put on your exposure sheet. It will take a bit to get used to this process, but breaking down the sound this way

Figure 4.18 *Go to Settings Advanced Settings Play. Select the Play menu and choose Display as sequential frames 1, 2, 3. This will make it easier to keep track of your voice track. Hit Apply and OK.*

ahead of time will give you an easy guide to follow that will allow you to concentrate on the character's performance, as the mouth changes become a simple matter of following the sheet.

Breaking Down the Sound

Using a 12-frame-per-second rate the first word "I" does not start until frame 8, so across from the number 8 I wrote in the letter "I." The "w" sound for the word "want" comes in on frame 11, so I penciled in the "W." The rest of the word "ant" took frames 12, 13, and 14. The big "TH" sound of the word "that" happens on frame 15, and the "o" of the word "one" starts on frame 18. The exposure sheet is a good guide

Figure 4.19 *Go to Tools, Audio Record. A window will pop up that automatically recognizes your microphone input device and has a number of sound settings available. In this case, I am using a Gigaware C-Media USB Headphone set Cat. No. 43-203. This is a nice digital headset that sends digital sound directly to the computer. For the record setting, I used the default of 44 kHz, Stereo, 16 bit.*

Figure 4.20 *The audio sync tool.*

for knowing what mouth to use on what frame. For frame 8, you would use the first mouth of the series, and for frame 11, for the start of the word "want," you could use either the third or fourth mouth or create smoother animation by starting with the smaller mouth circle and going to the bigger circle mouth on the next frame before going to the "a" mouth shape.

The basic sound indicated below each mouth is just a starting point and not to be taken literally. You will find it is a good idea to say the phrase and think about what your mouth is doing and use that to judge which mouth you will use. The exposure sheet can also be used to put in directorial notes. On frame 3, I indicate to move the eye. On frame 15, I indicate that the eyebrows should move to emphasize that word. At the end, I throw in a blink. All of these subtle little movements will give added character to your animation. Now that we've planned what we are going to do, start animating using the set up shown in Figure 4.23.

Figure 4.21 *Making an exposure sheet is very useful when doing dialogue.*

Figure 4.22 *By moving the bracket boxes underneath the sound wave, you can zoom in on the image of the soundtrack to allow for a precise animation breakdown. Cycle through the sound once so you are at the start. The first frame of sound will now coincide with the first frame of animation.*

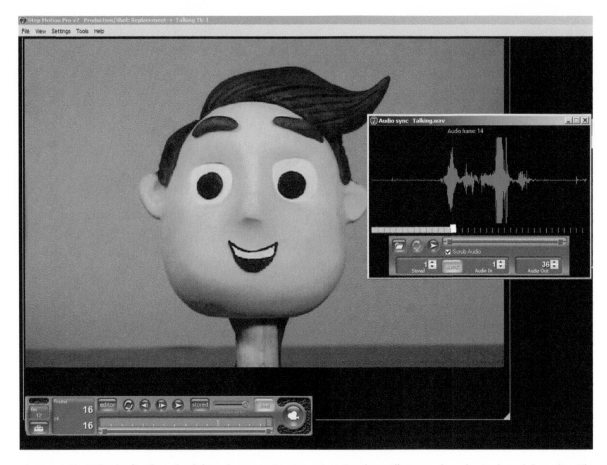

Figure 4.23 *Take the first frame by clicking the capture button, and a white box will appear along the timeline of the audio. This indicates the audio position of the frame you just shot. When you animate, you will always look to the waveform shape on the frame following the white box. This will allow you to anticipate what mouth shape you will use.*

If you get confused and mistake the white box as a marker for where you make the mouth position, you will be one frame late. This will not be a catastrophe. If you wind up with a sync problem, you merely go to the Editor and "hide" the first frame of picture. This operation will move all your frames of animation back one frame and you will be in sync. An impressive range of emotions can be expressed with just a few cutouts of paper and some bits of clay.

Action and Reaction

Thanks to the mass production of products such as pencils, straws, and other objects, you can make your own simple Puppetoon puppets by modifying mass-produced items. This next exercise demonstrates action and reaction in animation by using a drinking straw with a jointed end. This little shot will have our straw quickly move into position and stop on a dime, making the top of the straw spring back and forth in reaction. After the straw stops it will pause and then fall through the floor. As a director, you want to imagine the

Figure 4.24 *Be sure to add eye blinks and eyebrow movement to enhance the replacement mouth animation. The eyelids and eyebrows are made of soft, unbaked clay.*

movements in your mind's eye as you count out the seconds: "one thousand one" (representing 1 second) for the quick move to stop, "one thousand two, one thousand three" for the head of the straw to spring back and forth, "one thousand four" to pause and have the straw fall into the ground. You can puppeteer the straw with your hand as you count out the frames to plan your animation: 12 frames to the stop point and 24 frames for the head of the straw to spring back and forth. The pause and fall last 1 second. So reserve six frames for the pause and six frames for the fall. To get the straw to fall through the floor, get several identical straws and cut them into six segments. The straw can then look like it falls through the floor and disappears.

Figure 4.25 *You can plan out your movement by placing tape just outside of the camera's view. This will give you an idea of your stage space. You can also use wire to preplot the trajectory of your move. Note that the straws have been cut for replacement animation. Inexpensive ceiling tile is used for a stage to pin the straw to the floor.*

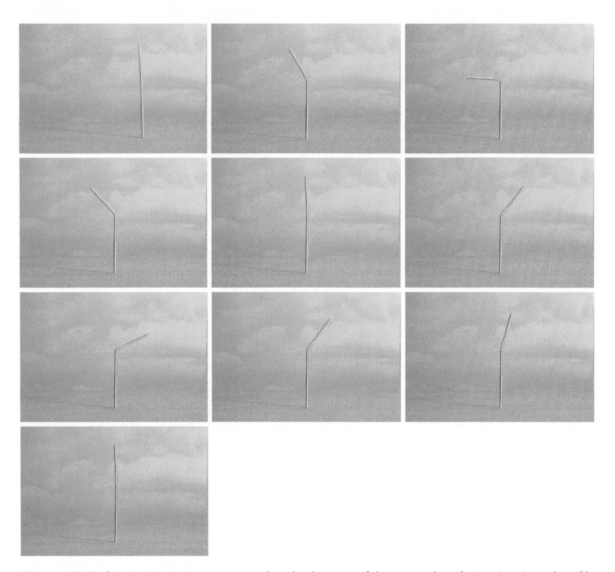

Figure 4.26 *In this animation sequence, you can see how the abrupt stop of the straw at the end point gives rise to the sudden forward tilt of the top of the straw in two frames as a reaction to the stop. When the straw springs back, it does not go as far and takes longer to get to the upright position. Subsequent frames will further slow the oscillation until the straw comes to a stop.*

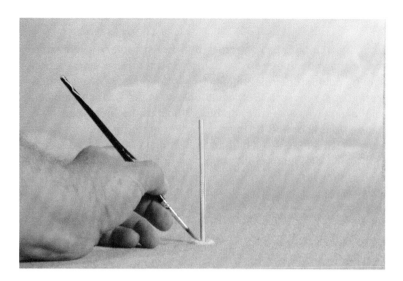

Figure 4.27 *Simple large-grain sea salt can be used to create a magic wave, as the straw seems to drop through the floor.*

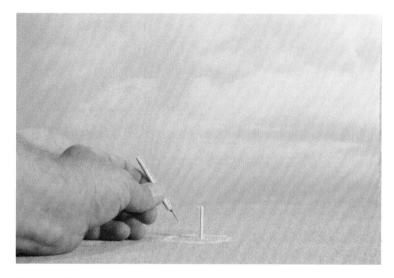

Figure 4.28 *Replacement animation is used to eat away at the straw and have it vanish into the floor without damaging the surface. Note the tie-down pin on the larger straw being removed. The salt circle has also been brushed bigger.*

Create a mount for the straws by taking a wood dowel that the straw can fit over and insert a pushpin into its base so you can stick it to a floor made of foam core, cork board, or ceiling tile. Use the marker tool in Stop Motion Pro to create a curve path to follow. Set the frame rate to 12 frames per second again and have the straw go from the far stage to center stage in a 12-frame arc. Stop the straw abruptly, but keep the motion going by bending the straw at the top. Use what you learned about eases to make the top of the straw tilt violently forward when the rest of the straw stops. Move two frames down, four frames back, then add positions as the straw comes back again but not as far as before. If it took two frames to bend down all the way at the stop, have it take three frames to bend down not so far when it comes back and so on until the head of the straw moves back and forth less and less and slows down like a spring. When this movement stops, shoot a few frames to create a "beat," or pause between actions. To get the straw to fall through the floor, you merely replace the straw with shorter and shorter straws until it is gone. To show a reaction of the straw going through the floor, you can use salt on the table to create a sparkly wave away from the straw.

Put Your Animation on YouTube

Now that you have done the talking exercise of having your puppet say, "I want that one!" while pointing to a copy of *Filming the Fantastic*, you can use Stop Motion Pro to package your animation for export to YouTube so the world can see your work.

Adding Motion Blur

Whenever you have a situation where a sharp image moves across the screen rapidly, such as the case with the straw, the eye will perceive the movement as "strobing." In traditional stop motion, animators resorted to blurring the object by painting petroleum jelly on a glass in front of the lens or finding ways of moving the puppet during the exposure. Both methods were time consuming and difficult to control. Fortunately, in the digital age we can easily add blur in post using Photoshop. After you shoot your animation, you can analyze your shot and selectively put in blur to make problematic animation smoother. In Photoshop, load the frame that needs blur and select that portion of the image. Then open the Motion Blur tool and adjust the parameters until you have a believable blur that will take away the strobe effect of fast animation moves.

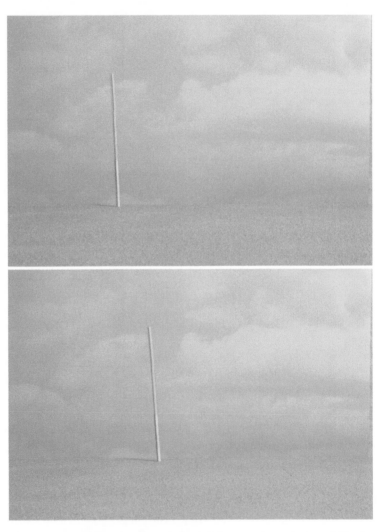

Figure 4.29 *Too big of a move of a vertical object going in a horizontal direction can cause a stroboscopic effect to the eye because there is no motion blur.*

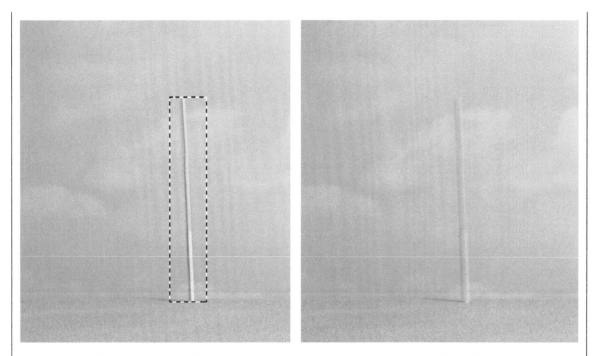

Figure 4.30 *In Photoshop, you can select the object you want to blur and by using the Motion Blur tool; not only can you create a blur, but you can also determine its direction. Blurring fast-moving objects takes away the stroboscopic effect.*

Figure 4.31 *Go to File, Export to YouTube.*

Summary

1. Drawn animation came to the forefront of animation art because of its easy adoption into the assembly line process of mass production.

2. George Pal devised an assembly line procedure for puppet animation by creating thousands of identical puppets with slight variance in their body positions. Pal called his system the Puppetoon.

3. George Pal went on to become a landmark figure as a producer of classic science fiction and fantasy films throughout the 1950s and 1960s.

4. While the Puppetoon system became too costly after the war years, the idea of "replacement animation" remained viable for speech and metamorphic effects.

5. A phoneme is the sound of a portion of a word, whereas a viseme is the visual representation of the mouth position making a sound.

Figure 4.32 *The Export window opens up. Be sure to input the same frame rate that you shot your animation with and include the sound file if you have one. Put in your user name and password, and click OK. Stop Motion Pro will package up your video and send it to YouTube so that squillions of people can see your work.*

6. Visemes for animation can be broken down with as many as 22 positions or more and down to a mere 7 positions for low-cost animation.
7. Traditional animators use an exposure sheet to correlate particular mouth positions with frames of the dialogue.
8. Whenever possible, the animator should judiciously pick visemes that will ease in and out of extreme mouth positions.
9. Be sure to add body language to the character; do not let the dialogue alone do the work.
10. Mass-produced objects can be modified to create simple replacement animation puppets.

Films to See

- *The Puppetoon Movie* (1987). Pay particular attention to *Tubby the Tuba* and *Tulips Will Grow.* Available on Amazon.com.
- The *Davey and Goliath* puppet films, www.daveyandgoliath.org.

Figure 4.33 *The* Davey and Goliath *films are an excellent example of fine puppet animation and the replacement mouth technique.* © *Evangelical Lutheran Church in America. Davey and Goliath® and Davey and Goliath characters are registered trademarks of the Evangelical Lutheran Church in America. All rights reserved. Used with permission.*

Chapter 5

Animate Puppets

Ladislas Starewitch

Eastern Europe was the birthplace of many stop motion pioneers. John Halas and Roger Manvell, in their book *The Technique of Film Animation* (Focal Press, 1953), postulated a likely reason: "The main development of the puppet-doll film has been in Czechoslovakia, Poland, Russia and Germany, all of those countries where there is a peasant tradition of craftsmanship in the carving and designing of puppets and dolls." (p. 263)

One of the earliest known practitioners of the puppet film from this region began as a natural scientist. Ladislas Starewitch was a Polish-Russian scientist who began documenting insect life using motion pictures during his stay at the Museum of Natural History at Korvo, Russia. His experience shooting live insects under the hot movie lights proved less than fruitful as the bugs became lethargic under the heat of the lamps. Not to be undone, Starewitch took it upon himself to construct realistic model representations of his stag beetle subjects and made them move utilizing stop motion animation. This technique led Starewitch to a lifelong career as a puppet animator. Much of his subject matter was geared to adult audiences, such as *Revenge of the Movie Cameraman* (1912), which dealt with the marital shenanigans of two adulterous bugs. Much later in France, Starewitch created *The Mascot* (1933), which is known for some of the most disturbing imagery ever to be realized in stop motion. The images are so striking that some shots have found themselves included in popular culture videos such as *Life in the Slaw Lane* by Kip Addotta.

Starewitch's work has been an inspiration for later artist such as the Brothers Quay and the more widespread Tim Burton features such as *Nightmare before Christmas*. Another contemporary of Starewitch was the Russian Alexander Ptushko, who garnered acclaim for his film *New Gulliver* (1935), which utilized 3000 dolls made of metal, rubber, wood, and cloth in a Soviet-oriented interpretation of the Swift novel. Much of Ptushko's work has been lost but once again can be seen as background imagery for comedic fodder such as the *Mystery Science Theatre 3000* series. Roger Corman released Ptushko's film *Sadko* 1953, retitled as *The Magic Voyage of Sinbad* in 1960.

© 2010 Mark Sawicki. Published by Elsevier, Inc. All rights reserved.
doi: 10.1016/B978-0-240-81219-9.00005-2

Figure 5.1 *The fabulous work of Starewitch.*

Jiri Trnka

After World War II, Czech animator Jiri Trnka became one of the foremost luminaries of the puppet film for two decades. He began as an apprentice to a puppeteer and graduated to becoming a book illustrator, a stage set designer, and eventually a producer of stop motion animation films. One of his most widely celebrated works is *The Hand* (1965), which won the Academy Award. It was Trnka's last film and a veiled political statement against enforced conformity that was prevalent among filmmakers of Soviet-bloc countries of that era.

China and Japan

In the Far East, Tadahito Mochinaga was unique in maintaining a career in animation in both China and Japan in the midst of the brutal war years. Little has been written about this remarkable artist, but more than a billion people have seen his fabulous work in the perennial holiday favorite *Rudolph the Red-Nosed Reindeer* (1964) by Rankin Bass. The charming work seen in the Rankin Bass library of films was coined Animagic and was made possible by Mochinaga's skill and artistry. A short biography of this artist and the making of the holiday classic can be found in the book *Rudolph the Red-Nosed Reindeer* by Rick Goldschmidt (2001, Miser Brothers Press).

U.S. Contributions

Much of the previous chapter was devoted to George Pal and his Puppetoons. Some of Pal's artisans in the States went on to form companies of their own, such as Gene Warren Sr. and Phil Kellison. US artists working for firms such as Cascade, CPC, and Coast were responsible for creating many of the corporate puppet icons popularized by television, including the Pillsbury Doughboy, the Swiss Miss, the Nestle Chocolate Man, and Speedy Alka-Seltzer, among others. Gene Warren Jr. continued the tradition with his company Fantasy II, which did excellent puppet and stop motion effects work for feature films and television, most notably the robot for the first *Terminator* film, animated by Peter Klienow. Although Ray Harryhausen worked with Pal for a short time, he was a unique paragon in his own right and in the late 1940s single-handedly made remarkable puppet animation films based on fairy tales. Fortunately, these films have been rereleased under the title *Ray Harryhausen: The Early Years Collection* (2005, Sparkhill).

The 1960s and 1970s ushered in an era of fan magazines such as *Famous Monsters of Filmland,* edited by Forrest J Ackerman; *Cinemagic,* edited by Don Dohler; and *FXRH,* edited by Ernest Farino. The latter

magazine was a tribute to the work of Ray Harryhausen. These publications celebrated the art and artisans of stop motion, yielding a fan base who yearned to make stop motion a career. Out of this energetic group came a new generation of animators and artists, most notably Jim Aupperle, Doug Beswick, Ernest Farino, the Chiodo Brothers, and Don Waller. These artists and many others contributed memorable stop motion work in both puppetry and effects during the golden age of visual effects that began with *Star Wars* in 1977. Since that time, studios have embraced stop motion as a technique and have generated amazing work in films such as *Nightmare before Christmas* (1993) and *Coraline* (2009), both directed by Henry Selick. In the independent world, there are many singular artists practicing the craft, such as Corky Quakenbush, who became famous for "Raging Rudolph," the comedic spinoff of the Rankin Bass film that aired on *Mad TV*. Stop motion puppet animation continues to be a popular venue for comedy and is probably best represented by the TV show *Robot Chicken,* where mainstream puppet toys representing actor celebrities are animated and placed in amusing situations. In many cases, shows such as this use live-action references as a guide for animating. For our next exercise, we will animate a puppet swinging a golf club using this technique. The process of using live-action footage as a template for animation and effects is called *rotoscoping.*

Figure 5.2 *Harry Walton animates the Goliath puppet for Art Clokey Productions' Davey and Goliath. Courtesy of Harry Walton, vfxmasters.com.*

Figure 5.3 *Harry Walton animates the famous "Chuckwagon" commercial spot. The horses' legs were done with replacement animation. Courtesy of Harry Walton, vfxmasters.com.*

Figure 5.4 *Walton animates a stop motion dinosaur for the original* Land of the Lost. *Note the surface gauge. Courtesy of Harry Walton, vfxmasters.com.*

Figure 5.5 *A closer view of a* Land of the Lost *puppet. Courtesy of Harry Walton, vfxmasters.com.*

Building a Collage Puppet

There is no need to build an elaborate puppet to practice animation. Blending together found materials to create a fanciful character can be just as effective. A good exercise for animation students is to create a puppet character using found objects. For this exercise, I built a robot designed around an electronic theme. Collage puppets can be made from a variety of materials connected with flexible wire. A short trip to the store and a bit of imagination are all that you need.

Shooting a Reference

One of the hardest things to animate is a human figure. There is much more to a good animated walk than merely moving the legs. The whole body engages in the activity. The arm swings, the head bobs, the knees bend—all in amazing synchronization. In the past, the great animators kept all of these movements in their heads and animated without a safety net. Today we can shoot an actor's performance and use it as an exact guide to animate to. For this exercise, we will shoot a reference of me swinging a golf club. It is good to shoot your figure against a plain background so that you can clearly see the positions.

1. Set up your video camera on a sturdy tripod.
2. Compose the shot.

Figure 5.6 *Collaging items together with flexible aluminium wire and epoxy putty can easily make fun characters.*

Figure 5.7 *You may need to drill holes in some parts to accommodate the wire.*

Figure 5.8 *Two-part epoxy putty is a great binder for connecting the aluminum wire to the various parts.*

3. Press the Record button, and have your actor swing the club.
4. Press Stop Record. You now have a live-action reference.

At this point, you are now ready to take the digital signal recorded on the tape or drive and capture it into the computer using a variety of programs such as Windows Movie Maker or Sony Vegas. These are the steps for Windows Movie Maker.

Connect the digital video out to the digital video input on your computer, and turn on the camera. Follow the steps in Figures 5.10–5.15.

Setting up for Rotoscoping

Place your puppet on a stage with lights and camera. For this exercise, the lightweight puppet was attached to the floor using Earthquake putty. Open Stop Motion Pro and create a New Production: "Golf shot: Swing Tk 1." Select your capture type, and you are ready to set up the Rotoscope tool.

It is important to note that because the live action was captured at 29.97 frames per second, your matching animation will also be at that rate, even if you shoot at 12 frames per

Figure 5.9 *A fun robot puppet made in minutes.*

Figure 5.10 *The computer will sense that you want to capture video. Choose Windows Movie Maker.*

Figure 5.11 *Windows Movie Maker will open with a Video Capture Wizard that will prompt you to enter a filename. Enter "Golf Swing."*

Figure 5.12 *The box will also ask you to choose a place for your captured video. The default option should be My Videos. Use the default or choose another location to store your video, and hit Next.*

Figure 5.13 *Another window will appear that will ask you to choose the quality of your video setting. Because this footage will only be used for a reference, you can use the default setting called Digital Device Format (DV-AVI), and click Next.*

Figure 5.14 *The Capture Method window pops up. Choose Capture parts of the tape manually.*

Figure 5.15 *You will now see a preview window that will show you the image as the tape plays back. Play back the tape by hitting play on the camera at a point just before you want to capture. At the appropriate time just before the actor's performance, press Start Capture. After the actor has swung the club, press Stop Capture. After you have captured the video, press Finish. The video will now appear on the Windows Movie Maker play window. The most important thing is that the video has now been converted to an AVI file and has been stored in My Videos where you can access the reference in Stop Motion Pro.*

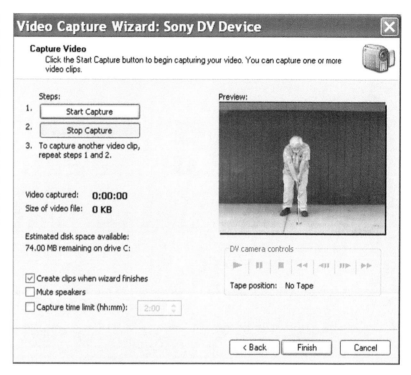

Figure 5.16 *Go to Tools, Rotoscope. The My Videos folder will appear. Open the Golf Swing reference.*

Figure 5.17 *The Rotoscope window now opens, which allows you to play the footage as you animate. When you press the Sync button, the live-action footage will be locked frame by frame with your animation and advance as you take the pictures. Press Sync and move the Rotoscope Opacity slider to the right.*

second. To speed up the animation process, you would have to speed up the live action by skipping out frames to obtain a time base of 12 frames per second. This can be done by speeding up the motion in an editing program. Another idea is to use the Muybridge sequences for reference, as they have far fewer frames. The Rotoscope function is a terrific tool for animating complex movements. Follow the steps in Figures 5.16–5.21.

Adding 2D Animation with the Paint Tool

Puppet films often have need of simple 2D graphic elements to represent snow, rain, fire, and so on. One traditional yet painstaking way of doing this was to set up an easel in front of the puppet stage and shoot through animation cels that had snow or explosion effects. Postproduction compositing was usually the best choice for adding these effects. Stop Motion Pro has a terrific paint tool that allows you to draw on top of your image to create similar effects on the fly. It is always a good idea to save your raw animation and draw on top of a duplicate sequence. If you want to modify your 2D animation, you can always go back to the raw animation. Here's how to do an explosion.

Figure 5.18 *You can now see the live-action image on top of your animation puppet. This will enable you to position your puppet to match the human figure. The thin wire limbs of the robot puppet make the positioning easy.*

Figure 5.19 *After you shoot a frame, the live action will advance to the next frame and your puppet will need to be repositioned to match.*

Figure 5.20 *Position the puppet for the next frame. Sometimes it may be hard to get an exact match because the figures are so different. The important elements are the head and the club position. If you can match those elements, the rest of the limbs will generally follow along nicely.*

Figure 5.21 *After you have finished animating, you can press the Play button to see your work. The ghost image will disappear, and your puppet will move exactly like your actor.*

Shoot the Animation

In this example, Stinky Fenton eyeballs a cake with a suspicious-looking "candle." Nip away at the fuse frame by frame to animate it. At the explosion frame, substitute a blown-apart firework and shine a bright light into the shot to create interactive lighting. For the last frame, doctor the figure and set to show the aftermath. Follow steps shown in Figures 5.23–5.30.

The Pillsbury Doughboy

The Pillsbury campaign was the bread-and-butter work for the small handful of stop motion shops in the 1960s and 1970s. When I entered the field, I was fortunate to have been invited by effects artist Harry Walton to stop by the

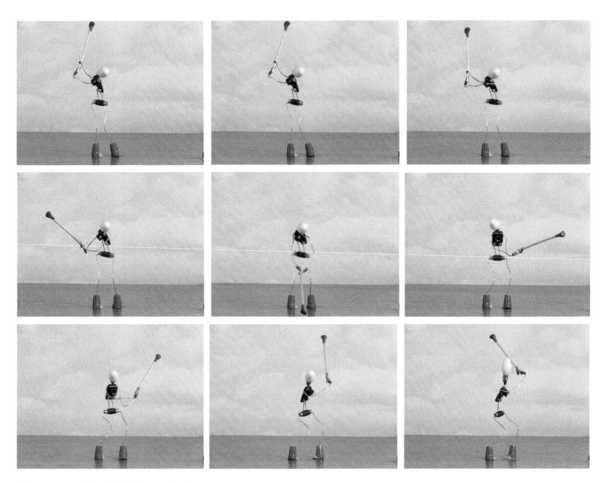

Figure 5.22 *The Golf Swing animation.*

CPC studio in Hollywood to see how these classic commercials were executed. Harry was one of my early mentors in the business who was always willing to share a tip or two and give encouragement to a young person starting out. He continues to share today, as seen by these wonderful images from his archive that he generously allowed me to use throughout this book.

Here are some of my recollections of a visit to a Doughboy stage in the 1970s. The puppet was a very small figure, about 6 inches in height with a ball-and-socket armature and a cast foam rubber body. His head was one of a series of wax heads used to make him speak. A master rubber mold was made of a mouthless face, and a number of white wax copies were made from this mold. Each wax head contained a small square metal hole that would fit over a square post in the armature, ensuring exact registration. The artists used heated dental tools to carve mouth shapes into the blank heads in order to create replacement heads for the voice. The chef's hat was a single model that was also pegged into each of the heads. As much as possible, the animators limited the replacement aspect to avoid accidental stuttering of the form as a result of imperfections

Figure 5.23 *Animate the fuse being eaten away by snipping it shorter frame by frame.*

Figure 5.24 *Shoot the blown-apart bomb, and create interactive lighting.*

Figure 5.26 *Go to Tools, Frame Painter.*

Figure 5.25 *Shoot the aftermath.*

Figure 5.27 *Open the Colour and Size panel, and choose the whitest white and a radius of 2, feather of 10, and opacity of 100. If you have a high-resolution image, you may want to increase the radius and feather settings.*

Figure 5.28 *Paint in the flame of the fuse using erratic brushstrokes. You don't have to be perfectly matched frame for frame. It is a flame after all. When you finish a frame, click the Next button. Select Save Changes.*

Figure 5.29 *When you get to the explosion, feel free to vary the brush size and feather to paint in the burst. If you open the Actions panel, you will see that you have a convenient Onion Skinning tool that will enable you to view your previous frame atop the current one. Continue to animate the explosion until you white out the frame.*

Figure 5.30 *A simple explosion sequence using the Stop Motion Pro frame-painting tool. A typical explosion sequence might be two frames before white out, and then you might use After Effects to do a quick 8- to 12-frame fadeout of the white to reveal the aftermath. You can also use After Effects to composite smoke on top of the figure. Stinky Fenton character, © Mark Sawicki.*

in the casting process; hence the same hat was used each time a new head was replaced on the single body. The blue pupils were sticky round paper that were affixed to the wax head and manipulated. The hand poking the Doughboy was (on occasion) a real hand that was mounted in place and held steady and animated along with the puppet, and in other cases a pointing hand was plunged into a bucket of dentist's alginate (the mold making-substance used for teeth) in order to make a mold. After the mold gelled, the hand was gently released, and plaster of paris was used to make a perfect hand model that could be animated for the "poke." Each time I visited, I made sure to poke the little fellow myself just to be able to say I did. Clever stabilization techniques were used for the kitchen props. For a pile of almonds, for example, the studio merely took a bunch of real almonds (nothing beats real) and pressed them into a lump of clay to make a stable pyramid of almonds that would otherwise be precarious. Many of the composites of the Doughboy interacting with people were done using front light back light techniques similar to those outlined in Chapter 11.

Small animation shops like CPC were divided into several areas, typically a machine shop, a wood working area, sculpting and mold-making areas, offices, and a stage. There was a marvelous sense of organized chaos in these small studios. The brightly lit perfect miniature set was surrounded in the darkness by a curious collection of puppets, molds, dollhouses, old lighting fixtures, raw materials, paint, and bric-a-brac. An old joke states: "You knew the lighting was done when there was no room left on the setup for the animator." These humble little shops gave life to the Doughboy and became the breeding ground for the pioneering artists who helped build the huge effects industry we know today.

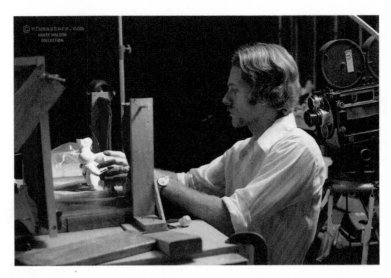

Figure 5.31 *Harry Walton, animating the Doughboy. Courtesy of Harry Walton, vfxmasters.com.*

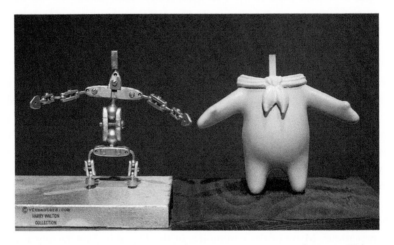

Figure 5.32 *The Doughboy and his armature. Courtesy of Harry Walton, vfxmasters.com.*

Summary

1. Puppet animation has many roots from Eastern European artists.
2. Ladislaw Starewicz (aka Ladislaw Starewitch) was a natural scientist from Russia who became one of the earliest practitioners of stop motion puppetry.
3. Jiri Trnka was a Czechoslovakian filmmaker who had many hidden political messages in the puppet films he made under Soviet rule.

4. Tadahito Mochinaga was the famed Japanese puppet animator who was responsible for the work on the world-famous Rankin and Bass holiday TV special *Rudolph the Red-Nosed Reindeer.*

5. George Pal paved the way for many puppet animators who made their mark in television commercials bringing to life corporate icons such as the Pillsbury Doughboy.

6. The simplest puppets to utilize for stop motion are collage puppets composed of parts interconnected with flexible wire.

7. Rotoscoping is the term used for any type of photographic or video reference for creating artwork for animation or visual effects. For Stop Motion Pro, it is often used as a reference of a human actor making complex moves to speed up the process of animation.

8. The paint tool can be used to add 2D animation to your scene.

Films to See

• *Rudolph the Red-Nosed Reindeer* 1964, Rankin Bass.

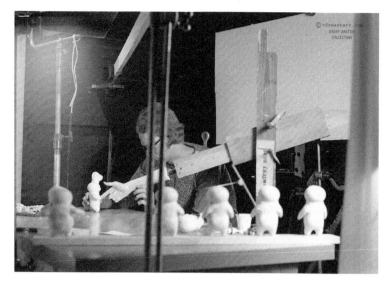

Figure 5.33 *Harry animates the finger poke with replacement Doughboys to facilitate the indentation of the belly. Courtesy of Harry Walton, vfxmasters.com.*

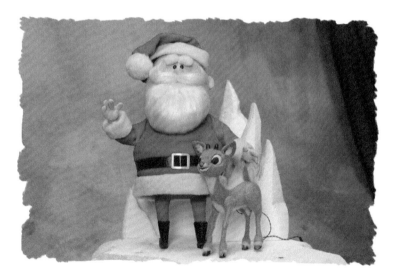

Figure 5.34 Rudolph the Red-Nosed Reindeer. *Courtesy of the Rick Goldschmidt archives, www.rankinbass.com*

Chapter 6
Animate Clay

History

Clay animation has been around for as long as cinema. Stuart Blackton used clay in *The Adventures of Dollie and Jim* in 1910, and Willis O'Brien animated clay boxers over wooden armatures in 1914. O'Brien gradually refined his methods by turning to rubber puppets and metal armatures. There will be more about O'Brien and his special contributions to the art in the next chapter. Puppet animators often abandoned clay as a medium, as they often had to resculpt the pliant clay after each move. Fortunately, this limitation did not prevent other artists from refining this specialized art, much to the joy of audiences around the world.

Art Clokey

Art Clokey was a cinema student at the University of Southern California and a protégé of his professor Slavko Vorkapich. Vorkapich was famous for the refinement of the montage sequence in films where narrative is condensed through a series of camera shots and editorial techniques. Clokey was inspired by his professor to make the short film *Gumbasia* in 1955, which utilized clay as a graphic medium of colors and shapes moving in time instead of representative figurative art. *Gumbasia* successfully opened the door for Clokey to create a short 15-minute film for the *Howdy Doody* show on American television that introduced the clay character Gumby. Soon after, Clokey was signed to create a 233-episode series, *The Adventures of Gumby*, which made the character world famous.

Will Vinton

The period of the 1960s and 1970s was great for experimental animation using all sorts of nontraditional mediums. Clay alone was used for the art film *Clay* in 1966 by Eliot Noyes Jr., which was nominated for an Oscar in that year. In 1974, the Oscar was awarded to Will Vinton and Bob Gardiner for the clay animation short *Closed Mondays*. The success of this film launched the spectacular career of Vinton and the development

of Vinton's clay animation technique, which he subsequently trademarked "Claymation." Claymation stands out from traditional clay animation primarily because of the tremendous attention to detail that Vinton's Portland Oregon studio demonstrated. After his Oscar win, Vinton went on to produce a number of Claymation shorts such as *Martin the Cobbler, Rip Van Winkle,* and others culminating in the all-clay feature film *The Adventures of Mark Twain* (1986). The films are remarkable, as the studio spent an amazing amount of effort to painstakingly resculpt the figures for each frame to not only make the movement as smooth as possible but also eliminate the inevitable fingerprints on the clay that one sees with traditional clay animation. Vinton went on to other stop motion work for television with the TV series *The P.J.s* and the ever-popular "California Raisins" television commercials. To learn more about Vinton and his marvelous Claymation creations, go to willvinton.net.

Peter Lord, David Sproxton, and Nick Park

In Britain, Peter Lord and David Sproxton formed the Aardman studio in 1976. Aardman's first big break came with creating animation for the children's TV series *Vision On* using a clay character called Morph. As time went on, the studio grew and began working on a series for Britain's Channel 4 called *Lip Synch*. By that time director Nick Park had joined the studio and directed Aardman's first Oscar-winning short *Creature Comforts* in 1989. This film recorded casual conversations of everyday members of the British public and then animated clay zoo animals to mouth and perform the speeches. The idea was similar to that used for the Oscar-winning short by John Hubley (creator of Mr. Magoo) in his film *Moonbird* (1959) where he audio-taped his children at play and animated to their imaginative conversation. The emotive power of the Aardman animators was unparalleled. During the same year, as in *Creature Comforts* Park utilized the amazing talents of the Aardman personnel to create the *Wallace and Gromit* clay animation series beloved the world over. Aardman went on to produce the spectacular *Chicken Run* in 2000 and introduce Wallace and Gromit to the feature film world with *Curse of the Were Rabbit* in 2005. Unlike Vinton's technique of making the entire world out of clay, the Aardman studio integrates clay and other materials to create magical worlds populated with lovable characters.

The developers of Stop Motion Pro consulted with Aardman and other studios on effective working strategies for animators. Many of the tools developed for Stop Motion Pro were created based on input from

world-class studios. In fact, the Aardman studio makes use of the professional version of Stop Motion Pro for all its television work. For this chapter, we'll examine how you can use clay to create and animate your own characters.

Clay

There are many different kinds of clay on the market, and some lend themselves to clay animation much better than others. Ceramic clay has been used for centuries as an excellent medium for making figurines and pots. It falls far short of the requirements for clay animation for several reasons. For one, it is only plastic and pliable when the mixture of water to clay is just right. You

Figure 6.2 *A scene from the Academy Award–winning short* Closed Mondays *by Will Vinton. Courtesy of Will Vinton, www.willvinton.net.*

can animate with it while it is in this state, but it will quickly dry out and crumble if you work with it under air and lights for too long. As it dries, it also creates a tremendous dust problem that leads to messy surfaces and jumpy dirt piles in finished animation. The other problem is that ceramic clay does not come in colors.

Roma Plastilina

This is a formulation of clay that is designed to be permanently pliable. Instead of water being added to the clay, mineral oil is used so that the clay never dries out and is consistently pliable over time. This formula is well over 100 years old, fashioned on the Gudicci Italian modeling clay of the late 1800s. Roma Plastilina is a Sculpture House brand started in 1946, and professional sculptors have used it for years to make prototypes for plaster molds. The clay comes in several hardness grades from very soft to a hard carvable wax-like grade. The drawbacks to this clay for animation use is that it only comes in gray-green and white and the oil tends to "weep" out of the clay if it sits too long under hot lights. Another side issue is that the clay contains sulfur, which makes it incompatible with rubber mold materials unless a sealant is used. Nonetheless, it is an excellent medium and can be found at www.sculpturehouse.com.

Van Aken Claytoon Clay

A good clay to use for clay animation is Plastalina clay, manufactured by the Van Aken company. This clay comes in a wide range of colors and has excellent pliability. The formulation of wax and clay makes this product very clean and less susceptible to weeping and stickiness that other toy modeling clays are subject to. The clay does not affect rubber-molding materials and is easily melted in a double boiler to create molten

clay that can be poured into molds. This is the same clay that has been used in the Will Vinton studio. This clay is featured at www.vanaken.com.

Polymer Clay

In the mid-1960s, a formerly shelved insulation product manufactured by the Zenith Corporation was discovered to be an excellent sculpting medium and started to be marketed in 1967 by the Polymer Products Company. We now enjoy this remarkable clay in arts and crafts stores all over the world under the brand name of Sculpey. The great thing about polymer clay is that it remains permanently pliable like Plasticine with the advantage that you can bake it until it becomes hard with nothing more than a home oven at around 275 degrees. After baking, it can be sanded, drilled, cut, shaped, and painted with a variety of mediums such as acrylic. The Sculpey product line comes in a variety of styles and colors:

1. Sculpey III has a wide range of colors and bakes to a semihardness.
2. Premo Sculpey is the company's premier brand that comes in an assortment of colors and is quite hard after baking.
3. Super Sculpey is exceptional professional clay used by the major studios. It comes in beige and bakes to a workable hardness.
4. Sculpey Flex is clay that lends itself perfectly to animation as it bakes to a flexible state like rubber. The advantage is that the clay will not distort because of compression during the process of animation.

You can find Sculpey at your local arts and crafts store or at www.sculpey.com.

For my own personal work, I find that the blending of different clays is the key to painless clay animation. For each shot I find that the combination of Plasticine or unbaked polymer, baked polymer, and flexible polymer makes animation much easier. Here is a breakdown of how you would combine different clays for a figure:

1. Use Premo for making props such as cups, vases, or knives. I also use it to make hard eyeball spheres that can be manipulated in a soft clay face. Premo is also good for teeth.
2. Use unbaked Premo or Van Aken Claytoon clay for anything you need to freely distort such as a melting body or the face. I find that small hands made from these clays without the use of an armature can be subtly manipulated without the distortion problems associated with moving a stiff armature supporting soft clay. If the hand is small enough, the fingers and hand will stand up to gravity all by themselves and can be gently moved without much force.

Figure 6.3 *Good clays for animation are the Van Aken Plastalina clay and polyform products Sculpey 3, Sculpey Flex Bake, and Bend and Premo polymer clays.*

Figure 6.4 *To make eyes, roll two balls of white Premo clay on a smooth surface. This same clay can be used for hard teeth.*

Figure 6.5 *Dots of colored Premo clay on top of the white balls are used to make the iris. Roll again to flatten.*

Figure 6.6 *Poke a hole in the center of the iris for the pupil and bake the eyeballs at 130° (275°F) for 15 minutes.*

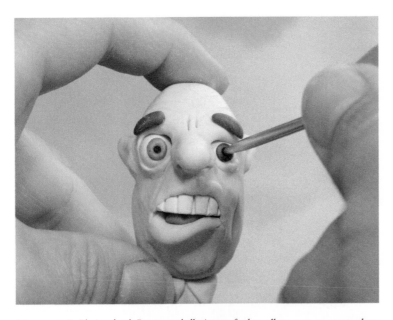

Figure 6.7 *Placing hard Premo eyeballs into soft clay allows you to create clever animation without accidentally blending two colors of soft clay into one another during the animation process. Note how the hole for the iris allows you to easily animate the eyeballs with a poker tool.*

3. Use Sculpey Flex for limbs that will move often and that utilize an armature. Because Sculpey Flex stays rubbery after baking, it will not distort or leave fingerprints when you use the force necessary to move the limb with an armature inside of it.

Clay without Armatures

An armature is the flexible skeleton inside an animation figure. You were essentially animating an armature when you manipulated the robot model in the previous chapter. When animating clay, it is best to avoid an armature if possible to get the best out of the medium. The force required to move a stiff armature embedded in the clay will cause you to distort the limb, requiring a resculpt of the figure. If the character is small enough, Plasticine clay can be self-supporting and the limbs moved with gentle pressure that won't distort the form. A good scheme is to support the torso of the figure with a rig such as the one used for our flying truck to allow the legs, arms, and fingers to be pure clay. If you are not fighting an armature, you can obtain some wonderfully fluid movement and are free to squash and stretch the character. The no-armature method works well for figures that are 4 to 5 inches in height, designs that don't require legs, or

nonrepresentational graphic projects. If your figures are larger than 5 inches, you will have to make an armature, as the clay will not support itself. It is best to first experiment with clay animation using clay by itself

Figure 6.8 *The problem with clay and armatures is clay distortions. Using bake-and-bend clay for frequently moved limbs can remedy this issue.*

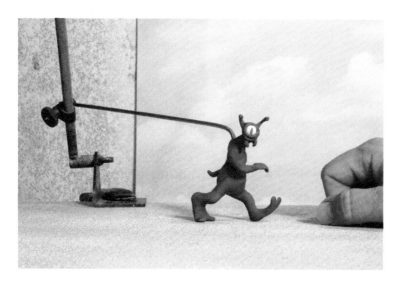

Figure 6.9 *If you can avoid armatures by using pure clay and torso supports, the animation will progress faster as you will not need to resculpt as often. "Glorp" character, © 2009. Mark Sawicki.*

and not worry about smoothing out fingerprints or making the medium look like something else. Animating clay should be loose, easy, and fun.

Clay with Armatures

Beginners just starting out in stop motion animation may be under the impression that armatures need to be the sophisticated ball-and-socket metal marvels that they have seen used in big-budget movies. Although these armatures are terrific, they are not the only solution to the problem. An excellent method of making armatures can be found in Susannah Shaw's book *Stop Motion, Craft Skills for Model Animation* (Focal Press, 2004), on page 53. As Shaw mentions, aluminum wire is best to use for animation. I obtain my wire from local arts and crafts stores in the United States under the brand name Almaloy. It can also be purchased over the Internet from www.sculpturehouse.com. It is a good idea to braid the wire to add strength and jacket parts of it with tubing to delineate the different bone structures.

For a clay animation armature, it may be useful to vary the strength of the skeleton to limit the clay distortion problem. For example, you could braid two wires together for the leg and spine armature because the legs and back have to support the heavier load of the body. For the arms, you might switch to a single wire, as it will take much less force to move and create less distortion in the arms. For the hands and delicate fingers, I avoid any type of armature at all and rely on the cohesive quality of the clay to support itself to allow for fluid and effortless animation. As with the robot model of the

Figure 6.10 *Braiding aluminum wire is a simple matter of using pliers and a knitting needle.*

Figure 6.11 *The aluminum tubing can easily be cut with a motorized Dremel tool (be sure to wear eye protection). The braided wire and cap nuts for the feet can be attached with epoxy putty such as Hercules Propoxy 20. This same putty can be used to build up the chest, head, and pelvis sections of the armature.*

previous chapter, I use epoxy putty to bond the armature wire together. Another good epoxy is called Propoxy 20, which is manufactured by Hercules. It comes as a tube of epoxy with a center of hardener. All you need do is tear off a bit of the two materials, knead them together to form a blended color, and apply it as a putty to your armature parts and wire; within a few minutes, the putty will be hard as nails and hold the armature together beautifully. This type of putty can be easily found at your local hardware store or on the Internet.

If you would like to see a step-by-step procedure for creating an armatured clay animation puppet along with animation, I have made a DVD titled *How to Create and Animate a Clay Puppet*, available from www.filmingthefantastic.com for individuals or www.firstlightmedia.com for schools.

Making a Greeting E-Card Using Clay Animation

In this first exercise, you will animate clay all by itself without benefit of armatures or support. This simple and fun exercise is great for children who may want to create a holiday card for the Internet and record their own greeting. This freestyle animation is the closest one gets to creative sketching with pencil and paper. This project will also demonstrate "destructive

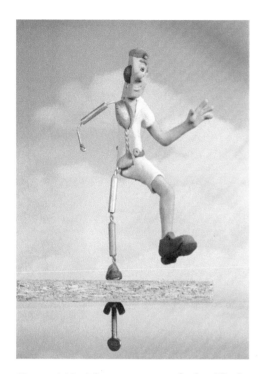

Figure 6.12 *A low-stress armature for clay. The feet have a screw hole that enables you to bolt the figure from underneath. Metal tubes around the wire create the stiff bone sections. A single wire is used for the lighter-weight arms, and no wire is used for the delicate fingers.*

Figure 6.13 *Pointing a light at the ceiling is a simple way of getting soft, shadowless light.*

animation," where you will plan to work in reverse. For this e-card, we'll have a ball roll in and transform into the words "Hi Gramma." That's kid slang for grandmother.

The Camera and Lighting Setup

Once again you will use a web cam simply mounted to a flexible metal bookend with tape. To get a nice, soft ambient light, you can point a desk lamp at the ceiling to get a soft shadowless light. Set everything to manual as you did before, and set the frame rate to 5 frames per second if you are working with a young child or 12 frames per second if you would like a smoother appearance to the movement. For this example, we will shoot at 12 frames per second.

Make the Finished Art

While looking at the video feed, use clay to spell out the words "Hi Gramma!" in front of the camera. Make sure that the table is a true worktable that doesn't have a sensitive finish. Clay may leave marks that are hard

to clean off or will damage some surfaces. If you are unsure, test a small area or C-clamp a plastic or disposable surface on top of the table to use as a work area.

Thinking in Reverse

The goal for this project is to have a ball roll in and form the words "Hi Gramma." If we shot in a forward direction, you would quickly find that when you start forming all the letters to make up the words you wind up with a fairly daunting sculpting task right in the middle of your animation. Not only would this be difficult and time consuming, but it would break your stride as an animator. It is helpful to take the least amount of time you can during the reposition process, as it prevents you from forgetting where you were and what you were about to do.

In your mind's eye, picture the animation you envision. In this case I imagine a ball rolling in from the left and forming the words that hold for perhaps 1 second. So start off by shooting 12 static frames of the words "Hi Gramma." Then start curling the letters inward from the top and bottom. Shoot a picture. Now continue the rolling motion a bit farther and take a picture. For this motion you can either play it by ear and not be too concerned about exact timing or you can make a determination that you want to go from words to ball in 1 second, in which case you mentally break down your letter-rolling positions into 12 separate units. Continue shooting and rolling the clay letters until they all squish together to form the ball. Once you have the ball, slowly roll it a bit to the left. Keep animating the rolling ball until it exits the frame.

Figure 6.14 *Make a simple phrase with tubes of clay.*

Figure 6.15 *Curl the letters forward.*

Figure 6.16 *Keep squishing the letters into a ball.*

Figure 6.17 *Animate the ball rolling off the screen.*

Figure 6.18 *Press the Editor button. You will now see all the frames you shot. Click on the first frame (the frame will get a red border). Hold down the shift key and click on the last frame (all the frames will get red borders).*

Figure 6.19 *In the Actions window, select "Reverse order of selected frames," and click Apply.*

Reverse the Animation Using the Editor

Now when you play the animation, the ball will roll in from the left and magically morph into the words "Hi Gramma."

Record a Greeting

For this function, you will use the same microphone you used for the talking puppet head. In this case we will be recording the sound after we do the animation. On the main screen, select Tools and Audio Record.

1. Choose the audio device and input you are using.
2. Plug in your microphone and begin speaking into it while viewing the record level window. You may have to move the slider all the way up to see anything. If you see no activity, switch to another input until you see the level.
3. Once you have detected the microphone (in this case it was Line in), move the slider until you achieve a healthy level. By this I mean bars, not slamming to the top of the box, which would cause distortion or bars barely moving at all.
4. For the format, you can make any number of selections from the highest quality 48 kHz Stereo, 16 bits down to 8 kHz Mono, 8 bits.
5. Click on the box Play Stored frames while recording and playing. (The Start Playing window will light up. Leave it at frame 1.)
6. Get ready to record your dialogue. Press Recording Start by pressing the red arrow button.
7. The animation will play back as you are recording. When appropriate, say, "Hi Gramma!" and then press the recording arrow again to stop the recording.
8. Check the recording by pressing the Play arrow button. If you don't like your recording, all you need do is press the Record button again and the prompt will appear, making sure you want to record over what you've done. Select Yes and record until you are satisfied.
9. Click on the Save button and save your recording in an appropriate place (where you can find it) as a WAV file.
10. After saving the prompt comes up asking if you want to copy the recording into the audio sync tool. Select Yes.
11. The window now switches to the Audio Sync window and automatically links your recording to the animation. If you press Play on the main control panel, you will see your animation and hear the sound together.

Figure 6.20 *The animation sequence is now reversed. You can also hide any error frames such as this hand in the shot. Close the Editor.*

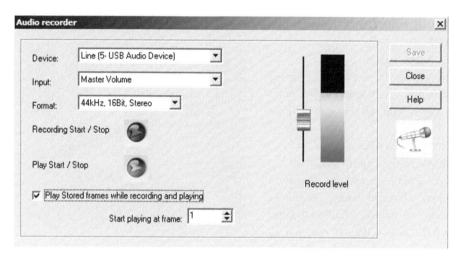

Figure 6.21 *The audio record to playback tool.*

Figure 6.22 *Any number of headsets and microphones can be used to record the sound. The animator and voice for this exercise was Francheska Balarezo. In a few years, she plans to become an actress.*

A word on the sound format selections. The first number represents Hz (or Hertz) or the frequency that the sound is recorded in cycles per second; 96,000 Hz means the sound will be recorded using 96,000 cycles per second for very high quality. The lower the Hz, the more tinny or mechanical the sound will be. The next word is Mono for monaural or only one channel of sound as opposed to Stereo, which of course means you have left and right channels for your right and left ears. Finally you have the choice of either 8 bits or 16 bits. These numbers represent the amount of digital storage that is used for the sound data; 16 bits can store more information than 8 bits, so the sound will be better. The higher numbers yield better quality at the cost of storage space. For example, the same phrase recorded at 48,000 Hz, Mono, 8 bits, and 96,000 Hz, Stereo, 16 bits, took up 244 kilobytes (KB) and 2322 KB, respectively.

Make a Movie File for Your E-Card

1. Go to File, Make movie.
2. The window should default to Stored frames, All frames, Use Capture aspect ratio, 12 frames per second. If not, put in those settings.
3. Select Include Audio Sync file.
4. Choose WMV as the export format.
5. The default settings should be Windows Media Video 7, Internet quality, Windows Media Audio 9 Voice, Audio Quality 8 kbps, 8 kHz mon CBR. If not, put in those settings.
6. Click OK.
7. Save the file in an appropriate place. Stop Motion Pro will now make a WMV file with sound and picture that you can e-mail to your friends.

A word about video formats. In the Make Movie window, you have a choice between AVI uncompressed and WMV. We chose WMV because it compresses the video information into a small enough size that you can comfortably send and play it back over the Internet. When you do this, there is a slight loss in quality because you are compressing the picture. The uncompressed AVI leaves the image at its original quality so that you can use it in editing programs for more sophisticated projects.

Make a Puppetoon Worm

When I spoke of Puppetoons, I mentioned how difficult it was to create replacement figures out of wood. Clay gives us a unique opportunity to create a replacement series fairly quickly. For this exercise you will need Sculpey Premo and a mold-making material called Amazing Mold Putty. The first thing we'll do is sculpt a simple worm out of the Premo clay with segments and all. Bake the worm to cure it. Now blend parts

Figure 6.23 *Sculpt a clay worm out of Premo clay and bake at 130° (275°F) for 20 minutes to cure. A knitting needle is used to sculpt in the furrows.*

Figure 6.24 *Make a mold of your worm using a material such as Amazing Mold Putty (www.amazingmoldputty.com). Blend equal amounts of yellow and white putty together and press over your worm. You will have a cured rubber mold in 25 minutes.*

Figure 6.25 *Push Sculpey polymer clay into the mold to create duplicates.*

Figure 6.26 *Bend the soft clay copies to create a replacement animation series and then bake at 130° (275°F) for 20 minutes.*

A and B of the Amazing Mold Putty until you obtain an even color and press it on top of your worm. After a few minutes you will have a durable rubber mold. After the mold cures, remove the original. Take more Premo clay and press it into the mold and make six identical worm casts. Before you bake the casts, you can modify each one to arch a little bit so it goes from a flat worm to a high arch in six positions. After you have done this, you can bake the casts to create your replacement animation cycle.

Animate the Worm

The animation of your replacement worm is easy. All you need do is remember to hand off the anchor points. You can also draw a path using the Stop Motion Pro tools to enable your worm to inch its way anywhere. The flat worm is position 1 and the first arch is position 2. To start, you use the anchor point of the head and replace and shoot positions 1 through 6, keeping the head in the same position. At the high point of the arch, you switch the anchor point to the tail and replace and shoot positions 5 through 1, keeping the tail in the same position to propel the worm forward. Repeat the process. You've just made a Puppetoon!

Squash and Stretch

The beauty of clay is that it gives us the same ability as the drawn cartoon to freely distort the character. Here are some simple procedures to animate a ball transforming into a head to create a freeform exercise. A terrific group project for a class is what is called a *clay jam*. A clay jam is where one artist is assigned to

Figure 6.27 *Begin the rise of the arch using the head as an anchor point.*

Figure 6.28 *For the fall of the arch, replace the figures using the tail as an anchor point.*

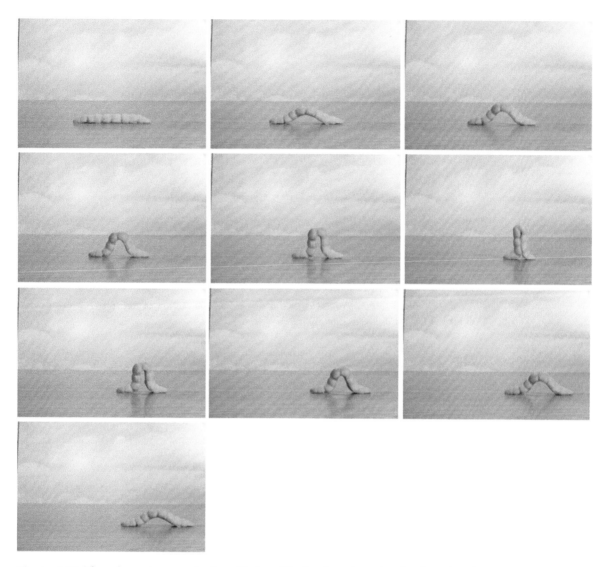

Figure 6.29 *The replacement worm animation with the switch of anchor point to introduce forward motion.*

animate anything he or she wants for a set number of frames, such as 120, and then wherever that artist leaves off, the next artist comes in and works from there. It is a great way to explore improvisational animation.

Summary
1. Clay animation has been used since the beginning of cinema.
2. Art Clokey's Gumby character was the Mickey Mouse of clay animation characters in the 1950s.
3. The term *Claymation* is a registered trademark.
4. Colored Plasticine clay or unbaked polymer clay is an excellent medium for clay animation.

Figure 6.30 *Animate your clay ball rolling in. Use a 12-frame-per-second rate and work out 12 positions so the ball hits the wall in one second. You can use an ease in so the ball hits the wall with force.*

Figure 6.31 *As the ball hits the wall, flatten it out so that is squishes to react to the collision.*

Figure 6.32 *As the ball bounces back, stretch it back to the original shape. Begin to put in a hint of detail for the face.*

Figure 6.33 *Clay can be added and blended into the form to enlarge it. Make the face detail more pronounced.*

Figure 6.34 *Colored clay can be added to introduce hair. Hard eyeballs and teeth can be inserted to bring in those features.*

Figure 6.35 *Transform the shape into a head by gradually adding clay and expression. Be sure to use the space bar often so you can flip between what you just shot and what you are about to shoot. Freestyle clay animation is great fun.*

5. It is easiest to work with clay as a pure form without use of an armature.

6. Whenever possible, figures should be small so the clay can support its own weight, enabling easier animation.

7. When armatures are used for clay, there may be a need to resculpt the figure, as the force used to move the clay will also distort it.

8. Blending hardened clay parts into soft clay is a good strategy for clay animation.

9. Using casting methods, clay can be used to create replacement figures for use in Puppetoon-style animation.

10. Animating in reverse is a good way to create transformation effects using "destructive animation."

Films to See

- *Claymation Classics'* Oscar-winning short *Closed Mondays* along with other Oscar-nominated shorts such as *The Great Cognito.* Volume 1 has a documentary on the Claymation process. The films are available courtesy of Will Vinton (www.willvinton.net).

- *Gumby Dharma* (2006) by Robina Marchesi. This fascinating documentary traces the life and times of Art Clokey, the creator of Gumby (Gumbydharma.com).

- *Wallace and Gromit: Three Amazing Adventures,* available from filmingthefantastic.com and Amazon.com. This compilation has three spectacular examples of Aardman animation: *A Grand Day Out* (1989), *The Wrong Trousers* (1993), and *A Close Shave* (1995).

Figure 6.36 *I wholeheartedly recommend* Claymation Classics, *volumes 1 and 2. Pictured is a scene from "A Christmas Gift." Courtesy of Will Vinton (willvinton.net).*

Chapter 7
Animate Monsters

Willis O'Brien

Willis O'Brien was born in 1886 and is considered the founding genius behind the art of combining stop motion animation with live action to create a specialized visual effects technique that has blossomed into today's computer graphic spectaculars. O'Brien had a colorful past of being, among other things, a cowboy, a trapper, a boxer, and a cartoonist. While working at a decorator shop specializing in marble, O'Brien engaged the assistance of a newsreel photographer and shot a brief animation of a clay dinosaur and caveman modeled over wooden skeletons. This early test was crude, but the unique illusion of life impressed a San Francisco producer enough to invest $5000 in O'Brien to create *The Dinosaur and the Missing Link* in 1915. With this film O'Brien made vast improvements to his technique by creating far sturdier metal jointed skeletons covered with more workable and resilient rubber sheeting. The success of this film and others led O'Brien to be hired by the Edison Company to make animation films in 1916, and he was paid $1 per foot for 16 frames of film.

These early days of motion pictures were a volatile time in the industry, and the Edison Company sold the facility in 1917. O'Brien went on to produce other films independently such as *The Ghost of Slumber Mountain,* another dinosaur film that was a tremendous box office success. By the early 1920s, O'Brien had used his remarkable work and reputation to enter into an agreement with Arthur Conan Doyle himself to depict the classic novel *The Lost World* using stop motion animated dinosaurs. Around this time, O'Brien was introduced to Ralph Hammeras who developed techniques of combining paintings on glass with live-action photography. Together they would create one of the first great fantasy films, combining people with dinosaurs.

The Lost World

In 1923, principal photography began on *The Lost World,* combining the talents of O'Brien and Hammeras. The primary technique was to sandwich a large miniature stage about 6 feet across by 4 feet deep on a sturdy

doi: 10.1016/B978-0-240-81219-9.00007-6

platform 3 feet above the floor. In front of the stage was a large pane of glass where Hammeras painted foreground foliage. Behind the set was a large backdrop with beautifully painted atmospheric effects. The most marked advance in the art came with combining the use of the latent image technique with stop motion animation. During live-action photography, a black card or matte was placed in the area to be taken up by the dinosaurs, effectively preventing exposure in this area of the film. After the photography session, the live-action footage was not sent to the laboratory but instead was held as a latent partial exposure and loaded into the animation camera set to photograph the dinosaurs. Before animation commenced, a counter matte or an opposite black card was placed in front of the camera to prevent reexposure over the live-action footage while allowing the scene of the dinosaurs to show through. If the technical details were executed properly, one would see a convincing composite of live actors cowering in front of apparently huge battling dinosaurs. Needless to say, this new miracle of the screen was the enormous hit of 1925 and laid the groundwork for one of the greatest fantasy films of all time.

King Kong

King Kong (1933) was the *Star Wars* of its day and created the technical foundation for almost all visual effects films to follow. As startling as the composites in *The Lost World* were, the main drawback was the lack of intimate synchronization of the live action and the animation. When the actors were photographed, they pantomimed their reaction to nonexistent dinosaurs. When the animators animated, they were unable to see the actors' performances as reference because the footage was as yet an undeveloped latent image in the camera. As a result, the composites, though brilliant, lacked a sense of intimacy. The use of rear projection was the next big breakthrough that allowed the actors and puppets to truly perform together. For *King Kong,* many of the same techniques of sandwiching models and stages between glass paintings was still used, but this time instead of using latent images the live-action footage was developed and the print was projected onto various rear projection screens hidden within the model (such as a cave entrance) or the model photography was projected behind the actors as they performed and reacted to the footage on the screen behind them. In the case of animation, the live action was advanced a frame at a time in between each reposition of the puppet. The animator could see exactly what the live actor was doing and animate the figure to react accordingly. This technique and marvelous animation made *King Kong* a household word and turned an animation puppet into a movie star.

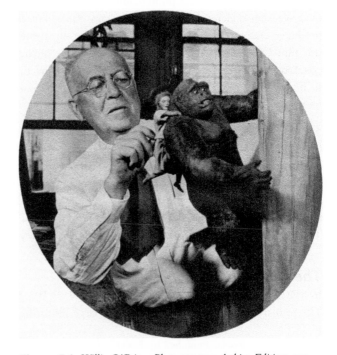

Figure 7.1 *Willis O'Brien. Photo courtesy Archive-Editions.com.*

Ray Harryhausen

Ray Harryhausen was born in 1920 and saw the film *King Kong* at the impressionable age of 13. From that point on, a lifelong ambition and career were born to one of the great classic animators of the 20th century. Harryhausen was so mesmerized by the film that he studied it endlessly and set about his own research and experimentation in the art. This eventually led to him to work with O'Brien on *Mighty Joe Young* in 1949. Harryhausen had finally got to collaborate alongside his mentor and animated some of the most heartfelt scenes of the film, breathing life into a stop motion gorilla. The alliance was short lived as O'Brien had difficulty launching new projects and Harryhausen had to strike out on his own in a new world of frugal independent film budgets. Harryhausen was a multitalented animator who worked alone and did almost all of the work himself. This proved daunting if he attempted to adopt the same large glass paintings used by O'Brien in his work. Harryhausen had to devise a system that was economical in time and expense in order to compete in the low-budget world. He created a system that was to become the foundation for stop motion film compositing.

Dynamation

Because Harryhausen needed to work in small spaces and large glass matte paintings were far too unwieldy and expensive, he found a way to utilize a variation of O'Brien's methods to streamline the animation process. In Harryhausen's method, dubbed Dynamation, he would go to the live-action set and shoot the live action without the use of any mattes in front of the lens. He locked off the camera and kept a well-thought-out plan in mind of where the matte would be introduced later to incorporate his fantasy creatures. The film was processed and a special low-contrast print was made and put into a stop action projector that (as with *King Kong* and *Mighty Joe Young*) could hold a frame of movie film in the projector for long periods of time like a slide projector. The live action was projected onto a rear projection screen that had the stop motion model positioned on a stage in front of the screen. The animation camera could then shoot both the model and the live action simultaneously. The print was made at a low contrast to compensate for the fact that a print always gained contrast when rephotographed. As with *King Kong,* the beauty of this procedure is that the model and live action could be seen simultaneously and the animator could match the lighting of the model to the live action by simply matching the quality of light and shadow direction. The problem, of course, is how to hide the animation stage without a time-consuming matte painting. The solution was to combine the latent technique with rear projection. A glass was positioned in front of the camera and a black matte was painted to artistically block out the platform that the model was supported on. Harryhausen animated the creature frame by frame, advancing the projector and posing his creature to react with the live action appropriately. What the camera saw was the creature in front of the live action with a large black matte obscuring the platform. At the end of the animation phase, the model and its platform were removed, the film projector and camera were wound back to the start, and a counter matte was placed in front of the lens. At this point, Harryhausen merely rephotographed the part of the live action that was previously obscured, effectively eliminating the puppet platform and making it seem like the creature was standing within the live action scene. Harryhausen had effectively created what is known as a *reality sandwich.* Harryhausen's Dynamation technique and his spectacular creations brought to life classic fantasy films enjoyed by generations of audiences, films such as *7th Voyage of Sinbad, Mysterious Island, Jason and the Argonauts,* and a host of others. All of the great visual effects artists to follow studied Harryhausen's films endlessly as Harryhausen had done with *King Kong*. These artists went on to form another generation of visual effects animators who created

Figure 7.2 *Ray Harryhausen animating the Roc for the* 7th Voyage of Sinbad. *Photo courtesy Archive-Editions.com.*

Figure 7.3 *A Dynamation shot from* 7th Voyage of Sinbad. *Photo courtesy Archive-Editions.com.*

marvels for the *Star Wars* films and the blockbusters to follow.

The Third Generation

Jim Danforth was a young animation enthusiast who actually made a rare visit to Harryhausen while he was working on *7th Voyage of Sinbad*. This visit so inspired the young Danforth that he went on to practice the art with a technical sophistication unmatched at the time. David Allen was another gifted fan who turned professional after seeing Harryhausen's remarkable work. Danforth, Allen, and others such as Dennis Muren and Randall Cook would work together and alone to strive to re-create the types of films Harryhausen and his brilliant producer Charles Schneer had created. Some of their more notable accomplishments of this period were *7 Faces of Doctor Lao, Wonderful World of the Brothers Grimm, When Dinosaurs Ruled the Earth, The Crater Lake Monster, Q,* and *Caveman* starring Ringo Starr. Many of these films adopted the technique of Dynamation and are excellent examples of the art. Making fantasy films of this nature during the 1960s and 1970s was exceedingly difficult, as producers were unwilling to accommodate the long production schedules inherent in these types of animation films until *Star Wars* became a huge hit.

Phil Tippet

Phil Tippet was one of the third generation of stop motion artists who was responsible for the

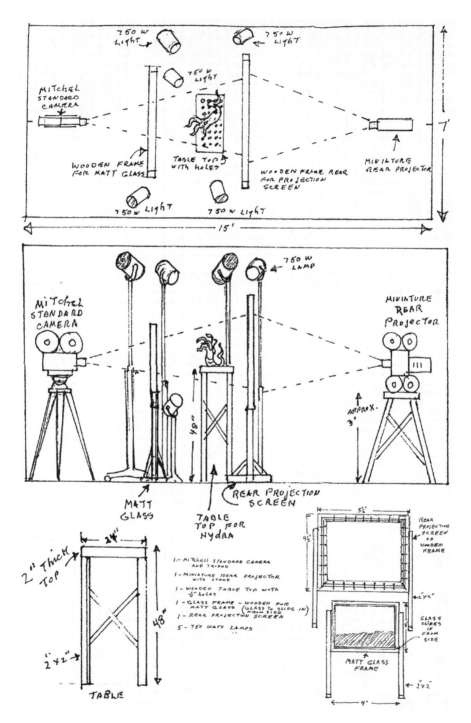

Figure 7.4 *Harryhausen's diagram of his Dynamation process. Photo courtesy Archive-Editions.com.*

Figure 7.5 *From left to right, the author and Ernest Farino discussing an animation sequence for the film* The Strangeness *(1985). Courtesy of Chris Huntley, thestrangeness.net and coderedddvd.com.*

Figure 7.6 *Jim Aupperle sets up a Dynamation shot for his film* Planet of Dinosaurs *(1978). Aupperle is using a two-screen front projection process that is similar to the exercise we will be doing with green screen. Farino, Aupperle, and I were the fourth generation of stop motion artists who found careers in the effects field because of the tremendous success of the* Star Wars *films. Photo courtesy of Jim Aupperle.*

animated creatures of the holographic chess game in the first *Star Wars* film. The tremendous success of *Star Wars* allowed Tippet to join the illustrious crew of ILM and raise the bar yet again for the stop motion art. The Industrial Light and Magic (ILM) facility built upon the work of Harryhausen and through the use of large teams of animators and technicians created an enormous number of memorable fantasy creatures for classic films. Harrison Ford riding the Ton Ton, the large walking tanks in the snow battle of the *Star Wars* sequel, and many others. The traditional art came to a high point in the film *Dragonslayer*.

Go Motion

One of the main techniques utilized for many years by ILM was the use of computer-controlled cameras dubbed *motion control*. The idea that you could move a camera and repeat its movement exactly smashed the limitation of latent image technique, which was that all elements had to be locked off, as you couldn't synchronize camera movement. Motion control changed all that and allowed the camera to identically repeat matte passes and element passes to combine later to create startling dynamic composites. The tremendous advantage a repeating camera also gave was the ability to reproduce blur in a moving object.

When shooting stop motion animation, you always obtain a perfectly sharp frame with no blur. Although

this effect is fine for most things such as puppet animation, it becomes problematic when you directly composite animation over blurring live action. For some subjects it can be magical, as with Harryhausen's skeleton fight with Jason in *Jason and the Argonauts*. The sharp-edged appearance gave the skeletons an unearthly weird look that heightened the fantasy. ILM, being perfectionistic, began experimenting with moving the puppet's limbs during the stop frame exposure through the use of motion control. This generated an overall blur to the creatures that greatly enhanced their realism. This technique was dubbed *go motion* and was introduced in the groundbreaking film *Dragonslayer*. The introduction of the dragon utilizing this technique left audiences aghast in wonderment.

Even though go motion was extremely time and labor intensive, it was scheduled for use in *Jurassic Park* until the remarkable success of computer graphics as a new technique took hold. While *Jurassic Park* marked the end of the traditional stop motion era, Tippet still wound up animating previsualization sequences for the film that formed the template for the computer-generated imagery (CGI). Since that time, Tippet has adapted his hard-won skills as a stop motion animator to CGI methods to create an impressive stream of new fantasy creatures that long ago germinated from a tiny seed planted by an old cowboy named Willis O'Brien.

Dynamation with Stop Motion Pro
Shoot Your Background

Go to your location with a video camera and a sturdy tripod. Mount the camera so it doesn't move and lock off the focus. Position your actor holding a broomstick handle for a spear, and have the actor pretend to look at a monster and throw the spear at it. Do a few takes until you are happy. Capture the video into your computer as you did with the golf swing. If you can, put the footage through a compositing tool such as After Effects to create a split screen in the sky area so the spear vanishes before it falls to the ground. Now all you have to do is make a monster.

Figure 7.7 *Shoot your background plate on video having your actor pretend to see the monster. Make a split-screen composite and replace the falling spear with sky and ground.*

Making a Monster

We will use two techniques for making our stop motion creature. One will use flexible clay called Sculpyflex, and the other will be the traditional buildup technique that O'Brien used. The more sophisticated method of putting liquid foam rubber into a mold will be covered in Chapter 9.

Figure 7.8 *Use epoxy and wire to make an articulated skull.*

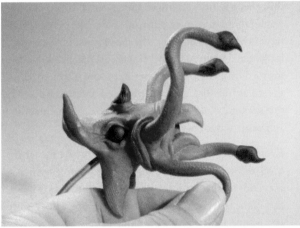

Figure 7.9 *For thin appendages like these skull tentacles, Sculpey Bake and Bend (Sculpey Flex) is a fast, direct medium to use for creating a flexible model. A simple thimble created the texture on the clay.*

The Armature

The armature, as before, will be a simple affair of using sturdy aluminum wire in a base of plumber's epoxy along with a skull made of epoxy with thinner wire embedded into it. This skull will be the foundation of our flexible clay. Form the wire and epoxy together and let it harden.

The Head

We will be using green screen technique for combining our creature, so pick clay that does not have green in it or the monster will disappear. You can use Sculpey Flex to form tentacles and a head surround-

Figure 7.10 *Use Pliobond adhesive (available at local hardware stores) to glue the foam rubber together and attach the latex skin. Be sure to wear gloves.*

ing plastic spheres for the eyes. Bake at 275°F for about 15 minutes. You will now have flexible tentacles made of clay that will act just like rubber.

The Snake Body

For thicker parts of the creature like the body, we will use foam rubber cut to the shape and cover with a textured latex skin. To make the body, simply purchase some sheet foam rubber from an upholstery shop and glue it together over the armature with Pliobond adhesive. Try to obtain the firmest foam you can, as this will prevent undue wrinkling of the latex skin. The proper procedure for gluing is to coat both sides of the foam with the adhesive and let dry. Once dry, coat one side and wait until it is tacky; then press the two

halves together. Pliobond is an industrial-strength glue that is far superior to rubber cement for adhering rubber together.

Making Skin

Roll out a flat slab of clay and texture with the rind of an avocado or other texture stamp. Mix up some plaster of paris or Hydrocal, and pour it on top of the clay. When the plaster hardens, you will have a textured surface to make your skin. Spray lacquer onto the surface of the plaster to seal it. When dry, brush on pure liquid latex and dry with a heat gun. When the latex is dry, brush on another coat and dry. Repeat this procedure for about three coats. Once dry, remove the latex while powdering the surface with baby powder so that it does not stick to itself. You can now use Pliobond to glue the skin around the foam rubber form.

Figure 7.11 *Texture some flattened clay with an avocado, and make a plaster mold of the texture.*

Fixing Seams

With any rubber model, you will inevitably have gaps and seams that will need to be touched up and repaired. For that you can blend the latex with ceco powder available from www.7ceramic.com. With the latex thickened to a paste, you can smooth over rough patches to correct any seam issues. Another thickening agent that generates a smoother paste for latex is Cab-O-Sil. Fine powders such as Cab-O-Sil should be used with caution and care should be taken to use proper masking and ventilation to prevent inhalation.

Figure 7.12 *Paint about three or four layers of raw latex into the plaster mold and dry with a heat gun. Dust with talcum powder to prevent the latex from sticking to itself, and remove the textured skin from the mold.*

Figure 7.13 *Mixing raw latex with acrylic paint will create a flexible paint that will stick to rubber. Foam rubber wedges can be used to apply the paint using a subtle wash technique.*

Figure 7.14 *Sandwich the monster in between two green screens to create a Dynamation shot using the Chroma Key tool. Note that sand is pressed into clay to create the sand crater the creature comes from.*

Painting Latex

The first step is to prime the latex surface with vinegar. Spray it on and tap dry with a paper towel. This will help the paint to stick to the latex. Mix the raw latex with acrylic artist paint and thin with a water ammonia mix until you get the consistency desired. Another option is to mix rubber cement with acrylic paint and thin the mixture with xylene. Details of this procedure can be found at www.silpak.com.

Setting up the Green Screens

Instead of rear projection, we will be using green screen to do our Dynamation shot. Stop Motion Pro's Chroma Key function will work with any number of colors. As long as your subject isn't the same color as the screen, you will be able to pull a good composite. For this exercise you can purchase a pre-painted bright green poster board. Cut a section of the sheet and attach it to the front of your table. This screen will allow you to see the foreground in front of the monster. Place the rest of the screen behind the monster.

Lighting the Scene

Whenever you composite one image on top of another, it is very important to match the lighting. The shadow direction of the monster should match the shadow direction of the live-action background. In this example, we were fortunate because it was an overcast day with no shadows so all we had to do was light the whole shot with soft, even lighting. For an in-depth examination of visual effects cinematography, you can consult *Filming the Fantastic* from Focal Press.

Setting up the Chroma Key Tool

Figure 7.15 *Create a new project called "Monster shot Dyna Tk-1." Set the capture device for the camera you are using. You will see your monster in a field of green. Note that the green screen is cut away erratically in the area under the monster. This will help disguise the split of the monster into the sand.*

Chroma Key Is a Previz Tool

You will now be able to see the monster and the background together in a rough composite. If your green screen falls into darkness, you may get some noise or chewing of the composite image. Don't be concerned as this rough composite is only a guide for animation. As you shoot the frames, you will have the choice to view the composite or the camera view. The trick is to align and animate the elements using the Chroma Key previz tool and then do a final composite in another software package such as Digital Fusion or After Effects. The illustrations that follow show the equivalent of a final composite using compositing software.

The Old Switcharoo Trick

With this setup you will be able to see the composite as you animate and have the monster react according to the actor's performance. Harryhausen developed clever methods for creating interaction between the actors and models by substituting model substitutes at the last moment. As the actor throws the spear, it will eventually go behind the monster. If, however, you substitute a model spear at the point where the spear hits the monster, the audience will get the impression that the actor's spear has stabbed the creature when in reality the real spear has fallen to the ground hidden behind the creature.

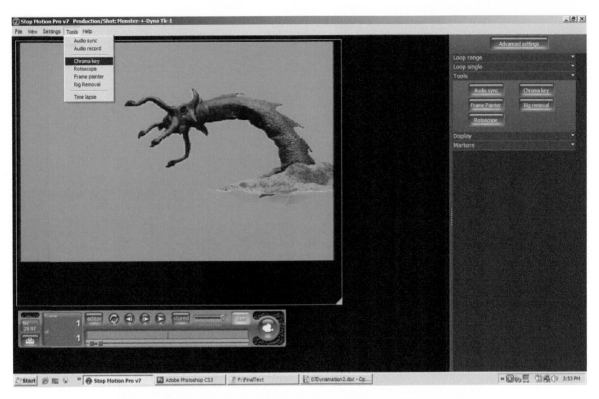

Figure 7.16 *Go to Tools, Chroma Key. The Chroma Key tool will now open along with the browser.*

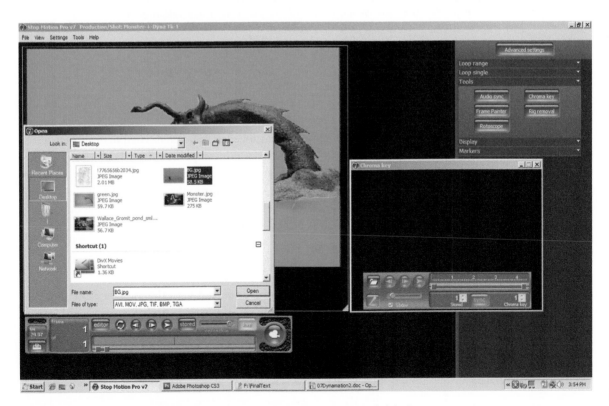

Figure 7.17 *Find the monster shot background you previously shot, select it, and click Open.*

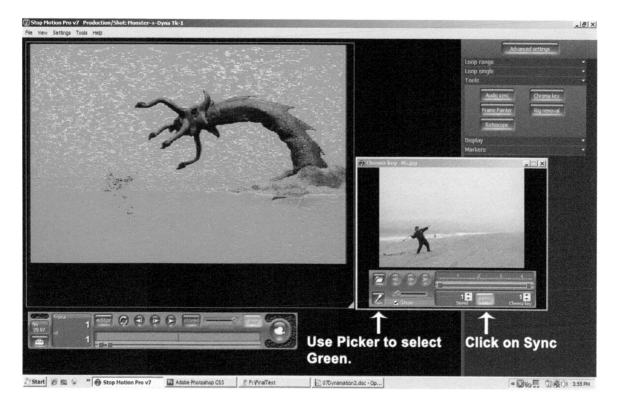

Figure 7.18 *Click on the Sync button, and then select the Eyedropper tool on the left. Wipe the cursor across a patch of green to select that color.*

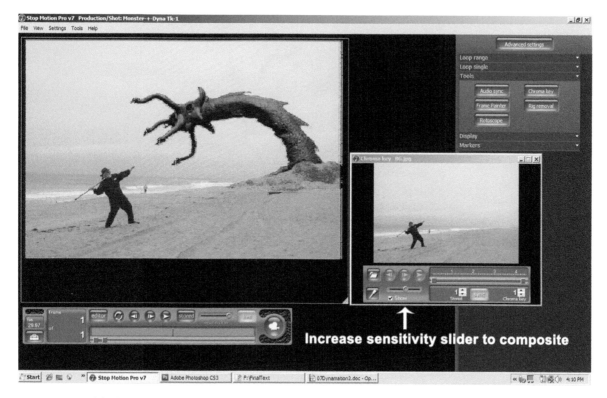

Figure 7.19 *Slide the Chroma Key slider to the point that the green disappears and is replaced by the background. Make sure the Show box is checked. Readjust the camera until the composition is just right. Clicking the Show box will toggle the composite on and off.*

Figure 7.20 *A final composite showing the Venusian Devil Worm threatening the author.*

Figure 7.21 *As the performer throws the spear, the animator can adjust the model to align with the spear using the Chroma Key previz tool.*

130

Figure 7.22 *A substitute miniature spear is replaced at the last minute to create intimate interaction with the stop motion creature.*

Figure 7.23 *The original spear was split-screened out, so it disappears. The artist can now animate the Devil Worm to get really angry. In the meantime, the author ran away.*

Make the Movie for Export to Compositing Software

Figure 7.24 *Go to File, Make Movie.*

Summary

1. Willis O'Brien was considered the founding father of combining stop motion animation with live action. His groundbreaking accomplishment was the film *King Kong,* made in 1933.

2. The main integration technique used in *King Kong* was rear projection. Actors were either photographed standing in front of a rear projection screen imaging stop motion footage or live action was projected a frame at a time behind stop motion models.

3. As a boy, Ray Harryhausen became fascinated with *King Kong* and set about to build a lifelong career as a stop motion animator.

4. Willis O'Brien encouraged Harryhausen as a young hobbyist, and this eventually led to their working together on the film *Mighty Joe Young*.

5. In the 1950s, Harryhausen set out on his own to create effects for low-budget fantasy films. Because of budgetary considerations, Harryhausen was unable to employ the time-consuming and expensive techniques that O'Brien used, namely, large glass paintings coupled with rear projection. To be cost effective, Harryhausen devised a system of compositing using rear projection and mattes that he dubbed *Dynamation*.

6. Dynamation consisted of photographing the live-action footage first with actors pantomiming duels with invisible creatures. This footage was subsequently rear projected frame by frame behind a stop motion

Figure 7.25 *Select all frames and AVI Lossless compression, and click OK. The choice of Lossless will ensure that you have the highest quality image to work with when you composite.*

model supported on a stage. The stage was eliminated through the use of a black mask or matte that prevented exposure in that portion of the film. Harryhausen would animate his creature, providing an interactive performance using the projected live action as a reference. After the animation was done, a counter matte was introduced and the model and stage were removed, allowing the bottom half of the live action to be added in, thus providing a "reality sandwich" for the animation model.

7. Harryhausen would often substitute the miniature equivalent of live-action props at specific points in the action to enable the stop motion figure to intimately interact with the live-action characters.

8. An early drawback of stop motion animation was that each frame of the animation puppet was sharp and devoid of blur, unlike the live-action figures on the screen. For early audiences, this was an imperceptible

Figure 7.26 *Create a filename and save. Stop Motion Pro will now save a high-quality version of the green screen shot without the composite that you can plug into After Effects.*

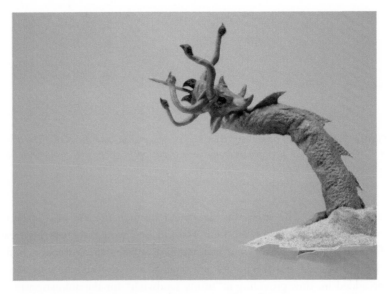

Figure 7.27 *The final animation file that you will use for compositing in a program such as After Effects.*

and insignificant flaw. As audiences became more sophisticated, a method was introduced by Industrial Light and Magic (ILM) called *go motion,* which was able to move the model during the exposure of the frame and recreate the blur of live action. The high point of this technique can be seen in the film *Dragonslayer.*

9. The milestone film *Jurassic Park* was to have used go motion as its primary technique until the startling realization that high-end computer graphics had finally developed to the point where they could replace go motion and stop motion animation and usher in a new era of fantasy film creation.

Films to See

I highly recommend any of the Harryhausen films as excellent examples of the Dynamation process and fantasy filmmaking. My personal favorite is *Mysterious Island* (1961).

Books to Read

* *An Animated Life* by Ray Harryhausen, ISBN-10: 0823084027, www.rayharryhausen.com.
* *Ray Harryhausen, Master of the Majicks* by Mike Hankin, ISBN: 978-0-9817829-0-4, www.archive-editions.com.

Figure 7.28 *The Dragon from* 7th Voyage of Sinbad. *Photo courtesy Archive-Editions.com.*

Figure 7.29 *The giant crab from* Mysterious Island. *Photo courtesy Archive-Editions.com.*

Chapter 8

Acting for Animation

Real-Life Acting

It is beneficial for animators to do some stage or film acting to round out their skill set. Good animation is nothing more than acting in extremely slow motion where every gesture and movement is micromanaged. There is no better way to get a sense of proper timing in animation than by actually being an actor on stage. The way to gauge a successful performance is twofold. If your humorous performance elicits laughs, you have achieved proper timing. If your dramatic performance yields an anxious and attentive stillness in the crowd, you are also successful. The powerful feedback loop between a live audience and a performance is a great way for an animator to learn dramatic or comic timing. By timing I mean the breakdown of when movements and reactions occur so that they convey a comic or dramatic statement for the stage or screen. A common example of comic timing is the double take, which occurs when an actor reacts to a statement in a habitual manner, pauses to think about what was said, and then gives a second "take," reacting more appropriately to what was said. As an example, let's look at a few lines of dialogue between a boss and his employee:

RUMBLEBOTTOM (Furious)
Filbee! This situation is untenable! I want you to turn in your keys, set fire to the building, and JUMP OUT THE WINDOW!
FILBEE
Yes, sir.
(Filbee starts to walk away, then pauses.)
FILBEE
Turn in my keys sir?

These few lines of dialogue are a treasure trove for the skilled comedic actor. To begin with, we previously establish that the boss is a screaming bully and Filbee is a meek and mild yes man. If Filbee is asked to jump, he responds "How high?" What makes the dialogue humorous, of course, is the boss's outrageous request to

doi: 10.1016/B978-0-240-81219-9.00008-8

jump out the window. It would be good comic timing to have Filbee respond with "Yes, sir" quickly with no emotion. The audience will find this funny because they have heard the outrageous request to jump out the window met with the absurd "Yes, sir" and they know that Filbee has obviously not thought this idea through. At this point comes the first laugh wave, giving Filbee time to think things through as he walks away. At the appropriate time, the actor playing Filbee will pause and turn, and at just the right point where the wave of laughter is dying down he will utter the last funny line about turning in his keys. The audience once again will find this absurd, as the keys matter more than Filbee's peril at jumping out the window, and the next wave of laughter will erupt. Timing is crucial at this point, because if Filbee says the line about the keys too soon, no one will hear his line as the roar of the first laugh will mask the joke. If he says the line after the laughter subsides, the audience may give a chuckle but it will be too late to ride the descending crest of the first wave of laughter and will essentially kill the power you could have had with the punch line.

In Chapter 3 I related the principle of ease in and ease out in animation. This idea not only applies to movement but to dramatic structure as well. The wave of laughter I mentioned also has an ease in and ease out. It can be an abrupt explosion of laughter with a slow die out or it can be a slow build to an explosion and then a die down. As an animator you can build on the ease idea and extend it to the timing of your animated characters.

Figure 8.1 *Studio bosses of old condensed story structure into these basic events. As you can see, the idea of rising and falling waves is also apparent throughout the script of a film or movie.*

Animation Performance Breakdown

The easiest way to prepare an animation performance is to run through the actions with a stopwatch or timer. You can use your hand or body as a substitute for the character and use it to roughly run through the movements. Step 1 would be to pantomime the movement with your hand on the small stage, such as fingers walking through the set. Do this a couple of times, making sounds or humming music to get a free and easy flow to the motion. Once you have practiced this a few times, do the movement again while counting off seconds: one thousand one and so forth. In the case of walking, you would run the movement while counting both seconds and footfalls.

Your hand may walk four steps in one second. Do the movement of four steps while counting the steps 1, 2, 3, and 4; memorize this rhythm and do the movement again counting one thousand one. You can quickly determine that you want to do four steps in 1 second, for example. If you shoot at 12 frames per second (fps), you know you have to make four footfalls in 12 frames. Divide 12 by 4 and you wind up with 3 positions. A foot must hit the ground every third frame. You can now use your finger positions to determine where each foot will fall and can drill holes for the tie down or make marks in Stop Motion Pro to let you know where to "pin" a foot to the ground.

In other instances, you can use your body or face to act out the movement. Many artists who animate drawings have a mirror nearby so they can see their facial expressions to get inspiration for how to make the

Figure 8.2 *Do a real-time freewheeling performance with your hand while counting out seconds and determining how many frames it will take to make the movement. After this plot, you can confidently animate the figure because you have broken down and planned the motion.*

Figure 8.3 *Performing the action ahead of time with your hands or body helps to lock the timing in your head and make animation easier.*

drawing. Stop Motion Pro's Roto-scope tool allows you to use this mirror idea on set by referencing a prerecorded performance. A walk would involve much more than the feet hitting their marks. The body will bounce up and down, the arms will sway, and the torso will have some movement.

Breaking Down a Voice Performance

Let's examine how an animator might break down the Filbee scene for animation. To start with, the actors will have laid the ground-work for the basic timing, so you will have a template of when the lines need to be said. In particular, Filbee will take about four "beats" to get to the last line. A "beat" in animation as in music is an indica-tion of rhythm in a scene. You can determine the tempo of a scene by working with 1 beat representing a second. If I were performing Filbee, I would probably give about 4 seconds before I said the last line. This timing is based on the experi-ence I've had with audience reac-tion. The director may have a different interpretation. Usually most good directors will let the actors do the first interpretation and then modify the performance and timing from there.

The way you build upon a dialogue soundtrack is to pick out key words and have that prompt key poses to hit in the animation. If we break down the first line, we see that the boss yells out Filbee's name in no uncertain terms. As an animator, I want to make a broad entrance and decide that the boss should raise his arms in a fury and shake his hands to

emphasize the "eeee" sound in Filbee's name. In this case, the "Fil" sound takes about 3 frames on the soundtrack and the "bee" sound lasts about 16 frames (at a 12-fps rate). So the animator might perform this action live just before the animating to solidify the movement in his or her head and then, starting with the first frame of the start of the word, would begin to animate the arms thrusting upward from the character's sides.

We break up the movement of the arms raising into four positions and skew the positions to be smaller at the start to create ease in of the movement. Because the end of the word is loud and angry, we decide not to ease out but just abruptly stop when the arms are stretched and have the hands quickly jump between two positions until the end of the word, just as if his hands were ringing bells to amplify the boss's anger. As a secondary movement, you can disturb Filbee's hair as it reacts to the screaming fit.

The next line is a bit calmer and once again a bit of a descending wave. Because Filbee is still the focus of attention, I decide to ease in a downward movement of both arms having the left arm move down to the side and form a fist while the other points a wagging finger at Filbee on the word "this." Once again, it is useful to act out the action ahead of time so you can deconstruct the actions in slow motion and hit the marks as you animate. There is a pause of 12 frames before the word "this" so you know you have to fill this time with movement and break down the positions of the arm to fit. Throughout this time, of course, you will be animating the mouth and face to coincide with the dialogue track as we did in Chapter 4.

For the line "is an untenable situation" I decide to use the principle of "stillness" in acting by moving nothing but the pointing finger and the mouth. This not only saves animation time but also emphasizes the fact that Filbee is the point of attention. For the finger movement, I decide to not do the violent two-positions animation that I did with the hands but to do subtler random positions of the finger in small increments so it is more of a slow wandering type of movement that shows, through movement, the "slow burn" of the boss.

The next line, "I want you to turn in your keys, set fire to the building, and JUMP OUT THE WINDOW!" has three high point words: "keys," "building," and "WINDOW." Once again we have a bit of a wave here, and the line ends with WINDOW set all in caps, indicating an ease in that is verified by the sound track. At his point I find the frames that these key words fall into and decide to have the boss slam his fist on his hand for the first two key words and then point to the window by the last word. After Filbee responds, the boss's arms can ease down to his sides as the anger

Figure 8.4 *The quick, two-position animation of the hands accentuates the "ee" sound in "Filbee." The Filbee character reacts to the sound with a hair-raising cringe.*

Figure 8.5 *For the fall of the dialogue said in a menacing tone, "this is an untenable position," the figure is primarily still while only the pointing finger wanders about as Filbee's eyes follow.*

Figure 8.6 *The fist hitting the hand drives home the key words "keys" and "building."*

has been partially vented. Filbee, of course, is also acting in the scene during the boss's tirade. As an animator I could choose to give him very small erratic repositions to make him "shake" in terror, or I could opt to have him remain still while I concentrate on the boss.

In good acting and animation, the other performer is usually doing *something* besides waiting for his or her line. In between lines, a good actor will choose to either listen to the other actor and react, be distracted and ignore the actor but be focused on something else, or both. In this case, I decide to make it simple and just have Filbee calmly listen to the boss in rapt attention until he turns to go. For Filbee's line "Yes, sir," I keep the body still until after the line is uttered and then I do freeform animation of him turning to go and stop just before the punch line. During this animation, I continue with the boss by slowly noodling him about and have him unclench his fist. After Filbee asks about the keys, I can then use the wave idea and have the boss start to explode and grossly exaggerate his form for comic effect. This is an example of how I as an animator break down a scene to exploit the best parts of the performance. The actor's voice performance gives clues as to what type of movements would be best to convey the drama. With the Rotoscope tool you have even more of a template to use to capture the live-action performance and then reproduce, embellish, and exaggerate the scene.

Figure 8.7 *Breaking a pattern such as two hits of the fist to the point to the window is a good way of building drama through movement.*

Figure 8.8 *Filbee quickly says the first punch line, "Yes, sir," which introduces the first wave of laughter, and the "beats" start counting until the double-take punch line "Turn in my keys?"*

Anticipation, Action, and Reaction

These three terms are important to keep in mind when animating the interplay of two characters in a scene. It seems like an obvious concept, but it is easy to lose sight of these important principles when you are in the throes of animating one frame at a time. Each character will constantly switch between these different states throughout the scene. One character may look up at a teetering pillar and anticipate that it may fall and start to cringe or prepare to do something if it falls. The other character, the pillar, is teetering and may in and of itself be anticipating that it will fall but it doesn't know the direction. Eventually the tension is broken and the pillar falls or takes action. The character below, seeing the action, moves from anticipation to reaction by covering his or her head. When the pillar hits and breaks over the character's head, we continue the action until it is spent and the character covering his or her head moves from this action to the reaction of falling down.

The 12 Principles of Animation (Hint: You've Done Most of Them)

Disney animators Ollie Johnston and Frank Thomas wrote a book in 1981 called *The Illusion of Life: Disney Animation* (Disney Editions).

In this book, these fabulous animators outlined 12 principles they had used over the years to animate the Disney classic films they were involved with. Let's take a look at these 12 principles as they relate to stop motion animation and what you have done so far.

Figure 8.9 *At the punch line, don't be shy about exaggerating the character's reaction. The beauty of clay is that it is as elastic as drawing. Characters Filbee and Rumblebottom.* © *Mark Sawicki.*

Squash and Stretch

Many objects in nature have a certain amount of resilience and flexibility when force is acted upon them. A rubber ball, for example, squashes and flattens a bit when it hits the ground and then stretches and elongates when it begins its bounce upward. Humans and animals also exhibit this tendency, as we are 90% water and as such our bodies tend to squash and stretch as well. This principle is so important to animation that creating and animating a bouncing ball with squash and stretch is one of the first exercises used to train computer graphics animators. This principle is difficult to accomplish with conventional puppet animation unless you use predistorted replacement figures as George Pal used. Clay animation, however, is a terrific medium for adding this all-important distortion, and we already used it to great effect with our clay animation ball hitting the wall and turning into a head.

Figure 8.10 *Squash and stretch.*

Anticipation

We examined the principle of anticipation in this chapter and put it to good use with our animated worm. When the worm is at its high arch, it anticipates the fall or reaction to the arch and vice versa. You can play with the anticipation reaction by changing the pattern of this replacement animation sequence. Hold the high arch for two frames, then three. Hold the flat worm for five frames. Cycle the first few models to give a sense of hesitation in forming the arch. You can create a tremendous amount of character by merely changing the pattern of a cycle.

Figure 8.11 *Anticipation.*

Figure 8.12 *Staging.*

Staging

Staging involves how the characters are positioned in the frame to make best use of their performance. It comes from theater and the positioning of actors on a proscenium stage to give the audience the best dramatic effect. As an example, one of the most used stage instructions given to actors is not to "block" the other character so the audience can always clearly see the action. Actors are also told not to "block" themselves by being asked to use their upstage arm. The term *upstage* refers to the back of the stage away from the audience. When the boss points at Filbee, I chose to use the upstage arm to that the boss character was "opened up" to the camera and the audience could see more of the figure that would be blocked if the other arm were used. Staging animation movement in terms of profile is another extension of this idea. If you can instantly see the action and tell the story if the characters were turned into a silhouette, this too would be good staging.

Straight Ahead and Pose to Pose

This principle mostly relates to the two systems of doing drawn animation. Straight ahead means that a new drawing is made in succession for each new frame much as a new position is made for each new frame of stop motion. What is relatively impractical to stop motion is the idea of pose to pose. In drawn animation, animators draw key poses of an action. In the case of a pitcher, the animator may draw a resting pose, a windup pose, an about-to-throw pose, and a throw representing perhaps frames 1, 12, 24, and 30. After these drawings are made, in-between animators fill in the drawings in between the poses. Although this method may be technically possible in the stop motion process, it becomes far more cumbersome than the straight-ahead approach. All of your work thus far has been straight-ahead animation. The idea of pose to pose is used in planning stop motion as you saw with the Filbee breakdown.

Figure 8.13 *All stop motion is straight-ahead animation.*

Figure 8.14 *Follow-through.*

Figure 8.15 *Slow in slow out.*

Follow-Through and Overlapping Action

Movement in life often has many interrelated motions. Some motions carry through, others are reactionary. Hair and body fat may continue moving while the bulk of the body has stopped or altered direction. In the case of our straw animation, the body of the straw stopped but the top of the straw kept moving and bounced back and forth in reaction to the sudden stop. This can also incorporate the principle of drag where some parts of a body "catch up" to other parts at a later time during movement. A great comic example of this motion in the extreme is Chuck Jones's work on the Wiley E. Coyote Warner Brothers cartoons where the Coyote runs off a cliff and his head stays still as the feet and then the torso fall to earth, first leaving the head suspended to a stretched neck until the poor Coyote's head is the last to go.

Slow In and Slow Out

We have been using this principle throughout the book, calling it ease in and ease out. Always keep in mind that although realistic movement can be rendered with ease in and ease out, the eases do not always have to be identical. By varying the "wave" of the eases, you can create a tremendous variety of movement. You can even completely dispense with one ease entirely, as in the case of accelerating a car until it crashes abruptly into a brick wall. That would be an ease in stop effect that would, of course, be followed through with an explosion of car parts that would have their own ease in and ease out.

Arcs

This refers to the natural arcs that occur with objects traveling through the air or by limbs

Figure 8.16 *Arcs.*

Figure 8.17 *Secondary action.*

Figure 8.18 *Timing.*

attached to a skeletal structure. When things move, they tend to travel along a smooth arced path and not bobble or skitter about erratically. When we animated our flying car, we had it fly in a smooth arc that imparted a natural trajectory of a flying object.

Secondary Action

The most common example of this principle is a person swinging her or his arms while walking. You animated such a secondary action with the talking puppet by animating the eyebrows to emphasize a word. Other secondary actions might be facial expressions, a wagging tail, or eye movements that help emphasize the action.

Timing

We explored theatrical timing at the beginning of this chapter. You used a bit of it in the straw animation where a beat was taken before the straw sank into the floor. Timing is learned by experience, and a good route to gain that experience is through actual acting.

Exaggeration

Exaggeration is a natural extension of the animation art. The ability to caricature the human form to highlight certain features for dramatic effect has always been fun to explore. Even when animation is used to create photo-real representations such as the T. Rex in *Jurassic Park,* the slight exaggeration of features made the dinosaur even more menacing than if it were merely an exact representation of the beast. Anime is an extremely popular form of animation that exaggerates the eyes of the characters to a great extent. When used judiciously, exaggeration can create magical effects; if taken too far, it can be grotesque and perhaps successful in a different way, as evidenced by the wonderful exaggeration used in the classic Ren and Stimpy cartoons.

Figure 8.19 *Exaggeration.*

Figure 8.20 *Solid drawing and sculpture.*

Solid Drawing

This principle relates to becoming disciplined in traditional artistic rendering in order to use the skills of cartooning in an effective manner. The artist should be well grounded in anatomy, composition, weight and balance, light and shadow, and perspective. Drawing from real life and executing representational art by way of drawing and sculpture is an essential foundation for becoming a professional animation artist. Ray Harryhausen has related that when he was a young man and showed his mentor, Willis O'Brien, his early sculptures, he was told that the limbs looked like sausages and didn't have the anatomy or muscular definition that was needed. Harryhausen took this to heart and went on to study anatomy and develop his traditional art skills. This exposure to traditional art training enabled Harryhausen to develop into a master stop motion artist. Recruiting departments for the large studios have expectations that new digital hires will have both traditional and digital art skills. A skilled representational artist who can draw from life will always be able to draw or sculpt a cartoon, but a self-styled cartoonist may not have the skills or flexibility to draw or sculpt realistically or adapt to different styles.

Appeal

This last principle is a bit ephemeral as it relates to the creation of characters that capture that certain something that makes them watchable. It is difficult to formulate what makes one character more marketable than another. As a result, we have the old studio joke that follows the arc of an actor's career:

1. What's his name?
2. Get me what's his name.
3. Get me someone who looks like what's his name.
4. Get me a cheaper version of what's his name.
5. What's his name?

So the joke is basically about a producer trying to capture the illusive something of what's his name who was hired only once using any inexpensive means available. Studios often attempt to groom new versions of actors who have been popular in the past by matching facial features and mannerisms. As far as animation characters go, one workable template that has been used for many of the adorable cartoon characters in the past, such as Donald Duck, has been fashioning the character around the universal appeal of the human baby. The human baby has a big head, small limbs, and a pear-shaped body. It is only natural to love babies, and many of our classic cartoon characters are fashioned around these basic body attributes with a bit of exaggeration thrown in. As you develop as an animator, you may find your own illusive "thing" that will give your characters that special something.

Figure 8.21 *Appeal. Character design is another fun aspect of animation. Pictured is a design sketch of Gold Digger Joe for* Gold Digger Joe and the Rumblebottom Roundup. *© Mark Sawicki.*

Summary

1. Taking a course in acting or being in stage plays is excellent training for an animator.
2. An important skill for an actor is learning how to react rather than act.
3. An actor learns timing on the stage by being aware of his or her performance and paying attention to the waves of audience reaction to it.
4. Good comedic timing of a punch line involves not saying the line too early or too late but timing the delivery by riding the waves of laughter coming from an audience.
5. Motion has a curve, laughter has a curve, and dramatic structure has a curve. The manipulation of these curves or waves is an essential tool in the dramatic arts.
6. Prerecorded dialogue in an animated film creates a basic template for the timing of animation.
7. An animator embellishes the basic timing of the dialogue and uses movement to enhance the performance.
8. Ease ins and ease outs do not have to follow a uniform curve but are manipulated for maximum impact.
9. Ollie Johnston and Frank Thomas wrote about the 12 principles of animation used in Disney films in their book *The Illusion of Life*.
10. A good length for animation exercises is 5 seconds. Five seconds is a manageable size and quickly builds confidence.

Films to See

A wonderful example of stop motion animation that demonstrates many of the 12 principles is the 1989 Academy Award–winning German film *Balance* by Wolfgang and Christoph Lauenstein. It concerns a number of characters on a tilting platform and their competition to obtain a box. It is a wonderful nondialogue story on the folly of selfishness and well deserving of the award.

Chapter 9

Sets for Animation

All the World's a Stage

The most important attribute of a stop motion animation stage is stability. The slightest wobble of the platform in between frames will give the appearance that your characters are performing in an earthquake. A flimsy card table would be susceptible to jarring and bumps with no guarantee of the table springing back to exactly the same position frame after frame. You want to find a sturdy table with cross bracing that is expendable as you will most certainly damage the surface by drilling, applying C clamps, or manipulating waxy clay on the surface.

For students who are doing simple clay animation projects that will not require tie-down holes or other physical damage to a surface, a good, quick, inexpensive platform is a kitchen countertop. Ideally this would be a work island that you have 360-degree access around. You have room to place lights, camera, and a backdrop around the island. It is a comfortable working height and very stable. You can purchase a laminated Formica board with a neutral color such as white or gray and carefully C clamp it to the surface of the island, separated by a thick protective plastic sheet. You should be careful to use just enough pressure on the C clamp to affix the board, as too much pressure can crack or split expensive Silestone or granite countertops. Needless to say, this improvised method is best implemented using the fixtures of inexpensive utility housing that you find on college campuses instead of Grandma's house. For those needing to drill holes in the stage, the platform can overhang the island, giving access to the bottom of the stage while still providing the needed stability.

Another good surface is a bathroom countertop with a cove. Once again, it is easily cleaned and has the advantage of a sloping backstop that is good for a "limbo" environment for your clay characters. Another advantage to this platform is that most bathroom lighting tends to be soft, even light that is pleasant for photography. The disadvantage of a bathroom is lack of space and traffic to and from the facility. This can be an issue with a shared apartment.

© 2010 Mark Sawicki. Published by Elsevier, Inc. All rights reserved.
doi: 10.1016/B978-0-240-81219-9.00009-X

Figure 9.1 *You can use a bathroom countertop as a quick limbo set for a clay animation shot.*

Building a Platform

A custom platform is easy to build and fairly inexpensive. A good animation stage should allow access under the platform and be cross-braced for stability. The stage can be a base platform onto which a variety of set pieces can be attached via C clamps or screws for quick replacement, eliminating the need to make a new platform for each set. A good starting point for a base platform is to determine a good, workable height and draw out a rough plan so you can build a stage in a timely and cost-effective manner. A good height would be about 4 feet off the floor to allow you to animate in a comfortable standing position without needing to stoop over. You have to keep in mind that animation can be a tedious and time-consuming activity, so the fewer physical demands on your body, the better. The other good reason to have the set be 4 feet off the floor is that it is an easy subdivision of a standard lumber issue in the United States—that is, it makes use of a 2″ × 4″ × 8′ long board. If you purchase two of these boards and saw them in two, you now have four legs of your table. For the cross bracing, you can use 1″ × 2″ × 8′ long boards. To obtain your measurements, it is useful to draw your plan on grid paper and use the intersections as a standard of measurement, such as each square represents 2 inches. Each leg would be 4″ × 12″ or 48″ high divided by 2″ (for each square on your paper), making each leg 24 squares high on your diagram. To obtain the length of the cross braces, you merely draw them in and measure them against the squares to obtain the inch length. If you are on the metric system, all you need do is have each square represent 25 or 50 centimeters and follow the same procedure. A good table would be cross-braced at the back and the sides, and the front would be open except for two straight cross braces at the top and bottom. This will allow the animator to have access to the bottom of the stage to easily unscrew tie-downs if that system is used. For the tabletop itself, it is good to use a sturdy 1″- or ¾″-thick sheet of particleboard. Particleboard is made of compressed and glued sawdust and is much better for drilling tie-down holes, as no splintering will occur as happens when using plywood.

In situations where I have had to put together a tabletop set rapidly, I avail myself of the cutting service offered by hardware or lumber shops. Once you have a plan, you can purchase only what you need and have all the pieces cut to length for a small fee. You can then merely assemble the stage by nailing the precut pieces together. For film work, it is a good idea to use stage nails or double-headed nails. These specialty nails allow you to work quickly when building and dismantling temporary setups. The raised secondary head of the nail allows you to pull it from the boards with ease. The last bit of business will be attaching the stage to the floor. Many sound stages will have wooden floors that you can nail sets into. Today, many stages have concrete floors that don't allow for this opportunity. In this case, the best procedure is to weigh down your

Figure 9.2 *Draw up a simple plan on graph paper to work out the size of the materials you'll need. Planning ahead can save a good deal of money. In this diagram, each square represents 2 inches per side.*

set with a number of sandbags hung from the cross braces.

Model Building Tools

Whereas the basic platform can be put together with hammer and saw, miniatures require more sophisticated tools. One of the more popular instruments is the Dremel tool. It is a small handheld motor that can drive cutting and polishing discs as well as saws, drills, and grinders. I highly recommend this device for miniature model building. Here is a partial list of other tools that are handy. Don't forget or scrimp on the most important tools of all such as rubber gloves, eye protection, and protective masks.

Figure 9.3 *A typical stop motion stage. Pictured from left to right is Harry Walton and model maker Tom Scherman. Courtesy of Harry Walton, vfxmasters.com.*

1. The Dremel tool with an assortment of cutting bits
2. A high-wattage hot glue gun

Figure 9.4 *Some handy tools.*

Figure 9.5 *Don't forget to purchase and use protective gear.*

3. A variety of glues, such as super glue, wood glue, and epoxy
4. An assortment of acrylic paints and brushes
5. An assortment of spray paints and primers

Construction Materials
Balsa Wood

For stop motion work, you always have the demand for a set to be rigid, sturdy, and lightweight. A common technique is to use a sturdy structure of inexpensive material such as poor-grade plywood and cover it with a workable veneer. The walls of the set can be made of easily removable plywood flats that are clamped into place. A thin veneer of balsa wood can then be glued onto the surface of the plywood to be a canvas for wooden walls. The impression of individual boards can be easily etched into the thin balsa wood sheets, and doorframes and windowsills can be added as well. Balsa wood can be obtained at local hobby stores and comes in a variety of shapes. It is easily cut and broken (even with your bare hands) and accepts wood stain and paint quite well.

Foam Core

Foam core is a terrific art material that consists of two sheets of thin cardboard that sandwich a sheet of Styrofoam. These so-called foam core sheets are used quite often in film production because they provide easily cut bounce boards for lighting and model building. They come in white and a variety of colors. The cards take paint easily and can be quickly glued together using a hot glue gun. To cut the board, it is best to use a razor blade or an X-Acto blade. You should be cautious when painting the foam core, to avoid oversaturating the card with wet paint. This will result in the card curling as it dries, as the painted side will tend to shrink. You can overcome this mishap by hot gluing the card onto a flat wooden board. Having plastic foam in

Figure 9.6 *Balsa wood is easily cut, carved, glued, painted, and stained. This simple set was constructed of foam core hot-glued together with a veneer of balsa wood.*

Figure 9.7 *Foam core and hot melt glue form a great combination for quick model building. Here the card is torn away from the foam interior to expose "bricks" carved into the Styrofoam.*

between the card can be handy for certain effects. If you wish to depict broken plaster revealing brickwork, all you need do is peel away the card to expose the foam, scribe in the mortar of the "bricks" into the foam, and paint appropriately.

Styrofoam

For dimensional organic shapes, Styrofoam is an excellent choice for things like chimneys or distant hills. This material can be purchased from your local hobby store or scavenged from the form-fitting packing material of a variety of appliances. It is easily carved or cut with a heat knife. The surface can then be coated with plaster to create a lightweight yet sturdy set piece. One technique I used to put together a collection of brick walls was to cut brick-shaped rectangles out of cardboard and then pin them onto the surface of a Styrofoam sheet. Using a heat gun, I rapidly sent a wave of heat over the card and foam collection and melted indentations in the plastic in between the cards (that acted as a heat barrier) to create an inset mortar effect. Once the foam was melted in this manner, the cards were removed and an application of paint completed the illusion.

Plaster of Paris

This substance has been the traditional model material of model train enthusiasts. The simple basic technique of making mountains or stone structures was to build a number of pillars of wood and staple a blanket of chicken wire on top of the frame to form a foundation for the plaster. At this point, you immerse burlap rags, cloth, or even paper towels into plaster slurry and drape the material over the chicken wire to dry. The wonderful accidental creases and folds that evolve from this process make a convincing rock pattern. After the plaster dries, you can paint this hard

Figure 9.8 *Plaster is an excellent mold-making material for rubber. In this illustration, we see a procedure for restoring a model from a 30-year-old mold. The mold was originally used for casting foam latex, but because of its age, it was decided to use a reverse "buildup" technique where layers of raw latex are painted into the mold to build a skin and then the bulk built up with latex-soaked cotton and foam rubber glued to the inside of the body cavity. A heat gun is used to dry the latex in between coats. The* Strangeness *monster is courtesy of Stellarwind Productions.*

shell of fabric and plaster and adorn it with any number of textural embellishments. Plaster is also an excellent choice for mold making. Its qualities of absorption and resistance to heat make it ideal for rubber and ceramic castings. Plasters come in a variety of strengths and harnesses. For mold making, popular materials such as Hydrocal, Ultracal, or dental stone are often used. This extremely hard material captures excellent detail and is used throughout the makeup effects industry. Molding plasters are available at monsterclub.com.

Foliage

The local craft store and model shop sell any number of tree models or raw materials for grass and bush. One of the more popular products is Icelandic moss or lichen, a natural plant that has been soaked in glycerin to act as a preservative. Although the texture of this moss is appealing, the uniformity of color tends to have a cartoon quality. If you are attempting to create a realistic representation of foliage, it is important to have a variety of colors and textures within the piece. I learned a terrific method for making realistic trees from matte painter Robert Stromberg. The basic technique is to obtain a branch from a manzanita bush and glue smaller flowered twigs to the ends of the branches. These materials can be obtained from the home decoration aisle of many craft stores. The advantage of the manzanita is that the intricate shape of the branch is an excellent simulation of the branching of a full-size tree. Attaching the smaller twigs to the branches adds to the illusion and creates a variation in color. The base roots can be sculpted putty to complete the miniature.

Aluminum Foil

Foil comes in a variety of grades and thicknesses. For film work it is best to invest in thicker grades of foil that can stand up to the rigors of model making. Foil offers another way of creating rock textures that is fast and effective. I first saw it used for the trailer for the film *The China Syndrome* (1979). I had the pleasure of working with miniature specialist Tom Scherman, who was a noted Disney model maker responsible for supervising the construction of the full-size Nautilus submarine attraction at Paris Disneyland. For this trailer, Tom was required to make a long tunnel in the earth symbolizing the menace of a nuclear meltdown. The process was ingenious and simple. Chicken wire was used to form the tube of the tunnel that was lined with thick, crumpled aluminum foil to form the shapes of the earth. This assembly was then cemented together using spray insulation foam from behind. With appropriate paint and lighting, the illusion of a deep rocky tunnel was flawless.

Figure 9.9 *Crumpled aluminum foil backed by insulation foam and painted appropriately can also create lightweight yet sturdy rock sets. Note that the plastic insulation is being sprayed outdoors with the use of rubber gloves.*

A Word about Safety

I want to pause a bit as I am starting to discuss plastic compounds. Although these materials are wonderful model-making tools, they can also be extremely toxic and potentially carcinogenic. Certain brands of two-part plastic foam, for example, give off a low level of cyanide gas as the foam cures. This is why the manufacturer recommends that you use the substance in a well-ventilated area and use a quality respirator when working with the product. Whenever you work with plastics, always pay close attention to and heed the safety precautions. Wear protective gloves, glasses, and a mask if required. There is good reason for these safety notices to exist. When all these plastics started to come out to the general public in the 1970s, little attention was made to safety considerations. Though I cannot truthfully state a cause-and-effect relationship, I do know that many wonderful model makers I knew from that era are no longer with us. My colleague Tom Scherman died of lymphoma at the age of 55, as did the great stop motion animator David Allen. Although this is a sad commentary, it serves as a reminder to be careful. You don't need to swear off the modern plastics (I make use of them all the time); just make sure you protect yourself and stay healthy.

Plastic Model Kits and Dollhouse Props

Because the creation of individual props is time consuming, many stop motion artists purchase off-the-shelf items to speed up the miniature-making process. In the case of the original *Star Wars* film, a process called *kit bashing* was used to add detail to the intricate spaceships. To obtain all the myriad pipes, hatches, gun turrets, and other structures that made up the surface of a spaceship, the model makers simply purchased a number of plastic model kits of aircraft, tanks, cars, and other vehicles and mixed and matched the many parts to detail the miniature. This method saved a tremendous amount of work. In the case of puppet films, model makers can save production time by purchasing dollhouse furnishings from local stores. The scale or size of the animation puppets was often determined by how many props were available at the local dollhouse supplier. In the United States, a common scale is 1/12, or 1 inch to the foot. This would make your average character about 6 inches tall, which is a comfortable size for a puppet film. For those who decide to retool GI Joe– or Barbie Doll–style toy figures, the challenge will be to find or create all the settings that work with these large figures, which average 11.5 inches tall.

Polymer Clay

As you saw in Chapter 4, polymer clay is a great three-dimensional medium for models. It is good for puppet heads and any number of props in a set. Sculpey comes in a number of specialty clays such as Granitex, which simulates rock texture, as well as gold and silver. Sculpey Flex or Bake and Bend clay can also be used to create a flexible clay form around a wire armature to create an animation puppet. Bake and Bend clay is not as flexible as rubber materials. It works best as a thin layer of flexible clay around a wire armature. For bulky appendages, raw clay or foam rubber is the best choice.

RTV Mold Material

One of the most popular mold-making materials today is what is called room temperature vulcanizing (RTV) rubber. This essentially means that two liquid plastics can be mixed together that will form a flexible rubber at room temperature without the addition of heat. It is similar to the putty that was used for the replacement worm. This liquid material is absolutely fabulous and will capture every detail of a master, enabling you to create a flawless copy. This rubber is also known as silicone rubber. The silicone is an important designation because it means that the material doesn't need what is known as a mold release. If I poured two-part foam into a plaster mold, for example, I would never be able to remove the cast because the foam would stick fast to the plaster. If, however, I coated the plaster mold with a mold release, it would form a barrier that would prevent this adhesion and enable you to remove the cast. Silicone rubber has the built-in mold release of silicone, so nothing sticks to it (unless you pour the same silicone rubber into it). Plaster, plastic, molten clay, and other substances can be freely poured and removed without the need for a release. A good source for this material is www.monsterclub.com.

Figure 9.10 *Silicone rubber is the mold material of choice for professional makeup and stop motion artists.*

Mold Applications

Rubber molds are very handy for stop motion production. Here are a few ideas of possible uses:

1. Cast a large number of ornate objects, such as Roman pillars for a set.
2. Melt molten clay in a double boiler to create many identical heads that can then be individually modified to create a replacement animation effect. This was the method used to create the heads in Figure 4.4.

3. Cast a number of wax replacement heads and carve different mouth shapes into them for speech. This was the technique used for the early Pillsbury Doughboy commercials.
4. Cast large props by creating a slush cast of hard resin backed up by hard foam. A slush cast is one where the liquid plastic is slushed around the inside of the mold until it cures, leaving an even skin or shell of hard plastic.
5. Create a collectable series of your character that you can sell as a limited edition. As an example, I sell limited editions of the characters I created for my book *Filming the Fantastic* from Focal Press through Mountainviewstudios.com. This company is a cast on demand firm that will provide fulfillment services for fine art. After the limited edition is cast, the mold is then destroyed, locking in the value of the casting run. You can either use a service such as this or cast your own collectibles from two-part resin.

Two-Part Resin

Many props and figurines are cast using a two-part urethane resin that takes great detail and cures quickly. Air bubbles can be an issue with both molding and casting. With molding it is best to use a vacuum chamber if you have one available, and with resin casting it is best to have a pressure chamber to avoid air bubbles on the surface of your cast. For RTV rubber molds, a good technique sans vacuum chamber is to pour the rubber from about 6 feet high so it forms a tiny stream devoid of bubbles. You then patiently fill the mold cavity and wait for the rubber to cure. Good casts can be obtained from resin even without a pressure chamber by preparing the surface of the rubber mold before casting. Air bubbles tend to be attracted to the rubber surface, but you can break that attraction by coating the surface with marble dust or spraying the surface with a plastic paint primer. The advantage of the primer method is that it not only helps to eliminate bubbles but also bonds to the slick resin and primes the surface so that you can paint the cast as soon as it comes out of the mold. To mix urethane resin, you just add equal amounts of parts A and B by volume and pour the mixture into the mold. Tap the mold while the resin is still liquid to force air bubbles to the surface and away from the figure area. When the mixture starts to cure it will generate a bit of heat, so care should be taken at this stage. After about 5 to 15 minutes, you can easily remove the cast and start the painting process.

Figure 9.11 *Two-part resin is a fast and easy casting material. This material can also be found at monsterclub.com.*

Painting Materials

A tremendous variety of paint material is available today. For the sake of brevity, I'll mention only a few that I feel are quite useful.

Primer

A primer coat is a substance that seals a surface and aids in the ability of paint to stick to an object. Wood, for example, is a porous substance that can be difficult to paint as it will absorb the solvent in paint and disrupt its ability to dry and cover adequately. A primer seals the wood and gives the paint something to adhere to. If you use a wood stain, there is no need for a primer as you are relying on the porosity of the wood to absorb the stain and bring out detail. Materials such as urethane resin have the opposite effect and are so slick and resistive that paint will not stick to them unless you use a primer. Some paints that have come on the market are self-priming, allowing you to skip this step.

Acrylic

For model building and figure painting, an inexpensive basic color kit of acrylic paint works very well. Liquitex makes a variety of kits that can be found at your local art store (visit www.liquitex.com). Acrylic is water soluble, is easy to work with, dries fast, and adheres well to most surfaces. The paints come in tubes in a variety of base colors. This paint can be used as is or diluted with water to create watercolor-style washes. The product was developed as an alternative to traditional oil paint.

Figure 9.12 *Acrylic paint is a great medium for painting models and sets.*

Oil Paint

Traditional oil paint has been used for years as the primary medium for fine art paintings. It is so versatile that visual effects artists such as Albert Whitlock chose to use this medium for their matte painting work. Because it has a slow drying time, the artist has the ability to do soft blends and feathering without having to worry about the paint drying before the artist finishes. Once the paint dries, the artist can paint transparent tones and glazes on top of the painting to add another dimension to the image. Whereas oil has been the medium of choice for many artists, others have been frustrated by the slow drying times and have also found themselves allergic to the oil and turpentine needed for its implementation.

Genesis Heat-Set Oil Paint

A new product called Genesis Heat-Set Artist Oils, manufactured by AMACO, addresses the toxicity and long drying times that have been the drawback to traditional oil paints. This terrific paint comes in a wide assortment of colors along with a thinning medium. The main advantage of using Genesis paint is that it will not dry until it is exposed to heat reaching 265°F to 280°F (130°C to 138°C) for several minutes. Once the paint

Figure 9.13 *Genesis heat set oils has all the advantages of the traditional medium without the drawbacks of long drying times.*

has dried, you can paint another layer and build up effects at your leisure, just as with traditional oil paint. The painted object can either be placed in a home oven or be exposed to hot air from a heat gun to cure the paint. You must be careful to ensure that what you are painting can withstand this temperature and not be destroyed by the heating process.

Enamel Paint

Enamel is the paint most commonly used for styrene plastic model kits. It comes in small vials in an assortment of colors. The paint is thinned with a solvent and can generate a smooth, even finish. Be aware that these paints are not universally friendly to all plastics. If you use enamel paint on Sculpey, for example, the paint will lose its ability to dry and remain permanently tacky, spoiling both the paint job and the model. If you are unfamiliar with paint, be sure to test it on a scrap piece of the material you wish to paint.

Spray Paint

A trip to the local hardware store will expose you to a wide assortment of wonderful spray paint options. Today we have spray paint specifically designed to adhere to plastics and not attack them as I mentioned with enamel paint. Some paints are formulated to generate texture within the paint, such as Fleck Stone manufactured by Plasti-Kote (www.plasti-kote.co.uk). Texture paints are great tools for creating rough stone surfaces quickly. Some spray paints even simulate metal and chrome as long as it is sprayed on a smooth enough surface. Be sure to spray in a well-ventilated area or outdoors. If you do spray outdoors, be aware of the wind, as it is easy to get carried away spraying your model with white paint and ignore the fact that the wind is depositing some of your paint onto your neighbor's black car.

Preval Paint Sprayer

Even with all the colors offered by spray paint manufacturers, I have often been frustrated with not finding an exact tint I need. This is especially true for the myriad of skin tones used for a variety of characters. A good tool for solving this problem is the Preval paint sprayer (www.prevalspraygun.com). This is a clever device that essentially lets you create your own spray paint can. You mix your paint or any other liquid in the glass canister provided, screw on the charged canister, and you have an instant paint sprayer for your custom color.

Faux Painting Kits

There are also many paint kits for simulating marble and other materials. One of the more successful material mimics is a kit manufactured by Sophisticated Finishes called the Bronze Antiquing Set (www.patina.com). This paint consists of actual powdered metal in a liquid binder. It offers an extremely effective way to simulate

a bronze figure. The other plus about the kit is that it has a second ingredient that acts as an oxidizer. Once the base coat of metal becomes tacky, you can apply the oxidizer and it will attack the metal to create an authentic patina finish.

Painting Rubber

It has always been a challenge to paint rubber, as the material flexes and therefore prevents many paints from sticking to it. Although there are specialty industrial paints formulated for rubber, such as Rubberbond (www .parasolinc.com), most model makers choose the less expensive solution of blending acrylic art paints, such as Liquitex, with rubber cement. The paint adds the color and the cement adds the bonding and flexibility. It is usually a good idea to add pigment to the foam rubber mixture to create the base color in the cast. After curing, the fine details can be added using the acrylic/rubber cement mixture. www.silpak.com recommends using vinegar to prime the latex surface and xylene to thin the rubber cement and acrylic paint mix. Alternatively, you can blend acrylic paint with raw latex and use that combination to paint the model.

Brushes

It is most cost affective to purchase a kit of fine art brushes made from synthetic nylon. The kits are relatively inexpensive, come in a variety of brush sizes, and are easily cleaned. It is best to start with student brush kits until you are comfortable with painting techniques. You can then decide if you want to move on to the more expensive sable brushes. In the majority of situations, synthetic materials work just fine. Inexpensive synthetic brushes are a must when working with latex rubber, as they can easily be destroyed using this material.

Ball-and-Socket Armatures

Ball-and-socket armatures are pieces of art in and of themselves. They are so compelling that many beginning animators feel that they can't even begin to animate until they have a professional ball-and-socket armature. Although armatures are the best skeletons to use for stop motion models, they are not necessarily a prerequisite for good animation. Many a good animator had years of practice animating objects, clay, and puppets with wire armatures before enjoying the advantages of a professional armature. In the past, stop motion artists had to train themselves in the discipline of machining to create their own armatures. My hat is tipped to those who wish to attempt this. The ability to machine metal is always a good skill set to have. Today, several companies specialize in making armatures or selling modular kits for assembling a custom one. This is by far the best

Figure 9.14 *A professional stop motion armature is a work of art in itself. Note the use of braided wire to facilitate the delicate movement of the ears, tail, and mouth. Courtesy of Harry Walton, vfxmasters.com.*

approach for speed and quality. For those wanting to go it alone, a copy of an article I wrote for *Cinemagic* magazine on building an armature step by step will be available on the companion web site for this book.

Armature Parts and Services

Today, the artist has access to talented machinists who special-ize in constructing animation armatures. For a fee they will take your character design plan and create a custom armature from scratch. As you can imagine, it is extremely time con-suming to make a custom piece, and these services are not inexpensive. A good halfway approach is to purchase indi-vidual components and solder them together to make a custom armature. Artist John Wright (www.jwmm.co.uk) has an entire catalog of basic armature joints and predrilled balls. With this arrangement, one has the advantage of using mass-produced materials. Once you make your plan drawings, you can take careful measurements and choose the joints you need from the catalog. It will then be a relatively simple matter to build up your own custom armature from professionally made joints by soldering together a configuration. I used this method to quickly make my Biomechadroid robot puppets for a rock video project. It is fast, convenient, and flexible. Another source for modular armatures in the United States is Mark Spess (animateclay.com).

Figure 9.15 *This Biomechadroid was created from modular armature parts purchased from Bill Hedge and finished off using Sculpey and "kit bashing."*

Making a Foam Rubber Puppet

Creating a mold, aligning an armature within, and casting foam latex into this assemblage is a complex procedure involving many nuances. The technique benefits from experience, as the materials such as the foam rubber are delicate and subject to temperature and humidity fluctuations. Although challenging, the process yields the most workable solution to the problem of making a robust and flexible stop motion figure. I will highlight the main points in this section. For those who wish to pursue this endeavor, I highly recommend an excellent DVD program, *Do It Yourself! Foam Latex Puppet Making 101* by artist Kathi Zung. Zung was one of the skilled model makers on the show *Celebrity Death Match* (1998), which required a constant supply of unique puppets for each episode. Zung has been extremely generous in sharing her hard-won knowledge of this exotic process, and her video program gives a better instruction than any text can hope to do. The DVD is available at www.angelfire.com/anime4/zungstudio. Here are some highlights of the basic process.

Making the Original

Because of the need for pliancy throughout the mold-making process, it is best to stick with the nonhardening clays and smooth as needed with solvents such as alcohol. A human figure is best sculpted in a classic Da Vinci pose with the arms and legs akimbo with hands facing forward to allow for a simple mold and a cast

that can be easily animated. For creatures such as dinosaurs, the anatomy should be sculpted for the most common pose of the creature. The best procedure for including an armature is to make the armature first and sculpt around it to ensure that the skeleton will fit inside the figure. This is not always possible, and in professional circles the sculpture and armature building will commence simultaneously and final adjustments to the armature will be based on the plaster mold.

Making the Clay Dam

Once the Plasticine original is made, you will want to screw in the tie-down bolts to the feet to provide a way of registering the armature within the mold. In Kathi Zung's tutorial, she also advises animators to project a mounting rod out of the top of the head so that the armature is registered within the mold in three places (the tie downs and head) and create a "handle" for the puppet for subsequent modeling chores. At this stage, we begin to rest the original in a bed of water-based clay to provide an organic dam that will allow our plaster to only mold up to the halfway point of our sculpture to avoid what is known as *undercuts*. An undercut occurs when the mold's cavity captures the casting material and prevents it from coming out of the mold. An example would be pouring plaster into a rubber bowl. A bowl being a container that funnels outward has no undercuts and the plaster can be removed from the mold easily. If, however, we poured plaster into a narrow-necked bottle, the hardened plaster would be captured by the narrow neck and could not be removed unless we broke the bottle.

Fortunately, rubber casting is more forgiving of undercuts than plaster, as it can flex past minor undercuts. Water-based clay is used, as it is soluble in water and provides a good working material that isolates well from the oil-based clay. Water will dissolve and smooth the water-based clay while leaving the oil-based original unaffected. The final step in making your dam is to include clay keys on the flat face of your dam. A key is simply a tapered rectangular shape of clay that will provide a positive interlocking mechanism for the two mold halves. Side A will have a depression, and side B will have a protrusion that exactly fits the depression. This guarantees that the two mold halves will fit together in perfect register. Once you have made your dam, a plastic sealant called Crystal Clear is sprayed on the surface of the clays to provide a uniform coating in preparation for the plaster.

Mixing the Plaster

Because the casting process requires durability and heat resistance (you will be baking the rubber mixture in the mold), the best material to use is dental stone or ultra cal. These hard materials are a cross between plaster of paris and cement. They take excellent detail, are extremely hard, and stand up to heat well. The mixing of ultra cal should be done with the use of rubber gloves, as the material contains lime and also gets hot when curing. Always sift plaster into water instead of water into plaster. This is critical to obtain a good mixture without air bubbles or dry pockets. Patience is the watchword here. In a rubber container of water, sift in the plaster until you have created a small hill of the powder that extends above the water line by about an inch. At this point you wait and watch until the plaster "slakes." Slaking is when the powder starts to absorb the water and look wet. When your hill of plaster has become saturated with water, you can then begin to stir and mix the solution. If you see a layer of water above the plaster, then you will need to sift a bit more plaster until you obtain a smooth mixture. Once the plaster is mixed, you make the cast in layers and reinforce with burlap fabric. Zung demonstrates the excellent shop practice of smoothing the shape of the mold for a safe and professional finish.

Mold Release

Once the mold has cured, it is flipped around and the water-based dam is removed exposing the ultra cal underneath. The clay sculpture is touched up to repair any slight damage from the casting process, and the plaster is coated with petroleum jelly (Vaseline) to act as a mold release. The Vaseline is critical to prevent the second half of the mold from sticking fast to the cured plaster. You must be careful to fully coat the surface of the cured plaster that will come in contact with the new batch. Before mixing and pouring the second half, you may consider placing thin clay slabs at the edge of the mold. Once the second half is cast, these slabs of clay will leave small gaps at the edge of the mold to allow you to insert a flathead screwdriver to pry the mold halves apart.

Prepping the Mold

Once the second half of the mold is cured, the two sides are pried apart and the original is removed and discarded. The two halves must be thoroughly cleaned of clay and residue and the interior of the mold inspected for air bubbles and repaired if need be. The interior is coated with another type of mold release specifically made for rubber. When dry, this release consists of a fine layer of powder. The armature is then placed within the mold and adjusted so that it fits and does not touch any of the mold surfaces.

Mixing the Foam

Kathi Zung's video makes use of the GM foam product that consists of a latex base, a foaming agent, a curing agent, and a gelling agent. The kit also includes the special mold release. The kit is available from www .monsterclub.com and other makeup supply stores. You will need an electric mixer and oven dedicated for model making, along with a digital scale or balance scale for making exact measurements. There are different formulations for foam rubber and each manufacturer will have different instructions. Zung's program is a great tutorial in that you witness the process in real time. There are exact timings involved for adding the agents to the mixture, and the chemicals are sensitive to the humidity and temperature. It is easy to become frustrated when the rubber suddenly gels in the mixer and you are left with a useless glob. Similar disappointments can happen when the mold is opened and you are left with a gooey, uncured mess. Pay close attention to instructions, take safety precautions, and don't become discouraged. In Zung's process, the foamed rubber is poured into both mold halves and brushed to fill every crevice. The armature is inserted, and the mold halves are closed and clamped together. Once the rubber has had time to gel, the mold is placed in a 200-degree oven to cure.

Some artists choose to insert the armature close to the mold and inject the foam into the cavity using special plunger devices. Exhaust holes are drilled at various places along the mold and are plugged as the injected foam oozes out. Although injection can yield good results, the paint-in method is a less fretful guarantee of filling the cavity. The final density of the foam mixture depends on the design of the puppet and the longevity required. For a chubby puppet with a lot of bulk, a light, fluffy foam might be the best bet. Some of the dinosaur models used on *Caveman* (1981) used dense foam that held up well during months of animation. Be aware that if you use dense foam, the armature has to be particularly sturdy and tight to flex the stiffer rubber.

Finishing and Painting

Whenever you cast foam rubber in a multipart mold, you will obtain a "flash" of excess foam around the perimeter of the cast. This flash rubber will need to be snipped off with scissors and doctored to create a

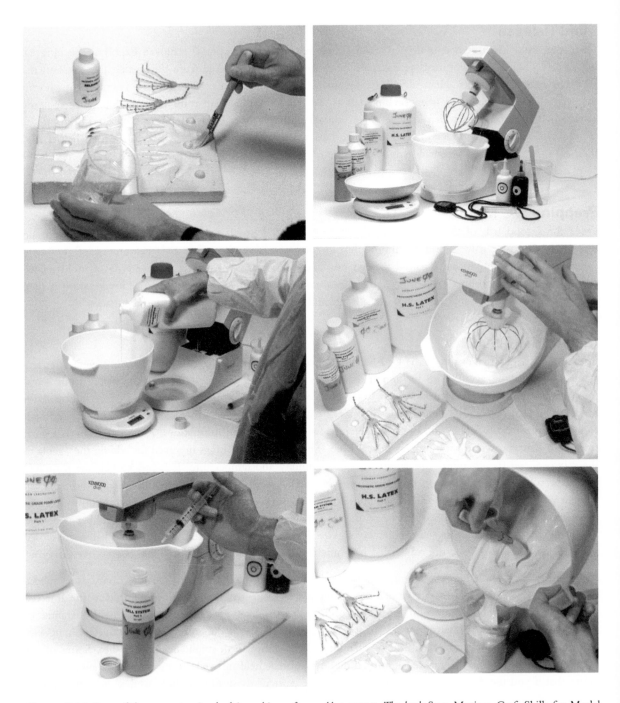

Figure 9.16 *Some of the many steps involved in making a foam rubber puppet. The book* Stop Motion: Craft Skills for Model Animation *by Susannah Shaw is an excellent text for providing details on many of the techniques used in the field. Shaw's book is available from Focal Press.*

seamless cast. Zung engages in a two-fold process of melting away rubber and filling in with liquid rubber to eliminate the seam. It is time consuming and can take several applications, but the results are well worth it. After washing and priming the cast, special rubber paints are applied using makeup sponges. Upon completion of the painting, the entire model is dusted with talcum powder to prevent the freshly painted puppet from sticking to itself.

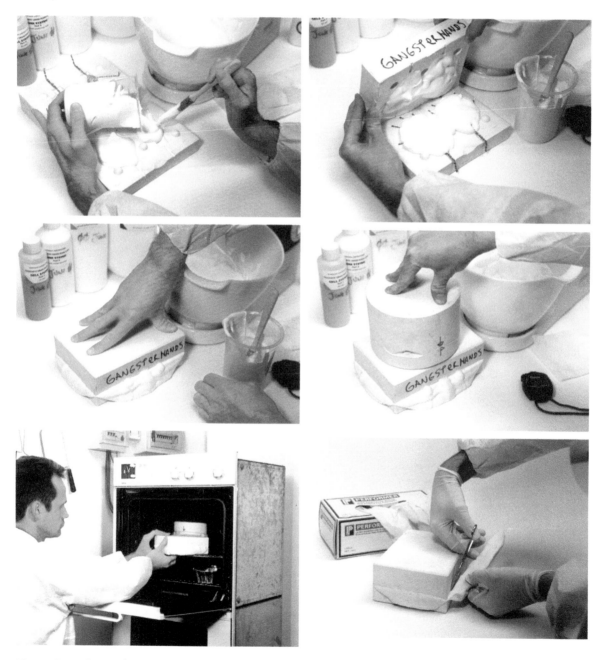

Figure 9.16 *Continued*

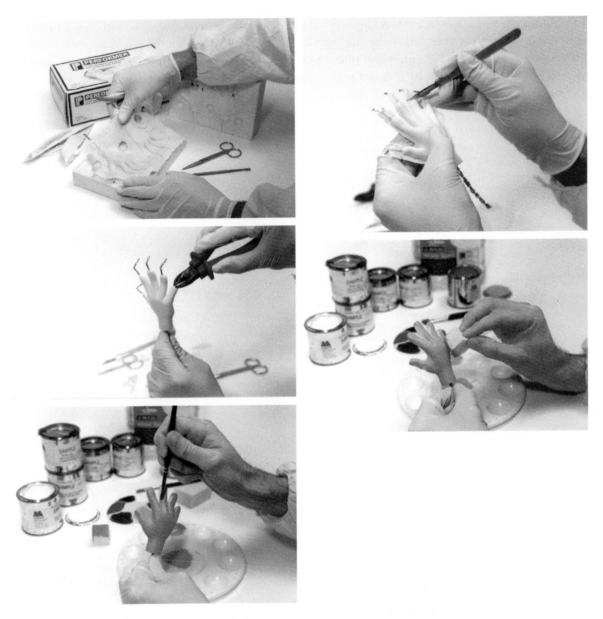

Figure 9.16 *Continued*

Summary

1. Build a stage that is a comfortable height using precut lumber from a building supply store.
2. Cross-brace your stage with lumber, and weigh it down with sandbags for stability.
3. Make separate sets mounted on boards that can be easily clamped and removed from your basic stage.
4. Balsa wood is a malleable model material that is excellent for wood settings and props.

5. Foam core and hot glue are mainstays for creating sturdy, lightweight sets. Be careful, as the glue is extremely hot.

6. Aluminum foil backed by two-part Styrofoam makes terrific rock formations. Always use plastics in a well-ventilated area with protective gear.

7. Chicken wire covered with plaster-soaked fabric is the traditional medium for low-cost rock models.

8. Super Sculpey is an excellent prototype material that can be hardened in a home oven and drilled and sanded to finish.

9. Silicone rubber, or RTV, is an excellent mold material that does not require a mold release. It is great for casting plastics and plaster.

10. Two-part urethane is an excellent and durable casting material that can be tooled and sanded and, after priming, easily painted.

11. The local hardware store has a wide variety of paints that adhere to plastics and simulate rock and chrome as well as other special surfacing effects. Take advantage of them.

12. Creating ball-and-socket armatures is an involved endeavor that requires an assortment of special tools to do the job. A better approach is to invest in modular components and do a custom assembly.

13. Casting a foam puppet is an involved endeavor that gets easier with experience.

Films to See

I strongly recommend Kathi Zung's excellent video, *Do It Yourself! Foam Latex Puppet Making 101,* which allows you to watch every step of the process in detail. She shares many fine points and tips that go well beyond my basic outline of the procedure.

Chapter 10

Cameras for Animation

TV and the Computer

For many years, television and the computer industry were different worlds. Video was an analog system that used a continuously variable electronic signal to create pictures not unlike the traditional clock with sweep hands or the groove in a phonograph record. Computers did their magic by breaking down the world into the binary language of ones and zeros. Instead of being constantly variable, the computer's signal is made up of discrete components much like a digital clock that tells you in no uncertain terms that it is 12:01 exactly. It has taken a long time, but we are finally in an age where video and the computer can finally talk to each other. The problem is that the camera can talk to the computer in many ways. Let's look at a few solutions.

The Computer Industry Makes a Camera

One popular scheme to avoid translating a video camera's signal into something the computer can use was to have the computer industry make a camera that spoke its language, hence the web cam was born. As you learned from the first chapter, these tiny cameras already have a USB hookup that plugs right into the computer and is happy in that environment. As long as you install the driver for your web cam, Stop Motion Pro will be able to easily recognize it and take over its control as you animate. The one drawback is that web cams are fairly low-quality cameras and only good for initial experimentation. Chapter 1 shows how to use a web cam with Stop Motion Pro.

Video Goes Digital

Sony and other manufacturers began to see the value of creating digital cameras to overcome the problems of the original analog signal. Traditional video was always subject to deterioration of the image each time it was copied, and certain aspects of the image such as color could not be relied on to be consistent. In the rush

doi: 10.1016/B978-0-240-81219-9.00010-6

to be the first to establish "the" system, video manufacturers created a large number of formats and specialty connectors such as FireWire, i.LINK, and IEEE. These special cables required computers to also have these sockets and boards to take in the video information that used a large amount of data and storage space. Always turn cameras off when connecting to or disconnecting from a PC when using FireWire. This is important because the digital video (DV) connection can be damaged if the camera is on when unplugged. If you do not have a FireWire lead or connection on your PC, you can purchase one from any computer shop. Any generic FireWire card or PCIMA card (for laptops) should work. Chapter 2 shows the step-by-step process of using a DV camera with Stop Motion Pro.

Can't We All Just Get Along?

Although connections such as FireWire are still available and viable, a more common solution is to use what is called a USB connection. USB stands for universal serial bus and was developed to connect not only cameras but also printers, keyboards, mice, and other peripherals to the computer. The important thing is not the cable itself but the information it carries. In this respect, you need to find cameras that will have some type of digital output signal that can go through a USB or other connector to talk to the computer.

I Don't Have a Digital Camera

This is a common issue for schools and individuals who can't afford to keep up with current digital technology. You have a computer and your copy of Stop Motion Pro but just have Grandpa's old home video camera that shot in Hi 8 format. Fortunately, a solution is readily available in an inexpensive hardware device called the Stop Motion Pro Video Adapter Kit. Stop Motion Pro sells the SMP Video Adapter along with the software on its Amazon site. You can easily find it on the products page of filmingthefantastic.com. You simply install the software for the adapter on your computer and plug the older video outputs of your analog camera into the device and out come clean, crisp digital signals that go right into the computer's USB port to transport you into the 21st century where you can do old-time stop motion using the high tech of Stop Motion Pro.

Figure 10.1 *Here is an old Hi 8 camera that was damaged in the 1994 earthquake. It can't record on tape anymore, but the camera output signal can still be used with the SMP Video Adapter to shoot animation using Stop Motion Pro.*

How to Use the Adapter

Older video cameras that use tape and the newer video cameras that use DVD, hard drive, or memory card have one thing in common—all of these cameras have a standard video output labeled AV for audio/video. This analog output usually has a single plug that divides into three plugs that represent video and left and right audio output. These plugs have a universal color code, and yellow always represents video. This is the only plug you need to connect to the SMP adapter. The hookup for my Hi 8 camera was even easier, as it had a separate output for video and audio, so no confusion there.

What If I Need to Make a Decision?

Stop Motion Pro will be able to determine what the signal coming out of your camera is and adjust the input accordingly. But yikes! What if it doesn't? What do all those menu settings mean? What if I have to make a decision? Here is a quick breakdown. Open the menu list for the size. You will get a slew of numbers that indicate the number of

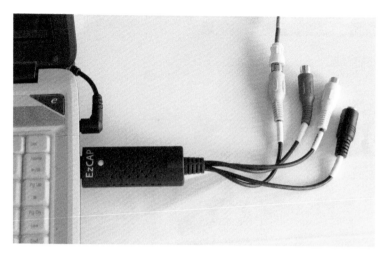

Figure 10.2 *Plug in the yellow video output lead into the yellow input of the Stop Motion Pro Adapter. Plug the adapter into a USB port on your computer. Once plugged in with the camera turned on and live video in the viewfinder, start Stop Motion Pro and start a new project. The capture settings dialog will appear; select Capture type Video/Web cam. You can then scroll through the device menu until you find "USB 2861 Device" or similar. This is the name the computer uses for the SMP Video Adapter. Adjust the size to the maximum option available. The Input selection is what is important to watch for. All you need do is let Stop Motion Pro know what kind of video you're using. Video comes in a number of signal formats: composite, component, and S video to name a few. The audiovisual output of my Sony camera is called a composite signal because it lumps all three colors that make up an image (red, green, and blue) into one analog signal. Component video used on professional video cameras will have three separate cables, one each for red, green, and blue, for the component colors that make up the signal. S video is a better quality version of the composite signal. If you have an S video output, you would improve your quality by choosing that output over the AV output. The S video cable is the black input jack on the SMP adapter. The white and red jacks are for audio, so you won't be using those. In the case of the Sony camera, just connect the yellow video output lead to the yellow input jack of the adapter, plug the adapter into the USB port, choose Composite for the input on the control screen, and hit Apply.*

pixels in the horizontal and vertical dimensions of your image. Typically you would pick the one with the largest image but you have to do it for your format. If you look to the right of the image dimension numbers, you will either see 25 fps (frames per second) or 29.97 fps. If you recall, in Chapter 1 I wrote of the development of frame rates, so you know that 25 fps is for Europe and 29.97 is the NTSC frame rate for the United States. Because I'm in the United States, I will choose the biggest picture available at the 29.97 rate. You can choose a smaller image size to store more images, but the quality won't be as good.

Okay, I Did That but I Still Don't See a Picture

In the unlikely event that you do not see a picture, click on the Format button of the Capture settings control panel to open the Settings properties panel. If you open the video standard list, you will get a dizzying assortment of choices. Let me quickly break this down for U.S. formats:

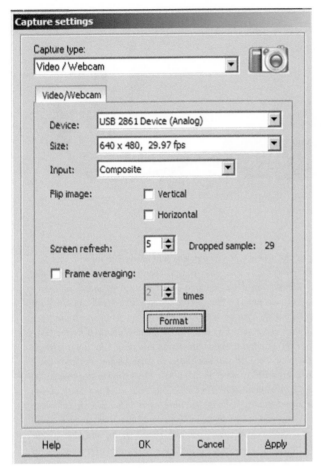

Figure 10.3 *Choose USB 2861 for the input and Composite for the format. If you are in the United States, choose the highest resolution at the 29.97 frame rate.*

1. *NTSC-M.* The is the standard NTSC used in the States and would be the default selection.
2. *NTSC-M-J.* This is the Japanese variant of NTSC. If you're in Japan you may want to select the J option.
3. *NTSC_433.* This is a wacky signal that transmits the color information so it can be read by some laser disc players and other devices. If you are in the States it is best not to choose this option, as the color will disappear on most standard TV monitors. You can see this for yourself if you watch the image on your computer and change to each of the three options. In the States, NTSC-M will have the best color, NTSC-M-J will have weak color, and NTSC-433 will have no color at all.

The Rest of the World

Here are some formats used in other parts of the world:

PAL-B: Most of Western Europe
PAL-D: Mainland China
PAL-G: Western Europe

PAL-H: UHF signal used in Belgium, Luxembourg, and the Netherlands
PAL-I: UK, Ireland, South Africa, Macau, Hong Kong, and Falkland Islands
PAL-M: Most of the Americas and Caribbean, Philippines, South Korea, Taiwan, and Brazil
PAL-N: Argentina, Paraguay, and Uruguay
PAL-60: The PAL equivalent of the NTSC 443 discussed previously
SECAM-B: Middle East, former East Germany, and Greece

Figure 10.4 *Stop Motion Pro accepts signals from all over the world*

SECAM-D: Commonwealth of Independent States

SECAM-G: Middle East, former East Germany, and Greece

SECAM-H: Invented to accommodate teletext

SECAM-K: French-speaking African countries

SECAM-K1: A variant of above

SECAM-L: France

SECAM-L1: A variant of above

UNKNOWN: Outer space and beyond

Wow, that's a ton of information, but not to worry; Stop Motion Pro makes the choice automatically. If you decide to do it yourself, the software definitely has the world covered. If in doubt, select Unknown or go through a trial-and-error process until you find a setting that yields the best image quality. You can do stop motion animation anywhere.

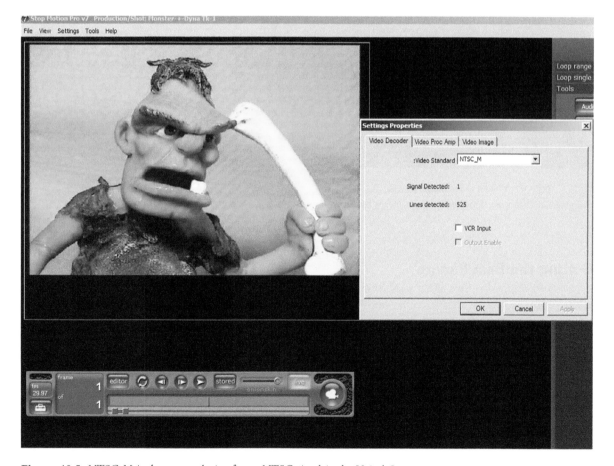

Figure 10.5 *NTSC-M is the proper selection for an NTSC signal in the United States.*

Figure 10.6 *NTSC-M J is the proper selection for an NTSC signal in Japan. If you are using a Japanese camera, this setting may be appropriate. Select the best-looking image and go by that.*

Getting the Best Picture

If you open the Video Proc Amp page of the Setting properties, you will see a number of controls that can modify the video image after it comes into the computer. It is a good policy to use these controls only as a last resort. If you are shooting in low-light conditions, it may be tempting to go to this control panel and crank up the brightness and contrast to make the image somewhat acceptable. What you have to keep in mind is that if you have a poor signal coming in, you won't be able to turn it into a great signal by boosting what isn't there. If you have a dark picture, the best procedure is to add more light on the set so you obtain a good image at the default settings for both the camera and the Settings Properties panel.

High Definition

The spectacular high-definition imagery that we all enjoy isn't really all that high definition. A standard video image has an image size of 720 × 486 pixels, whereas a high-def image is typically 1280 × 720 pixels. A

Figure 10.7 *The NTSC 433 is obviously incorrect, as we have no color information at all. If in doubt, experiment with a few formats from your area until you find one that generates the best image.*

high-definition image is huge if compared to standard definition, and there lies a problem. For several years computers have been happy sending standard video to and fro in real time lickety-split. You might compare this to someone drinking a pint of milk through a straw during the span of a minute. Now imagine using the same straw and the same minute to drink a gallon of milk. The problem of high definition is how to get these enormous images to move through the system at the same speed as standard video. The solution was to add compression to the high-definition images called MPEG (Motion Picture Experts Group). You can think of compression as trying to get a nice 8-by-10-inch photograph of yourself through a 1-inch hole. Lossless compression would be rolling up the photograph, passing it through the hole, and unrolling it with no damage done. Unfortunately, high definition uses MPEG compression that is more like crumpling up your picture, shoving it through the hole fast, and uncrumpling it. You see the image, but it looks fairly poor with all the wrinkles and creases. High-definition cameras with a high-definition video (HDV) FireWire, i.LINK, or IEEE connection can be used with Stop Motion Pro, but this creates artifacts and substantial compression of the image quality because of HDV technology. If you are connecting a high-def camera by this means,

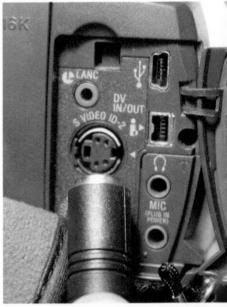

Figure 10.9 *Inserting the S video output of yo[u] camera into the black S video plug of the SMP Vid[eo] Adapter will give you a slightly better video image.*

Figure 10.8 *Only use the Video Processing amplifier panel as a last resort. It is always best to just add more light to the scene.*

you will need an MPEG decoder. A free decoder can be downloaded from the Stop Motion Pro web site.

Another High-Definition Possibility

To get the best quality from a high-definition camera, Stop Motion Pro recommends another type of translator card from Black Magic Design. In this case, you would connect your camera's component output red, green, and blue or a high-definition multimedia interface (HDMI) output to the card called Intensity/Pro and Extreme to obtain clean, high-definition images. This is the high-definition version of the SMP Video Adapter.

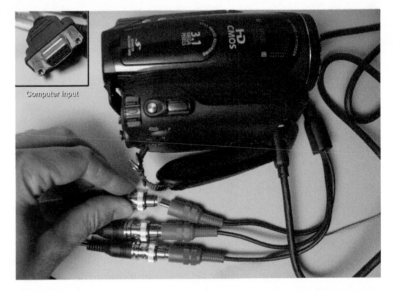

Figure 10.10 *A high-def camera connecting its red, green, and blue outputs to the computer via a Black Magic Design box.*

Hey, I've Got a Compact Digital Camera. How about a Cell Phone Camera?

Uh…, no.

Let me elaborate on that. Although it is possible to use a compact camera with Stop Motion Pro, you wind up losing many of the great advantages of the software. First of all, any camera used with Stop Motion Pro *must* have remote control software supplied by the camera manufacturer. This is software that will allow you to control and capture images from the camera via the PC. If this requirement is met, Stop Motion Pro can monitor and grab pictures as they travel from the camera to the computer. This would be similar to shooting all your animation with the camera by itself and then importing all those images into Stop Motion Pro so that you could play back the animation and do editorial and sound functions. Unfortunately, you lose the live view, onion skinning, rotoscoping, markers, and chroma key functions that make your animation shooting so much easier. The other problem is that these cameras tend to be entirely automatic, so you have little control over exposure and focus (setting them and locking them off), thereby compromising the animation process.

Controlling a High-Resolution Still Camera

One thing that is completely revolutionizing the photographic industry is that the lines between digital still cameras and video cameras have completely blurred. The new still cameras not only shoot exquisite high-quality stills but high-definition video as well. As I mentioned previously, high-definition video cameras have special challenges involving the streaming of large images in real time. Fortunately, animation is a collection of still images that are turned into motion; as a result the quality of those individual frames can be excellent so digital still cameras fit the bill quite well and can be used directly without the need for a translation device. The important attribute of a still camera is that it must have a remote control capability so that Stop Motion Pro can control it. Manufacturers that include this feature are Canon, Nikon, Olympus, Pentax, and Leica. Let's start with an earlier model of digital camera that creates high-quality images but perhaps does not have as many of the bells and whistles of a newer camera. Let's hook up a Nikon DSLR D5000.

1. Make sure you have a fully charged battery or a power supply so the camera won't shut down during the animation process.
2. Set the camera to M for manual.
3. Go to the camera's menu and select USB PTP, not mass storage. This will let the computer communicate with the camera.
4. Plug the camera into the USB port and fire up Stop Motion Pro.
5. Select Capture type to Nikon DSLR, not video assist.
6. You now have control over the exposure and aperture of the camera.

Finding the Exposure

Using the camera controls, you can use a trial-and-error method of shooting frames and adjusting the camera exposure speed until the image looks correct. A more surefire way of finding the correct exposure is to use an old-fashioned light meter. In the camera control, you will have four major settings to adjust:

1. *White balance.* You have a choice of Fluorescent, Daylight, Tungsten, or other light sources. Pick the one that matches your lighting conditions.

Figure 10.11 *The camera control menu. This window gives you control over resolution, exposure time (TV time value), and f-stop (AV aperture value).*

Figure 10.12 *The camera advanced exposure settings. Here you would input the sensitivity and white balance.*

2. *ISO setting.* This stands for International Standards Organization and this number represents the sensitivity of the camera to light. This ISO number was also known as the ASA on older cameras and light meters. These terms stand for the same thing. This setting can vary if you need to adjust the f-stop or exposure to obtain a certain look. A standard default setting of 200 ISO is fine in most cases.

3. *F-stop.* This is also called the AV (for aperture value). This number represents the position of the iris inside the lens. The smaller the number, the wider the iris or aperture and the more light that can get through to the camera sensor. The bigger the number, the smaller the iris and the less light that will get to the sensor. The advantage of using a bigger number is that more objects will be in focus.

4. *Exposure time or time value.* This number is represented in fractions of a second, such as 1/25 of a second.

Put the camera control at Tungsten, 200 ISO, and exposure time of 1/60. You now take your light meter and set it to 200 ISO and place it in the scene with the white half sphere pointing toward the camera. After you take your reading, you can align the meter's needle to the dial and then read across from the 1/60 of a second to read the f-stop value of 5.6. Now you know that the correct exposure will be f/5.6 at 1/60 of a second. If you have less light, the meter will tell you to set the f-stop to something like f/4.

If you don't want to use a stand-alone light meter, you can use the meter in your camera. Set the camera to M for manual and adjust

Figure 10.13 *You can use a light meter to find the perfect exposure or you can use the camera's built-in meter.*

either the exposure time or f-stop until you reach the correct exposure point as seen in the viewfinder. Once you hit the correct exposure, take note of the exposure time, f-stop, and ISO, and make sure those settings are the same in the remote control panel in Stop Motion Pro. Although you can use a digital still camera in this manner, you lose the Live View functions of Stop Motion Pro. A better solution is to grab a live video signal off a still camera.

A Still Camera with Video Assist

Some cameras, like the Pentax DSLR, have a low-resolution Live View function, which will allow you to work with Stop Motion Pro using standard video resolution. Keep in mind that the Live View function eats up a lot of power, so you are advised to use a constant power supply for your camera. If the camera should shut off due to lack of power, it won't remember your settings and you will have to set them all over again. In the case of this camera, you will once again use the SMP Video Adapter to take the video signal from the Pentax and convert it to a digital signal we can port into the computer. Open Stop Motion Pro and select web cam/video and the USB 2861 device as you did before with the video camera; lo and behold, you have a live view on your Stop Motion Pro screen. You now have all the great tools at your disposal, such as onion skinning and rotoscope. The trick here is to both shoot a frame using the video assist on Stop Motion Pro and push the button on the camera to capture a high-resolution frame. So for each pose you will push two buttons: the Stop Motion Pro button and the camera button. So pose, click, click, then make a new position. If you get into the rhythm of this, the procedure isn't bad and you can capture high-rez images while you have the advantage of the live view. After you have finished your animation, you can import all the high-resolution imagery from the still camera and use Stop Motion Pro to do the fine-tune editing adjustments.

High-Resolution Live View

The best of all possible worlds is to use a camera with a high-resolution Live View function. This live view is a direct live video image from the camera, streamed over USB2. Stop Motion Pro interfaces with this live view and controls the camera. The Canon 450D (Xsi), 1000D, 40D, 1DS Mk III, and 1D Mk III are examples of cameras with this capability. Nikon cameras are also starting to become available with this function. It is the ultimate in video assist and is a great way to "fly" with Stop Motion Pro. All the looping controls, frame editing, onion skinning, and audio sync

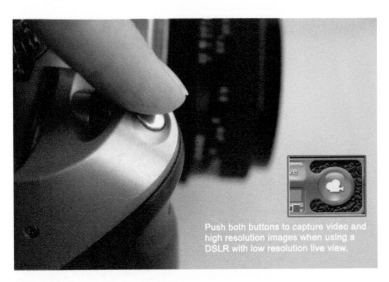

Figure 10.14 *With a low-rez video assist, be sure to press the Stop Motion Pro* button and *the still camera capture button to get those high-resolution frames.*

tools work with the new live view cameras. Remember to test your camera with the free trial of Stop Motion Pro to ensure compatibility. Only Stop Motion Pro Studio HD (and Studio HD Educational) and Studio HD Plus support the Live View function of these cameras.

Set up for the Canon Eos 40D

As mentioned previously, it is a good idea to use a mains power supply to prevent your battery from being exhausted and shutting down your camera. Set the camera to M and plug the USB cable into the port on the computer:

1. Under capture type, select Canon DSLR, EVF Assist.
2. You can see that you are able to select an extremely high resolution of 2816 × 1880.
3. As before, set your ISO, white balance, and exposure time. Once you arrive at your exposure setting, take a picture. You have now stored a video assist frame and a high-resolution frame at the same time. No need to push two buttons as with the Pentax.
4. When you press Play, you are playing back the video assist frames. If you go to View/Captured frames, you will be able to see the high-resolution frames.
5. To see the high-resolution frames in detail, go to the View/High-Resolution viewer. You can now see your high-res frame in extreme close-up detail to check for focus and other issues under the microscope. This setup is what you'll use for your Academy Award–winning short.

Hey! What about That F-Stop?

Those auto focus and exposure lenses that come with your DSLR are great for live photography but can be a little dicey for animation. They are so loose and delicate to accommodate auto focus motor functions that

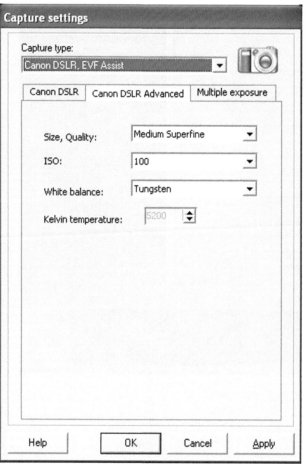

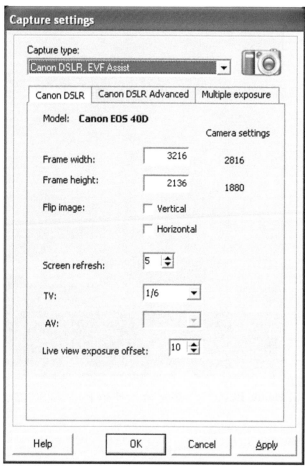

Figure 10.15 *The Canon control menu for white balance and sensitivity.*

Figure 10.16 *The Canon exposure menu. Note that the f-stop or AV (aperture value) setting is disabled because you are using a manual lens on the camera and will be setting the f-stop and focus on the lens itself.*

they can be subject to small mechanical changes in between frames of animation. These little frame-by-frame changes can result in a flicker effect in your animation. The best solution for this problem (which is used for professional productions) is to go retro and replace the automatic lens with an old-fashioned lens that allows you to set the focus and f-stop manually. This stops flicker because these excellent older lenses are tight and stable and not meant to move constantly. You can tape off the focus barrel to prevent any unwanted movement, and the f-stop often has positive click stop positions that lock the aperture in place. To attach a manual lens to your Canon, you will need an adapter that will allow you to attach a lens from a different manufacturer to work with the Canon. These adapter "rings" can be found on Amazon.com and eBay. Links to these adapters can be found on the Stop Motion Pro.com web site.

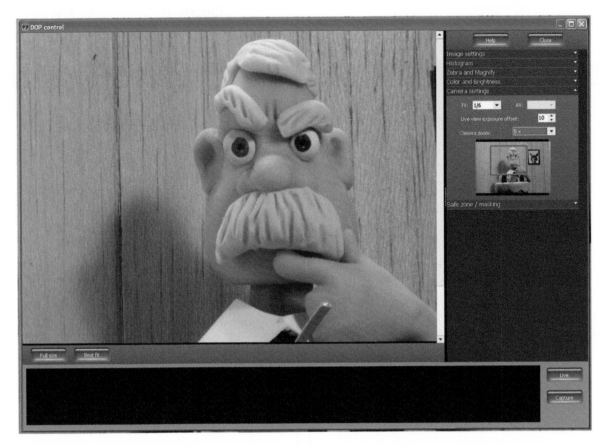

Figure 10.17 *The high-rez viewer allows you to examine the final image in extreme detail.*

Figure 10.18 *Use a lens converter attachment to connect a manual lens to a DSLR to eliminate flicker.*

Figure 10.19 *The manual lens attached to the digital camera. You might consider taping the focus down on the lens to prevent it from accidentally being moved.*

A Note about Focal Length

Still camera manual lenses were designed to be used with still film. The size of the film area exposed was bigger than the size of the sensor chips used in digital still cameras. As a result, the focal length will be slightly different from what is indicated on the manual lens. In other words, the field of view or how much of the scene you see will be different. If you put a film camera next to your digital camera and put the same manual lens on both, you would find that you could see more of the scene in the film camera's viewfinder than the digital camera's viewfinder because the chip is smaller than the film. For a DSLR, this is expressed as a crop factor of 1.6×. To get the effective focal length of a manual still lens on a DSLR, you would multiply the focal length by 1.6. So a 28-mm manual lens placed on a Canon DSLR would have the field of view of a 44.8-mm lens on a film camera. In other words, you will see less area. The important thing is to get rid of the possibility of flicker on your masterpiece by using a manual lens.

Speaking of Flicker
Here are some great tips from the Stop Motion Pro web site.

Minimizing Flicker
Does your animation "flicker" when you play it back? Here are some tips to minimize flicker and achieve a more professional result.

Flicker is an issue that affects everyone who animates. Basically the light intensity changes between frame captures and this change is reflected by a flickery movie when played back. It can be a frustrating issue to resolve, with professional studios spending many thousands of dollars to avoid it. These tips start at the most common causes, which happen to be the easiest to fix, so we suggest starting at the top and ensure you have minimized each step before moving onto the next. It is easy to become obsessed with flicker in your animation. Try not to let the pursuit of flicker-free animation stop you from the real task of making animated films!

Minimize Flicker, Step 1: Camera Basics
The camera is a key tool in animation; if functions are left in an auto mode, then changes to your characters or subject matter on set will result in minor adjustments going on inside the camera in between frames, causing flicker. Minimize this by doing the following:

Lock exposure. Go to a manual mode, which locks the aperture of the camera.
Lock shutter speed. Some web cams refer to this as "gain"; some video cameras have auto shutters, which can change the exposure time; ensure these are turned off.
Lock white balance. This is very important. Avoid leaving your camera set to auto white balance, as changes on set mean the camera will change the color balance in between frames. Set the white balance to whatever lighting you are using: tungsten (indoor), fluorescent, outdoor, and so on.

Minimize Flicker, Step 2: Lighting Basics
Control your light sources as much as possible. This means try to avoid having outside light creeping in on your set; when the sun goes behind a cloud outside, or if you stop for a cup of coffee, the light will change, resulting in flicker. If possible, black out all windows and doors; it is important, however, to keep fresh air coming into your workspace, so you will need to consider this. If you really want to control light, paint the room black, and avoid any surfaces that reflect light in the room. You better check with whomever owns the building before painting rooms black.

Minimize Flicker, Step 3: You

What you wear while animating can result in flicker! Try to wear black or dark clothing. In professional studios, people often duck under tables or under the set to avoid reflections and light bouncing off them in between frames. It makes a big difference. Try animating a scene with a white shirt on and then with a black shirt; you will notice less flicker when wearing black. Your body may also block or unblock a light source or reflection in between frames, causing flicker.

Minimize Flicker, Step 4: Your Computer Monitor

Yes, your computer monitor is a source of light, and it may cause visible reflections on set or off you and onto the set.

Minimize Flicker, Step 5: Your Power Supply Is Problematic

Changes in light may be due to different loads on the power coming to your home/studio. This is difficult to eliminate and is discussed later. If you are using a video camera or web cam, turn Stop Motion Pro's frame-averaging function to 10 to 20 frames. This will help to smooth out the variations somewhat. Note too when a refrigerator, washing machine, or other electrical appliance is operating; it can cause fluctuations in the power going to your lights, and therefore the intensity.

Advanced Flicker Reduction Techniques

If you have worked your way through the preceding suggestions and are still experiencing flicker that you find unacceptable, you need to move to the next level of flicker reduction. These techniques can be time consuming, cost money, and may not work in your situation, so please take this as general advice that are suggestions only. We do not want to encourage anyone to undertake tasks that are beyond their competence.

You should run tests using the Time Lapse tool in Stop Motion Pro at different times of the day with no one on set and with your studio lights running. See if flicker is evident, with a range of shutter speeds if possible. In our small studio, the power supply becomes more unstable (resulting in flickery lights) in the early to midevening, when everyone in the suburb comes home and turns on their appliances perhaps! Stormy/windy weather can play havoc with mains power.

Minimize Flicker, Step 6: Your Shutter Speed

If you are using a digital still camera, be aware that fast shutter speeds may contribute to flicker (faster than 1/10 of a second). Mains-powered tungsten lights and fluorescent lights with magnetic (rather than electronic) ballasts cycle in unison with the mains power supply; this means the lights are going on and off between 50 and 60 times a second. If your shutter speed is too fast, you will capture during the lighter or darker part of the cycle. Some studios solve this problem by changing to DC rather than AC power. You can minimize the effect by using a longer shutter speed.

Fluorescent replacement globes (that go in tungsten light mounts) often have "electronic ballasts." This means the lights flicker on and off thousands of times per second, thereby minimizing the flicker effect. Professional fluorescent light fittings have electronic ballasts. You should always check.

Minimize Flicker, Step 7: Your Lens

If you are using a DSLR camera with a removable lens, you may have an issue with the aperture open and closing (and being slightly different) in between frame captures. Every time a DSLR takes a shot, the aperture of the lens is shut down to whatever the aperture is set to; once the shot is taken, the aperture opens up fully again, giving a nice, bright image in the viewfinder. Slight variations in how closed the aperture is may result in flicker. This is a tricky problem to solve. You may want to turn this feature off if possible, or try using lenses that are 100% manually operated. We have heard of

one studio that simply unscrews the lens slightly and therefore disengages the auto mechanism; we are not suggesting you do this. Another professional studio actually pulls the lenses apart and removes this mechanism entirely.

The most popular option is to use a manual aperture lens on the camera. This keeps the aperture locked throughout the shot, giving even exposures. Canon lenses will need an adapter; these are inexpensive and available from eBay and other online sources. Look for a Canon EOS mount to Nikon lens, for example. Other popular lenses are older Olympus, M42, Carl Zeiss, and Pentax brands.

Minimize Flicker, Step 8: Your Power Supply, Part 2

If your power supply seems to vary a lot (after running the time lapse test outlined earlier), you may need to consider other alternatives. One option may be to go to a constant ("always online") uninterrupted power supply (UPS) for your lights. These are quite expensive, especially if you have a large lighting load, and may or may not work. However, they are worth testing. We have had success with a line-interactive UPS, much cheaper than an always online UPS, by turning it off (causing it to switch to battery backup power) when capturing frames. We found that the supply needed a couple of seconds to stabilize when turned off. Again, this may not fix your issue. We use electronic-ballast fluorescent lights, which have a much lower power load than tungsten lights (and are much cooler).

After all this, you may be required to call in a professional electrical engineer to outline ways to stabilize ("clean") your power, just like the big studios do.

Camera Moves

One common problem that animators run into is incrementing the pan or tilt of a camera. Even a fairly wide pan of the camera creates a huge challenge to make increment markings along the shaft of your tripod. The pan may take 2 seconds or 24 frames (if shooting at 12 fps), but the actual distance of the camera rotation may be only 1/4 inch. The animator quickly discovers that there is no room to draw in 24 marks in this tiny space, let alone use them. The solution comes from an age-old technique of using a pantograph. In times past, sculptors used a pantograph to transfer the dimensions of small clay figures to large stone monuments. It consisted of a wand with two pointers to magnify the dimensions. In the case of our camera move, all you need do is tape a laser pointer to the tripod pointing to a wall about 10 feet away. Place the camera at the start position, shine the pointer on the wall, and make a mark. Now move the camera to the end position,

Figure 10.20 *Attaching a laser pointer to the handle of the tripod can make plotting pans and tilts much easier.*

shine the laser again, and make a mark. You now have a distance of perhaps a yard between your marks that you can easily increment and animate. Isn't this much better than making 24 tiny marks in a teeny-weeny little space?

Camera Dollies and Mathematical Eases

In some cases you may be fortunate to find a secondhand lathe bed that will move a platform using a screw drive that allows for fine incrementation. The drawback to this solution is the finite length of a lathe bed and the weight of the device. Another alternative would be to create a sliding platform out of an aluminum channel as used with window sliders. It is important to have some type of locking mechanism so that the camera can be stabilized in between each camera position. Once you create a platform that is smooth and lockable, it is time to make your animation increments. The method I have used with great success is based on the Disney bell curve formula. It is a visual system that can be done graphically without a lot of mathematics. You will need lined paper and the ability to count. In this example we will be moving a camera 3 feet over 30 frames and include the all-important ease in and ease out. Here are the steps:

1. On your lined paper, write down the frame numbers from 1 to 30 along the side.
2. Choose the smallest increment you would like to use along your yard or meter stick. For this example, we will use $\frac{1}{4}$-inch increments along the yardstick. There are $144 \frac{1}{4}$-inch markings along a yardstick. To the right of each frame number, put down .25 representing $\frac{1}{4}$ inch or our smallest increment.
3. Add up the number of .25 increments you have used up. You will have 30 × .25, or 7.5 inches. In other words, you have used up 30 out of $144 \frac{1}{4}$-inch increments possible in your move.
4. Move one column to the right and put down $28 \frac{1}{4}$-inch increments from frame

Frames	30 inc	28	26	24	22	18	Camera Increments
1	.25						.25"
2	.25	.25					.50"
3	.25	.25	.25				.75"
4	.25	.25	.25	.25			1"
5	.25	.25	.25	.25	.25		1.25"
6	.25	.25	.25	.25	.25		1.25"
7	.25	.25	.25	.25	.25		1.25"
8	.25	.25	.25	.25	.25		1.25"
9	.25	.25	.25	.25	.25	.25	1.5"
10	.25	.25	.25	.25	.25	.25	1.5"
11	.25	.25	.25	.25	.25	.25	1.5"
12	.25	.25	.25	.25	.25	.25	1.5"
13	.25	.25	.25	.25	.25	.25	1.5"
14	.25	.25	.25	.25	.25	.25	1.5"
15	.25	.25	.25	.25	.25	.25	1.5"
16	.25	.25	.25	.25	.25	.25	1.5"
17	.25	.25	.25	.25	.25	.25	1.5"
18	.25	.25	.25	.25	.25	.25	1.5"
19	.25	.25	.25	.25	.25	.25	1.5"
20	.25	.25	.25	.25	.25	.25	1.5"
21	.25	.25	.25	.25	.25	.25	1.5"
22	.25	.25	.25	.25	.25	.25	1.5"
23	.25	.25	.25	.25	.25		1.25"
24	.25	.25	.25	.25	.25		1.25"
25	.25	.25	.25	.25	.25		1.25"
26	.25	.25	.25	.25	.25		1.25"
27	.25	.25	.25	.25			1"
28	.25	.25	.25				.75"
29	.25	.25					.50"
30	.25						.25"

2 to frame 29. We now have used up an additional 28 out of 144 increments. Combining the second and third columns, we have used 58 out of 144 increments.

5. Move one column to the right again and put down 26 $\frac{1}{4}$-inch increments from frame 3 to frame 28. We now have used 84 out of 144 and have 60 increments left.

6. Move one column to the right and put down 24 .25-inch increments from frame 4 to frame 27. We now have used 104 out of 144 and have only 20 .25-inch increments to use up.

7. Move one column to the right and put down 22 .25-inch increments from frame 5 to frame 26. We now have used 130 out of 144 and have 14 increments left.

8. Following this same pattern, we see that if we use frames 6 to 25 we have more frames than increments. In cases like this, all you need do is move to the right and put down a column of $\frac{1}{4}$-inch increments from frames 9 to 22 until we have used all 144 increments available.

9. Here comes the easy part. To get your eases, add the increments from left to right to obtain the animation increments. So frame 1 moves .25 of an inch, for frame 2 the camera will move .25 + .25 = .50 of an inch, for frame 3 it will move .25 + .25 + .25 = .75 of an inch, and so on until the there are fewer increments to add together and the ease out begins.

If you add your final increments from top to bottom, you will see that you will indeed have the camera travel 36 inches over 30 frames with a smooth ease in and ease out. This simple and easy-to-understand system can be modified in any number of ways to create moves that are ease out only or in which one of the eases lasts longer than the other for more sophisticated moves. Depending on how you prefer to work, the moves can be made to these absolute increments or you can convert them to precise positions along a yardstick scale. For example, if you are starting from 0 on your yardstick, frame 5 would put you at 3.75 inches. When doing dolly moves, you must remember to also animate the lens focus so your subject stays sharp throughout the move.

Focus Incrementation

Although it is difficult to attach a laser pointer to a lens, the same pentagraph idea can be implemented with a hose clamp and a stiff wire. Lightly tighten a hose clamp around the focus barrel of your manual lens and attach a long pointer off the clamp to press against a card that has increment markings. This can make effects like rack focus much easier. Keeping objects in focus during a dolly move is even easier. All you need do is place a focus chart next to your principal character every few frames (depending on the move) and just check to see that your focus hasn't drifted. If you keep checking the focus in this manner, the adjustments will be invisible.

Figure 10.21 *Camera mounted to a drawer slider to create a smooth dolly move.*

Figure 10.22 *A focus ring rig. The pointer rests against an inexpensive plastic protractor.*

Cinematography and Filmmaking

It is a good idea to learn the techniques of cinematography such as composition and lighting so that you can photograph your characters in the best way possible. Proper lighting can make all the difference in the world. This subject is a whole other book by itself. I cover some basics of lighting and composition in *Filming the Fantastic,* but a good overall book on filmmaking in general is Jason J. Tomaric's *The Power Filmmaking Kit* from Focal Press. This book is excellent because it talks about how to make a film from start to finish. As an animator you will want to eventually go beyond animation exercises and progress to making a film. When I arrived at USC Cinema in 1976 with a slew of animation experiments under my belt, the professors gave me the best advice I ever received. They told me to study live-action filmmaking and then apply what I learned to animation. All of the neat tricks you can do in animation will be much better if you learn how to tell a story with moving images.

Chapter 11
Professional Techniques

Throughout the text you have executed exercises at standard television resolution. This standard has good quality, and you can store a lot of animation in a relatively small space. When stop motion work is executed for motion pictures, we will use a much higher pixel resolution of 2048 × 1556 or greater. The choice of format will also vary from 16 × 9 (high definition) to the traditional film formats expressed as ratios such as 1.85 to 1 or 1.33 or 2.35. A detailed examination of the history of film formats can be found in *Filming the Fantastic*. The advantage that motion picture film has over conventional video is its high resolution and wide exposure latitude. Happily the stop motion process has a number of ways to achieve the wide range of exposure available in film emulsion. The professional editions of Stop Motion Pro can handle them all.

Dynamic Range

The majority of digital images sets tonal values for each pixel that range from 0 for black on up through a range of grays to 255 for white. Color images have 255 values for each of the color channels and when the values are multiplied together, 255 red × 255 green × 255 blue, we have more than 16 million possible color variations for each pixel. In the zero and one binary computer language of the computer, each one of the 255 values can be expressed in 8-bit words composed of zeros and ones. Adding the 8-bit placeholders together gives us a numerical value for the color capability of the system: 8 + 8 + 8 = 24-bit color.

As many color combinations as these values offer, they still fall far short of what film is capable of. An easier way of grasping this is to take a picture with a video camera outside in bright sun. If the picture has too much contrast such as a person in shade in front of a bright bald sky, you will get a situation where the 255 brightness values will not be able to cover this wide range of light. Either the sky will "burn out" to an even tone of white with no detail allowing you to see the person or the person will go black if you expose for the sky allowing you to see the sky. That is the limitation of having only 255 values. With the digital equivalent of motion picture film, you will have many more tones to work with. Motion picture film scanned to

doi: 10.1016/B978-0-240-81219-9.00011-8

Figure 11.1 *The problem of low dynamic range with a video camera. We have a good exposure in the shade but the bright areas blow out, as the video camera can't capture this wide range of light.*

a 10-bit-per-channel digital file will have the equivalent of 1023 values. This enormous range allows you to obtain tonal detail in both the sky and the shaded subject in the last example. This capability is known as *wide dynamic range*. Digital motion picture cameras capable of achieving this high resolution and wide dynamic range are extremely expensive. Fortunately, for stop motion projects this same high level of detail can be achieved with digital still cameras.

Raw Images

Many high-end still cameras will give you a choice between shooting a JPEG image that looks like a normal snapshot or a Raw image

that will look flat to the eye and needs to be adjusted. The peculiar appearance of a 16-bit Raw image is caused by taking the raw signal from the imaging device and redistributing the tonal values to capture a wider range of light. This allows you to use the full range of tonal levels captured by the digital camera. A JPEG image will perform much like a 24-bit video image and be limited in the number of adjustments you can make. A Raw image will allow for much more control over the brightness, contrast, and color. Stop Motion Pro allows you to capture Raw images and also convert them to JPEGs on the fly for the software to use. When the animation is finished, all of the editing functions you utilized, such as sequence duplication, will be applied to the Raw images. The new Raw image sequence will be numbered accordingly, and these high-quality files can then be ported into programs like After Effects for postproduction.

HDRI

For extremely high-end productions there is a method that provides an even wider range of latitude than Raw; it is called *HDRI*. HDRI stands for high-dynamic-range imaging, and stop motion provides the perfect vehicle for its use. Motion picture film is capable of capturing 8 to 10 stops of exposure range (stops refer to the f-stop range on the lens), whereas a digital sensor usually tops out at 6 stops of range. The scheme behind HDRI is to expose the same image at several exposure values and then blend them to create a file that has a 10-stop or higher range of exposure. In the case of our shaded subject in front of the bright background, we could take our two separate exposures and blend them to create the same wide latitude image we enjoy with film. The one requirement is that the multiple images must not change between the exposures, such as a person moving between exposure 1 and exposure 2. The two images need to match exactly or distortion will result. This is no problem for stop motion setups where the technique demands a frozen frame. The exposure value is changed with exposure time instead of using the f-stop, as that would create changes in focus.

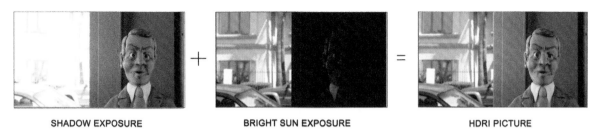

| SHADOW EXPOSURE | BRIGHT SUN EXPOSURE | HDRI PICTURE |

Figure 11.2 *Separate HDRI images blended to make a high-quality image.*

Shooting Lights Separately to Blend Later

One of the great advantages to shooting single frame is the ability to shoot the subject in a variety of lighting conditions and then pick and choose the blending at a later time. In the past, animators would use a process called front light–backlight to create mattes for compositing. On one frame a black backdrop would be lowered behind the subject and a fully lit "beauty pass" was shot of the figure. Before the puppet was moved, the foreground lights were turned off and a white screen was lit behind the figure to create a silhouette of the figure that you could create a matte with. This made compositing much easier in the old days. Today, we take that approach further by shooting the key light separately, the fill light separately, and any effects lights as well as a green screen. These different images are then blended using compositing software to accomplish a bit of "post" cinematography. This approach is cumbersome but allows for a high degree of control.

FRONT LIGHT EXPOSURE

BACK LIGHT EXPOSURE

FRONT LIGHT/BACK LIGHT METHOD

ALPHA CHANNEL PULLED FROM BRIGHTNESS OF BACK LIGHT SUPPORTS ARE REMOVED WITH GARBAGE MATTES.

FINAL COMPOSITE

Figure 11.3 *A front light–backlight scheme.*

Figure 11.4 *The fill light of the figure in front of a green screen.*

Figure 11.5 *The key light only.*

Figure 11.6 *The engine light only. The advantage of shooting a separate effect light like an engine or firelight is that flickering can be accomplished in post and adjusted numerous times. You no longer have to be "locked in" to a tedious flicker effect done on the set.*

Figure 11.7 *Combining the key, fill, and engine light.*

Figure 11.8 *Adding a background, a bird, and smoke effects for the engine. Post-cinematography allows for tremendous control over the image.*

Motion Control

In the camera chapter, I detailed how to plot out moves frame by frame in order to animate a camera. In the professional arena, motion control systems are used to generate sophisticated and repeatable moves using computers and motor-controlled cameras. Motion control gained widespread use in the 1970s with the *Star Wars* films. Through the use of clever compositing tricks the Industrial Light & Magic (ILM) crew was able to create the illusion of spaceships covering great distances by keeping the model in place in front of a blue screen and moving the camera toward and away from it on a long dolly track. This not only allowed for fewer lights (you could light the model in one place instead of lighting a huge area it moved through), but it allowed for motion blur as the repeatable camera could shoot while moving. The greatest advantage of motion control was the ability to do repeat passes and build up exposures to create images that would be impossible to do at one time.

A case in point is adding the hot rocket exhaust of the spaceships. In a typical *Star Wars* shot, you would shoot what was called a beauty pass where the model was lit with a key light and fill. After you accomplished this move and exposure, which may have been f/8 at 1/4 second, you would wind the film back in the camera and repeat the move exactly, only this time all the lights would be turned off in the room and a single bulb positioned in the ship's engine would be lit. This bulb would appear quite dim to the eye but would be made to glow white hot as the second pass would add a heavy diffusion filter and be shot at an exposure of f/8 at 4 seconds, effectively burning out the ship's exhaust. When the first and second passes were double exposed over each other, you achieved an exciting lighting effect.

Figure 11.9 *A motion control rig for a Nikon digital camera. Courtesy of Jason Rau of Camera Control, www.cameracontrol.com.*

Motion Control for 3D Movies

Traditional live-action 3D movies are usually made with special lenses that take the left and right eye view and place the images one on top of the other on a strip of film. Other processes use two cameras and a mirror to capture the left and right eye views. Stop motion and motion control have the distinct advantage of using one high-quality camera and using motion control to move the camera to take the left eye view and then move it a few inches to capture the right eye view for each position of the animation. This process allows ultimate control over the interocular distance (distance between the eyes) and parallax adjustments.

Figure 11.10 *A Canon camera on a motion-control head. Courtesy of Jason Rau of Camera Control www.cameracontrol.com.*

Lower-Cost 3D Technique

For those wanting to experiment with 3D projects on a budget, the Stop Motion Pro company recommends using a Loreo 3D macro lens and Pixie viewer. The Loreo lens attaches to compatible Canon and Nikon DSLR cameras and creates a simultaneous left and right eye view during capture. The macro lens has a focal length of 38 mm and a focus range of 23 to 85 cm (9 to 33 inches). The accompanying viewer enables you to see your animation in 3D while looking at your monitor. Details can be found at www.loreo.com/pages/products/loreo_3dmacrocap.html.

Motion Control Alternatives

The rental or purchase of a motion control rig can be an expensive proposition, even for professional studios. One clever workaround for TV broadcast is to once again use compositing to generate moves after the fact. TV shows with short production schedules use a DSLR camera to capture film size images or larger and then extract portions of that image that are at least equal to the size of the TV resolution to do pans, tilts, and cutaways. An amazing amount of impressive simulated camera moves can be done this way in a timely and cost-effective manner.

Figure 11.11 *The left and right eye view is easily accomplished with a single high-rez camera and motion control. If you look at both images at the right distance and concentrate, you will be able to merge the two pictures and see the 3D image, or you will get a splitting headache but go ahead and give it a try. This shot was taken with an interocular distance of 2.5 inches (the distance between human eyes). This will give the impression of the actual size of the character, which is approximately 4 inches tall.*

Figure 11.12 *These images were shot with an interocular distance of 1/4 inch (the distance between the character's eyes). This decision allows the audience to see the fantasy world in the scale of the characters. In the 3D movie* Coraline, *some of the left eye–right eye offsets were less than 1 inch. In visual effects compositing, it is sometimes appropriate to blend scaled interocular shots. One case in point was a Disney 3D film where a magician was shown looking at a table of miniature people. The magician was photographed with an interocular distance of 2.5 inches but the miniature people, being one-quarter scale, were shot with a large interocular of 10 inches (4 × 2.5 inches) to scale their appearance to the magician's camera.*

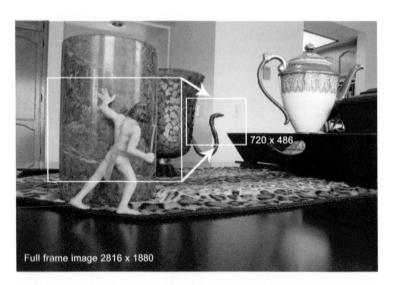

Figure 11.13 *The pan and scan approach for doing camera moves after the fact in post. Borak and the monster. © Mark Sawicki.*

Image Processing
Blur

As mentioned previously, creating blurs during the stop motion process can be done but the process may suffer from inconsistencies from frame to frame. Small errors that result from the "on the fly" process are usually overlooked as it involves rapid movement. Once again, however, we can transfer the uncertainty of blurring on the spot by shooting crisp imagery and using post-blurring tools in compositing software. Different parts of the image containing arms and legs can be isolated and directional blur can be added directly onto the digital image. Because the process is nondestructive, a sequence of blur additions can be made and played back for approval. If blurs need to be adjusted, it is a simple matter to do so.

Morph and Warp

Now for the first time stop motion animation can be carried forward into post to generate subtle enhancements not possible with the original puppet. One case in point was a dinosaur animation done by Chris

Warren using a traditional foam latex model. The model had limitations in how much the eyes and mouth would move and a tear developed in the latex during the animation process. The stop motion files were turned over to computer-generated imagery (CGI) expert and visual effects supervisor Glenn Campbell who added subtle warp effects to move the pixels that made up the eyelids so that they would appear to open slightly as the creature spoke. This same process was used to stretch the mouth in post so it could form a more effective smile than was possible with the rubber face. The tear in the rubber was easily repaired as well. Another example is the stop motion creature animated by Doug Beswick in the film *Beetlejuice* (1988) where the sand worm creature was animated with blank eyeballs and the pupils were put in and animated in post, allowing them to grow and shrink in a comic manner. Seams seen in replacement mouths for some of the Rankin Bass films were artistically placed and pleasing but could now be smoothed out with digital tools if desired.

3D Digital Printing

The amazing potential of replacement animation has received an exciting new dimension with the ability to create characters in the computer and print them out as dimensional figurines complete with sequential animation poses. This modern method was recently used on the film *Coraline* for the expressive faces of the figures. Using digital sculpting tools such as Z-Brush, high-quality replacement characters can be created, and the finished files can be printed with absolute precision and dimensional stability. The labor-intensive process of Pal's Puppetoons can now be accomplished with ease and amazing consistency. Companies such as Offload Studios are at the forefront of this technology (www.offloadstudios.com).

Figure 11.14 *The Offload Man figure from the Offload studios 3D printer. Note the high degree of detail and subtle color that can be printed. Artists can use this system to create collectable figurines of their characters. A clay sculpture can also be scanned into the system in full color to create printer data for reproduction. Courtesy of offloadstudios.com. Photo by Laura Henderson.*

Designing a Character for 3D Printing

Juniko Moody is a seasoned computer graphics artist/instructor who was kind enough to share a few stills for the process of creating an animal character for a studio. The first step is to draw a large number of character studies of the animal using many reference photographs. Anatomy and skeletal structure are adhered to, and the character is put through many poses to nail down the form and attitude. The next step is to stylize the character. In this case, Moody modified the bear by drawing in new retro cartoon style where the character is designed around a bold dynamic shape. Once the drawing is finalized, a model sheet is drawn and scanned into a CGI program like Maya. The style sheet drawings are used as a template in Maya to create a basic 3D character. Once the 3D model is created with a CGI armature, the form is taken into Z-Brush where the final detailing and refinement of the character are done. It is at

this stage that the character will be duplicated and distorted using Z-Brush tools to create an animation sequence. Once the sequence is made, the Z-Brush file is sent to Offload Studios where a full-color series of 3D figurines is created via laser scanning that cures, solidifies, and colors the printing powder. After the full-color 3D prints are made, they will undergo final finishing to prepare them for a replacement animation shot using Stop Motion Pro.

Polar bear with Hawaiian shirt and sunglasses

copyright
JMoody
Lineup
9/09/03

Figure 11.15 *Early rough original character concept art.* © *Juniko Moody.*

Figure 11.16 *A character study of the bear in a number of poses. Surfin Polar Bear. © Juniko Moody.*

Figure 11.17 *A model sheet adding retro style to the character. Courtesy of Juniko Moody.*

Figure 11.18 *Surfin Polar Bear converted to a 3D form in Maya.*

Figure 11.19 *An animated replacement sequence sculpted in Z-Brush. A simulated illustration by Juniko Moody, college online instructor. Surfin Polar Bear. © Juniko Moody.*

The Exciting Future Ahead

The introduction of marvelous digital technology such as Stop Motion Pro has made it so much easier for artists to explore and create in the exciting art form of stop motion. Gone are the days when the process of stop motion was a fearful undertaking and animators worked away on a wing and a prayer, not knowing the result until the next day. One all-too-common horror was to have the synchronization slip on your animation motor so that the film camera was photographing the animator animating and merely closing and opening every time the button was pushed. The next day when the film came back showing animators' hands ablaze all over the sequence, the artist would be beside himself with grief. Today with Stop Motion Pro there are no surprises and you can play back and correct as you go. The freedom and fun this affords are beyond measure. With today's digital tools, we can work on the set and in post, taking the pressure off getting everything right the first time. Last, we are able to easily blend live action and computer graphics with this gentlest of arts to create stories never before seen. I hope you have enjoyed this book and can join me in experiencing the wonder and joy of breathing life into something you've made with your own hands. Have a great time creating, animating, and bringing your magical stories to the world.

Index

About the Author

Cameraman, artist, and actor Mark Sawicki began his career as a stop motion hobbyist in Jackson, Michigan. His early work as a teenager led Sawicki to enroll in the USC Cinema program in Los Angeles, where he and his friends struggled to find ways of breaking into the film industry. An early effort of Sawicki and his classmates was the independent feature film *The Strangeness* (featured in the book *Nightmare USA* by Stephen Thrower, 2007, Fab Press, and rereleased by codereddvd.com) for which Sawicki was co-producer, visual effects artist, and actor. This film was a terrific introduction into the field and opened the door for Sawicki to work at Roger Corman's New World Pictures. While at Corman's, Sawicki experienced the rough-and-tumble world of low budget effects that recreated the spectacles of much larger pictures using very limited resources. After working on several 1980s genre pictures such as *Galaxy of Terror* and *Saturday the 14th,* Sawicki was invited to set up the optical department at CMI and was introduced to the world of commercials where he won a Clio for his camera work. During this period Sawicki went on to become an independent stop motion and clay animator for several MTV rock videos such as Nu Shooz, Judas Priest, Muppet Babies, and an assortment of educational programs for primary schools.

In 1986, Sawicki became a matte cameraman for Illusion Arts where he had the fabulous opportunity of working under Albert Whitlock in the last years before the great matte painter's retirement. Sawicki worked as a cameraman and animator under the mentorship of Bill Taylor ASC and matte painter Syd Dutton where he photographed and helped embellish over 1000 matte paintings used in major motion pictures. For his efforts Sawicki shared in an Emmy win for the *Star Trek* television series. Sawicki also appeared as a matte camera-man in an episode of Movie Magic.

In 1996, Sawicki was offered the position at Area 51 of co-supervisor along with Tim McHugh on Tom Hanks's *From the Earth to the Moon.*

After the miniseries, Sawicki became head cameraman, animator, digital colorist, and effects supervisor for Custom Film Effects, founded by former Disney effects supervisor Mark Dornfeld. Sawicki contributed to pictures such as *Tropic Thunder, Underdog, Premonition,* and *Eternal Sunshine of the Spotless Mind.*

Starting in 2001, Sawicki produced and hosted a series of instructional videos on the art of clay animation. After the programs were picked up by firstlightvideo.com, Sawicki was invited by the Weller Grossman Company to display his clay animation talents on HGTV as a product endorsement artist for the Sculpey Corporation. Since that time Sawicki has become a U.S. representative for Stop Motion Pro and teaches at UCLA Extension and the New York Film Academy at Universal Studios. In his spare time Sawicki performs as an actor for up and coming independent filmmakers and also creates fine cartoon art for collectors.

Printed and bound by CPI Group (UK) Ltd, Croydon, CR0 4YY

22/10/2024

01777530-0011